Art
for
Exceptional
Children

Art
for
Exceptional
Children

Third Edition

Donald M. Uhlin

Edith De Chiara
Herbert H. Lehman College
of the City University of New York

wcb
Wm. C. Brown Publishers
Dubuque, Iowa

Library of Congress Catalog Card Number: 83–72295

ISBN 0–697–03302–3

Source of figures 88, 91, 92, 93, 94, 95, 134, 135, 136, 222, 223, 224, 225, 226, 227, 228, 229, 236, 237a,
240, 242:

Uhlin, D. M.: The Basis of Art for Neurologically Handicapped Children. Figures 2–18. Art
Interpretation and Art Therapy, ed. I. Jakab; Psychiatry and Art, Vol. 2. Vth Int. Coll. Psychopathology
of Expression, Los Angeles, Cal., 1968; pp. 210–241 (S. Karger, Basel/New York 1969); and

Uhlin, D. M.: The Descriptive Character of Symbol in the Art of a Schizophrenic Girl. Figures 2–5. Art
Interpretation and Art Therapy, ed. I. Jakab; Psychiatry and Art, Vol. 2. Vth Int. Coll. Psychopathology
of Expression, Los Angeles, Cal., 1968; pp. 242–248 (S. Karger, Basel/New York 1969).

Printed in the United States of America

2 03302 01

contents

foreword

Since the second edition of Donald Uhlin's, *Art for the Exceptional Child* in 1977, special education has taken on new dimensions. Public Law 94–142, the Education of all Handicapped Children Act (1975) dramatically affected the position of mentally and physically handicapped children in the schools. It established new definitions and delimitations for working with them. Mainstreaming created new problems for art and classroom teachers, as well as school administrators and special education personnel. The National Committee Arts for the Handicapped, with statewide Very Special Arts Festivals is changing public attitudes and interests in the arts as avenues of creative expression and remediation for exceptional children. The decrease in school enrollments, the higher costs of education with less federal support led to schools closing nationwide. The resulting decline in art teaching jobs and the need for extending college art offerings to attract more students, each led to a new consideration of art therapy as career potential. Humanistic and Gestaltist modes of art therapy are challenging traditional psychoanalytic modes in popularity. The American Art Therapy Association is effectively establishing education and registration requirements for Art Therapists.

In preparing this third edition, following Donald Uhlin's death, Edith DeChiara expanded his book to meet some of the new demands placed upon special education, art and regular classroom teachers as a result of these changes. The years ago discussions in art education courses as to whether art teachers should get involved with therapeutic concerns have been resolved in part by P.L. 94–142. They will become involved—but, the special education personnel, art and classroom teachers need the information to do it well, and to know the limits of their involvements. There is a distinction between art therapy and art education therapy which is not always accepted in either field. It is one which DeChiara describes in this revision (Chapter 4). Art education therapy uses art for remedial purposes in handicaps and dysfunctions to improve the quality of the child's learning processes. This also includes improving self-image and dealing with personality and emotional disorders which interfere with the educational process. It takes place in the school setting. Art therapy, on the other hand, uses art for diagnostic purposes and assists the patient/client meet emotional and psychological problems or disorders arising from the conflict between his or her inner and outer worlds. This usually takes place in clinical or institutional settings, in a one-to-one relationship.

In a school setting, the P.P.T. (pupil planning team) may assign art through an I.E.P. (Individualized Education Program) in mainstreaming students. But the I.E.P. itself, should be planned jointly by the P.P.T. leader and the recipient art teacher. To be done effectively for the good of the child, each person should have basic knowledge of the other's field. This revision balances between basic art education information about normal stages of growth in art with that which is exceptional through handicaps and dysfunctions. The examples from the House-Tree-Person test, which is the most popular psychoanalytic procedure in the schools, are important for art and classroom teachers to know about, so they may be sensitive to how personality disorders are revealed through art in order to recommend further psychological evaluation, or to know what is being discussed during the P.P.T. But warning should be made that not all such examples in child art indicate severe personality disorders. The contribution of art teachers to a P.P.T. may be to provide the child art rationale, and indicate what is normal in child art to avoid mis-diagnosis.

Both Uhlin and DeChiara concentrated on the figural drawings, paintings and sculptures of children, rather than give extensive space to crafts projects. It is in the figural and symbolic subject matter that psychological and emotional disorders can best be diagnosed and discussed. Edith DeChiara has added sections at the end of certain chapters and one long chapter at the end of the book with suggestions for art activities including crafts for exceptional children. Her approach throughout has been to broaden the range of content, and address current needs in art for exceptional children, without losing or violating the essential strengths and personal direction of Uhlin's text. It is an excellent merger of the two.

Robert J. Saunders, Ed. D.
Art Consultant
Connecticut State Department of Education

preface to the third edition

Art for Exceptional Children, third edition is directed towards practicing and prospective teachers, parents, and other personnel who will or currently work with exceptional children in art: art therapists, therapists, special education, regular classroom and art teachers, psychologists, occupational therapists, counselors, and parents.

Important developments have taken place in special education which has had a direct impact on general and art education for exceptional children. Federal and state laws have mandated a free appropriate education in a setting that is close as possible to the regular classroom—the least restrictive environment. This has resulted in the movement to integrate exceptional children into the regular education program (including the art class) to the greatest degree possible. Due to these legislative developments, special education and concern for the "special" child is no longer the exclusive domain of special educators and therapists. The needs and development of exceptional children are now the shared responsibility of regular classroom and art teachers in addition to other professionals and parents who have always worked with these children.

The importance and value of art in the lives of exceptional children has been more fully realized. Responsibility for developing, facilitating, and adapting art programming and activities for exceptional children has been extended to regular classroom teachers, art teachers, and special education teachers as well as art therapists.

The purpose of the third edition of *Art for Exceptional Children* therefore is to broaden the scope of the book so that it meets the diverse needs of all those who work in art with exceptional children. Donald Uhlin and I have different orientations towards art for exceptional children. His perspective is primarily from an art therapist's point of view, mine from an art educator's vantage point. Uhlin's vast experiences included working with exceptional children in art therapeutic situations, writing, and training prospective art therapists. My experience includes working with exceptional children in art in classroom situations and preparing art, regular classroom, and special education teachers on the preservice and inservice level to teach art to exceptional children. The resulting book is the combined efforts and contributions of our experiences. Uhlin's material on art therapy is integrated with new material on exceptional children, art programming and art activities in the classroom, and the differences between art therapy and art education.

The first chapter in the book, "Development of the Normal Child in Art," introduces the artisitic development of the normal child, basic theories of child art and the significance of drawing forms in early childhood. This chapter provides the foundation for understanding the artistic development and expression of various clusters of exceptionalities covered in Part Two.

Part Two, introduces art for exceptional children. Chapters 2 through 4 describe individual clusters of exceptionality. Each exceptional modality includes the definition, characteristics, educational programming, art expression, strategies for art programming, and suggested art media, materials, and activities. In Chapter 3, the section titled "The Learning Disabled Child and Art," has been added to the book. Chapter 4, "The Emotionally Disturbed Child and Art," is also new. Chapters 5 through 7 have an art therapy orientation and topics include, "Recognizing Emotional Disturbance in Children," "Children in the Process of Art Therapy," and "Art and the Violence Prone Personality."

Part Three, "Theoretical Considerations: Structuring and Maintaining Reality," offers significant historical, philosophical and psychological material pertaining to the body image and psychological movements.

Part Four, "Procedures: Selected Art Activities," has been added to the text. It describes in detail art activities that require advance preparation, involve several steps, or require a more extended explanation because of their complexity. The activities are grouped according to categories: "Exploring an Art Element: Line," "Exploring Techniques: Relief, Construction, Modeling and Shaping, Weaving," and "Integration of Art and Other Subject Areas." Each activity includes the following sections: materials, advanced preparation, procedure, variations, adaptations.

A glossary of terms associated with art has been added; the terms associated with exceptionality expanded. The Reference section at the end of Chapters 2, 3, and 4 have been updated.

The opportunity for artistic expression is a necessity in the lives of *all* children including the exceptional. Hopefully, *Art for Exceptional Children* will help make this a reality.

Edith De Chiara
July 1983

preface to the second edition

It is fine to be sympathetic, but people in need must have help. The purpose of this book is that teachers, therapists, social workers, and others working with exceptional children might be given more insight to really meet the needs of these children. Help is dependent upon such understandings, as well as upon a love that looks respondingly to needs, with a subordination of one's self-interests.

Art expression will be our vehicle for understanding the child's needs, for communicating with him, and for sensitizing him in a way that will help him more ably function according to his potential. There are many people today who are devoting themselves to the production and the appreciation of art but this book is for those who would utilize art for people. And, it will be seen, that such a use of art will in no manner detract from the significance of art in itself, but it will rather reveal that truly great art of aesthetic merit is often produced by the hand of the humble. Adults have lost the spontaneity and freedom that characterizes the art of the child. Exceptional children are in this respect too often like the adult and they need to be restored to their normal flexible estate.

The parenting factor will be of prime concern in our discussion for the healthy development of children is directly dependent upon the parent. Their perceptual orientation will be determined by the parent's influence for the rest of the child's life. The child's feelings of security or insecurity in the emotional sphere will directly lead back home and will be of great concern to us for feelings, attitudes, and value systems do carry the individual into adult relationships with society—and we want the very best for every child! It is the only way that we will have a better society.

PART ONE
Artistic Development

Development of the Normal Child in Art

1

In this chapter the development of the normal child in art will be described for the purpose of establishing a background against which we will discuss the exceptional child. Such an identification is necessary for comparison when we later consider the art of the exceptional child. A review of the basic theories of child art will be presented before we discuss the relationship between developmental characteristics of child art and chronological age.

Basic Theories of Child Art

The first research concerning child art was initiated in the winter of 1882 when Corrado Ricci, an Italian poet, observed the drawings of children under an archway where he had sought shelter from a sudden downpour of rain. His reports encouraged the study of art expression as a means for more deeply understanding the total experiencing of the child. The Child Study Era at the turn of the century was a movement of world magnitude and centered upon the behavioral patterns of the child at each step in his development. International congresses were formed in those years to pool data and structure theories which would communicate just what it was that the child was resolving at a particular chronological age. By 1920 a rather clear idea of the "stages of growth" in artistic development had evolved from this study, and attention was centering upon tests of measurement for specific behavioral aptitudes. As the century progressed, other fields of inquiry formed and had a great influence upon our present understanding of child development in art. Prominent among them were the gestalt and psychoanalytic schools in psychology. It is imperative for our later discussion that we understand the broad implications which this historical body of research presents.

Ricci noted in his observations that the child starts drawing with an "interlacing network of lines" and then moves on to simple representational forms which become more detailed with age. He recognized in these simple forms that the child draws a description of the subject according to his knowledge of that subject and not according to its visual appearance. This "mental concept" consideration of the young child's drawing characterized all of the very early studies. It is emphasized, moreover, in another of Ricci's observations in which he speaks of the child drawing a sexton ascending the bell tower visible through the walls of the building. Such an "x-ray" view suggests that children not only draw their idea of the subject but that they also draw that which is most important. If the inside is more important than the outside, then the outside, or exterior, is made transparent or left off completely.

A number of the early studies, especially those by Lichtwark (1887) and Baldwin (1898) attempted to find parallels between the child's development in drawing and the evolutionary theories which were popular at the time. The development of the child in art was compared in the early years to paleolithic cave drawings, with the notion in mind that the child would progress in his life through all of the sequential stages of mankind. For many years anthropologists and psychologists drained this idea from every possible angle. It did have the effect of giving rise to an interest in the "stages" of development in child art.

3

In 1892 James Sully, an English philosopher and psychologist, published his *Studies of Childhood* in which he used the term *schemata* or *schema* for the child's simplified drawing concept. His work, highly influenced by Ricci, placed emphasis upon the simple plan or mental concept of the child which represents the subject rather than rendering it in its visual likeness. We find from this definition that the word *schema,* in referring to the child's drawing, always suggests a simple representational symbol which stands for the subject. It is composed of shapes and lines of a singular and direct character.

Earl Barnes was perhaps the first researcher to really organize, conduct, and report scholarly studies of child art. In 1893, in reporting on child drawing responses to a story motivation, he noted that a definite sequence of development occurred according to chronological age. He found, also, that figures in the drawings often changed from a frontal view to a profile view at nine years of age. In regarding the young child's art, he considered it generally to be a basic symbolic language.

In 1895 Louise Maitland found that young children had a decided preference for drawing the human figure. This observation had earlier been made by Ricci and is substantiated by many later studies.

The first description of developmental stages according to chronological age was given by Herman Lukens in 1896:

1. Scribbling (to 4 years).
2. The Golden Age—The child blends story and picture (4 to 8 years).
3. The Critical Period—The child's judgment of his art stagnates his efforts (9 to 14 years).
4. Period of Rebirth—Creative power and artistic development for a few (14 years on).

In 1902 Arthur B. Clark used an apple with a hatpin stuck through it as a device for studying children's attitudes toward an object in drawing (fig. 1). He found that ninety-seven percent of the six-year-olds drew the whole pin as if the apple were transparent. The younger children were therefore emphasized again to be conceptual in drawing. By nine years of age the majority of the children stopped the pin at the edge of the apple.

In 1904 Sigfried Levenstein of Leipzig used the term "storytelling" to describe the young child's art. In the early years he noted that it was "fragmentary," and we could probably best interpret that to mean disunified on the spatial surface of the paper. He observed that the older child used a storytelling which involved linear, panoramic, and time-sequence factors. The general term *storytelling* is an excellent description of the vivid manner in which the child expresses, through his concepts, in art.

The terms *ideoplastic* and *physioplastic* were used by Max Verworn in 1907 to describe the child's art development. Ideoplastic refers to ideas and regards the apperceptive process more than direct sensory experiencing. The symbolists or expressionists in art would be classified ideoplastic artists. Physioplastic refers to the individual's relationship to his physical environment as experienced through the senses. Impressionistic art would fit within this classification. His stages regarding the child's art development were basically as follows:

1. Unconscious Physioplastic Stage—Scribbling (to 4 years).
2. Unconscious Ideoplastic Stage—Symbols used to express ideas (4 to 9 years).
3. Conscious Ideoplastic vs. Physioplastic—The growing intellect vs. sensitivity of physical maturation (9 to 13 years).
4. Conscious Physioplastic Expression—Wins out in the adolescent period. Physical experiencing of materials must therefore be the emphasis while the intelligence aids in guiding these sensibilities.

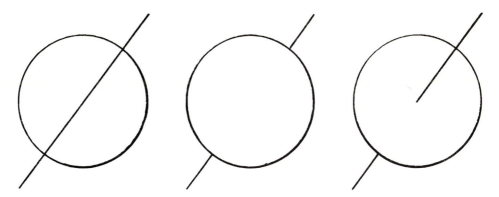

Figure 1. The Apple and Hatpin (after A. B. Clark). Three stages from pure concept to pure percept are represented.

In 1908 William Stern expressed a view that the child experiences himself as the center of space in his drawing and that he gradually attempts to subordinate his environment to himself. This observation will later aid us in understanding what motivates the child in his need to highly organize the space of the drawing surface. Stern also noted a relationship between drawing development and language development. He states, "Scribbling is to drawing much what babbling is to speech."

Through his experiences with children in his special art classes, Franz Cizek, the first teacher to actually sensitive children to a subject through art, came to speak of the earliest drawings as "smearings" and the later schematic representations as *abstract-symbolic* productions. He recognized that the drawings of young children are simplified representative forms standing for the subject. Perhaps his best biographer is Viola who describes in detail the wonderful verbal interchange through which Cizek extended the child's reference of experience and thus sensitized the child emotionally and rationally to the subject.

In 1921 Cyril Burt came out with a full and highly acceptable description of stages in the child's development in art:

1. Scribbling (2 to 3 years).
2. Line (4 years).
3. Descriptive Symbolism (5 to 6 years).
4. Realism (7 to 9 years).
5. Visual Realism (10 to 11 years).
6. Repression (11 to 14 years).
7. Artistic Revival (experienced by some).

His stages indicate a gradual growing from pure motor activity to linear storytelling. Realistic tendencies are then initiated in the transition to older childhood with the discovery of spatial depth and motion. The general tendency is for repression and a discarding of art in the early adolescent years. Many may enter such repression at an earlier age if they are not provided with adequate encouragement and guidance. A few children experience confidence leading to art involvement and further development of their capabilities in mid and late adolescence.

Viktor Lowenfeld published *Creative and Mental Growth* in 1947, which describes six stages of development. His work draws from much of the earlier research and theory but has had the advantage of placing the material in a manner that has received very popular acceptance in this country. He describes the following stages:

1. Scribbling (2 to 4 years)—Experiences of Body Motion.
 Disordered Substage—Lack of Motor Control (to 18 mo.).
 Longitudinal Substage—Visual-Motor Control (18 mo. to 2 years).

Circular Substage—Experimentation with Visual-Motor Control (2 to 3 years).

Naming Substage—Change from kinesthetic activity to Mental Activity (3 to 4 years).

2. Pre-Schematic (4 to 7 years)—Searching for Representational Symbols.
3. Schematic (7 to 9 years)—Storytelling By Using and Repeating Form, Space, and Color Schema. (The experience is expressed in Form by Exaggerations, Omissions, and Distortions. It is expressed in Space by Foldover, X-Ray, and Moving-Time Sequence Views.)
4. Dawning Realism (9 to 11 years)—Spatial Depth expresses deeper social awareness in the "Gang Age."
5. Pseudo-Realism (11 to 13 years)—Critical Awareness from Physical Change Stifles Many in "Early Adolescence."
6. Period of Decision (Adolescence).

From 1920 on, other disciplines began to take great interest in the child's art. McCarty used H-T-P drawings of children in 1924 to establish relationships between drawing characteristics and intelligence. In 1926 Goodenough published the Draw-a-Man Test which very accurately assesses intelligence through details of the child's drawing of a man. In 1963 Harris published an extensive revision of the Goodenough scale which holds broader implications for general intellectual maturity, or what he terms "conceptual maturity."

By 1930 psychologists were becoming primarily involved with the child's art as a core area for studying perception. Many were either strongly influenced by Gestalt psychology or even built their entire theory of child art from that reference. Most notable among these were Bender, Read, Schaefer-Simmern, and Arnheim.

There were several who stimulated an interest in perception. Hartlaub in 1922 and Jaensch in 1923 both wrote of "eidetic" gifts which were defined as mental pictures produced as an intermediary image between mental function and the act of perception. The theory was popular for a time but is essentially one more rationalization structured to compare the child to the paleolithic cave artist. Some of Jaensch's observations were the basis for gestalt experimentation.

While Britsch was not directly involved with the Gestalt School, his theories tie in very well with their principles. In 1926 he recognized that form develops from simple character in early childhood to more complex character with maturity and that the greatest directionality (vertical vs. horizontal) in the early years gradually changes to subtle variations of angle. He especially noted the matter of figure-ground relationship and the child's natural feeling for organization on the drawing surface. The influence of his work was introduced into this country by Henry Schaefer-Simmern (1948) who in turn highly influenced the work of Arnheim (1954) and Kellogg (1955). The terms used by these writers are often confusing, as they appear to be self-contradictory (*ex.:* visual conception). They basically aim, it seems, at revealing how the child develops a feeling of form, first from motor activity and then in conjunction with visual perception. The emphasis of the gestaltist, therefore, is basically a consideration of development from a view of the cognitive factor in sensory perception.

The earliest or more "primitive" activity of the child is motor activity, and the loop or whorl is the initial form of this expression in art. Seeman (1934) and Mira (1940) support this view. Bender (1952) mentions the gestalt form factor in the child in a very thorough manner. She states the gestalt view:

Gestalt psychology holds that the whole or total quality of the image is perceived. . . . The perceptual experience is a gestalt or configuration or pattern in which the whole is more than the sum of the parts. Organized units or structuralized configurations are the primary form of biological reactions . . . the organism in the art of perception always

adds something new to the experienced perception. . . . The final gestalt is the result of the original pattern in space (visual pattern), the temporal factor of becoming, and the personal sensori-motor factor. (pp. 50–51)

Her Visual-Motor Gestalt Test is perhaps her greatest contribution from this premise and is a means of recognizing the individual's capability to experience and organize self in the space and time of material reality. The test is structured in regard to perceiving motion characteristics in directionality, proximity, balance, closure, and other gestalt principles.

Read (1958) stresses the aesthetic factor from the gestalt viewpoint, a factor of strong agreement found later in the writings of both Arnheim and Kellogg. He quotes Koffka, one of the leaders of the Gestalt School:

"Perception tends toward balance and symmetry; or differently expressed: balance and symmetry are perceptual characteristics of the visual world which will be realized whenever the external conditions allow it." (p. 60)

Read further states:

If these facts are true—and the experiments of the Gestalt psychologists leave little doubt about the matter—then it is quite legitimate to call this factor of 'feeling' in perception and other processes, *aesthetic.* . . . Balance and symmetry, proportion and rhythm, are basic factors in experience: indeed, they are the only elements by means of which experience can be organized into persisting patterns, and it is of their nature that they imply grace, economy and efficiency. What works right; and the result, for the individual, is that heightening of the senses which is aesthetic enjoyment. (pp. 60–61)

Such enjoyment is obviously what the child seeks to naturally develop and enjoy. It implies a homeostasis or wholeness when achieved. It is easily recognized why Read is so open to accepting the gestalt principles for aesthetics when we also see how accepting he is of the Jungian psychoanalytic viewpoint. It, too, deals with this same unity or wholeness through the mandala form.

We could say that Read is as much, or more, Jungian as he is gestaltist, and through relating the *introvert* and *extrovert* concepts of Carl Jung to the four "directions" of the mandala, he arrives at eight types or categories of art:

1. Enumerative (Extrovert-Thinking Type)
2. Organic (Introvert-Thinking Type)
3. Decorative (Extrovert-Feeling Type)
4. Imaginative (Introvert-Feeling Type)
5. Rhythmical Pattern (Extrovert-Intuitive Type)
6. Structural Form (Introvert-Intuitive Type)
7. Empathetic (Extrovert-Sensation Type)
8. Expressionist (Introvert-Sensation Type)

Lowenfeld (1939) spoke of two perceptual types: the *visual* and the *haptic.* The visual type is stated to regard a person who identifies basically from visual environmental experiences. He could be recognized to be visually dependent, for maintaining self-identification, upon his environment and is essentially what Jung calls an extrovert. The haptic type is primarily concerned with his own bodily sensations and with the tactual space about himself. He is essentially what Jung labels an introvert. We must be careful to note that Lowenfeld sees these types on a continuum and not as discrete classifications. Most people, therefore, have both attributes to some degree but will tend to fit more into one category than the other. Many writers have grossly misinterpreted Lowenfeld on this point. Generally the visual type will follow these characteristics:

1. Through his art he will indicate a need to bring the world close to himself.
2. He will be biased toward analytical process.
3. His art will be spectator-oriented.

4. He will attempt to indicate spatial depth in his two-dimensional art and thereby reveal his social dependency.
5. He will attempt to draw realistically by suggesting light and shadow characteristics along with motion in his art.
6. He will use color according to realistic appearance.
7. He will tend to lack sensitivity for tactual factors.
8. His linear drawing will tend to be of a broken or "sketchy" character.

The haptic type artist will produce according to the following:

1. Through his art he reveals a concern for projecting his inner world or identification.
2. He will be biased toward synthetic process.
3. His art will be participant-oriented in that he will place himself as identifying from the center of the drawing space.
4. His two-dimensional art will have a flat and decorative appearance.
5. He will produce from an emotional identification with his subject and exaggerate, omit, and distort form according to emotional significance.
6. He will use color in a subjective or symbolic sense.
7. He will express a sensitivity for tactual and kinesthetic involvement.
8. His linear means will be bold and continuous in character.

Lowenfeld noted that the younger child consistently expresses in a haptic manner but that with progressing age the majority of individuals reveal a tendency for visual aptitude.

Witkin (1954) found two perceptual types which he called *field-dependent* and *field-independent*. Recent study indicates that there is a relationship between Lowenfeld's visual type and Witkin's field-dependent type—both are extroverted or dependent visually toward their environment and lack a sensitivity or respect for bodily cues in space. Witkin found that the parent who dominates the child produces a dependency by "constricting" the child's growth. In similar manner a relationship exists between Lowenfeld's haptic type and Witkin's field-independent type. Both are sensitive to bodily positioning and weight and esteem the body generally more than their countertypes. The "growth-fostering" parent was primarily responsible for this identification according to Witkin.

Piaget (1950) has been very influential in clarifying the development of the child by a discussion of three general stages:

1. Sensorimotor Period (to 2 years).
2. Concrete Operations (2 to 11 years).
 Pre-Operational Substage (2 to 4 years).
 Intuitive Thought Substage (4 to 7 years).
 Concrete Operations Substage (7 to 11 years).
3. Formal Operations Period (11 to 15 years).

His stages deal primarily with the perception of space, though the factor of time is also strongly considered. Like the gestaltist, he sees visualized forms as arriving through early motor play. His Pre-Operational Substage is very similar to Lowenfeld's "naming" period in scribbling, and they cover the same period of development. At that time the child is labeling the object, but there is little connection which would allow identification in the context of form or space. The Intuitive Thought Substage is similar to Lowenfeld's Pre-Schematic Stage in which the child is attempting to develop a schema and organize space. The Concrete Operations Substage is similar to Lowenfeld's Schematic Stage, but Piaget places emphasis upon the conceptualization of spatial perceptions and time sequences which indicate that the child feels a real part of his environment.

Tarmo Pasto (1965), another recent writer, deals very extensively with the physical and emotional identification of the child in his environment in the early years. Pasto

traces the emotional-motor experience of the young child in clarifying his "Space-Frame" theory. In his discussion he deals with a Jungian reference of symbolism in form and wonderfully relates it, from a gestalt influence, to the motor development of the child. While he does not actually label stages, they are described and are approximately as follows:

1. Swing Scribble (12 to 18 mo.)—"The joy of sound and the feel of muscle"—sensorimotor experiencing.
2. The Circle (2 to 3 years)—"The creative, the mother image, the feminine self"—suggests the child bound up emotionally in the mother but is seeking to be a physical entity as well.
3. The Cross (3to 4 years)—"Oppositional, the problem of the masculine and the feminine"—the paradox of a sexual role clarified.
4. The Rectangle (4 years)—Indicating closure of the ego—the inner resolving of identity in the environment.
5. The Homunculus (5 years)—The inner reality faces the outer reality.
6. Reality (6 to 10 years)—The exterior concept formed and the child moves into the perceptual-motor space-frame.
7. Deterioration (11 years on)—Tendency to visual appearance and loss of motor identity in reality.

The symbolic aspects of form in Pasto's theory are extremely important for our later consideration of the child and psychopathology.

Indebtedness is recognized for all of the mentioned basic theoretical constructs, as well as to many writers who have aided in their promulgation. With this body of reference in mind, it is now intended that we should turn our attention to the typical development of the child to note basic factors of significance for our discussion of the exceptional child.

Significance of Drawing Forms in Early Childhood

If a child is given a crayon before he is eighteen months of age, he will probably put it in his mouth and suck on it. After a while he may manipulate it by waving his arm, and he may even randomly hit at a paper. In such a case we would obtain what Lowenfeld called a disordered scribble (fig. 2).

Figure 2. Disordered Scribble by Debbie, 16 months.

Figure 3. Swing Scribble by Debbie, 18 months.

Such a drawing would indicate a lack of visual-motor control and would hold little significance beyond that fact. By eighteen months to two years the child gains control of the visual-motor factor and begins drawing a longitudinal or swinging-arc scribble. In figure 3 we can almost see spilled milk in the tray of the high chair being slopped by a small arm which moves back and forth. At this age the child is into everything— tearing paper, tipping things over, opening drawers and strewing the contents on the floor, pulling off buttons, and, in short, getting a sensory joy out of anything and every- thing. In this sensorimotor period he is testing reality and learning about form through manipulative and visual activity. It is one of the most creative periods in life, and we must not hamper his investigation. It will be well if we prepare the scene by providing an area with numerous and acceptable objects and materials. Plastic pans, string, balls, blocks of wood, and cardboard boxes are only a few of the many wonderful things from which the child may experience. Perhaps the most significant object to experience through at this age is a tetherball which may be hung from the ceiling by clothesline about eighteen inches from the floor. The child will hit the ball and immediately begin to "space" and "time" the motion of the object visually and bodily. He will watch it swing as a pendulum or even lay under it to watch it move in a circle. The parent can share with the child in the fun—which will continue for the ball will stay close and not roll away in a manner typical of most balls.

Auditory rhythms and tactual factors may be added by the parent to sensitize the child and increase the enjoyment of investigation. Try tying a bell on the tetherball! Then sound off with the progressive bumps of a bouncing super ball. That may be followed by spinning a heavy (unbreakable) plate on a table where the progressively increasing tempo will not be ignored! Most adults are too oriented to the utilitarian factor to *really* enjoy the child's level—but when the newspaper is "finished" do sit down with the child and shred it together into a pile. Then putting all of the scraps in the wastebasket can be a final sharing which the child will enjoy.

At about two years of age his scribbling begins to move in a circular motion (fig. 4), and if he has been rolling out coils with clay, he will now begin to roll balls from the same material. The circular form is the earliest form and holds great significance. The circle is the simplest gestalt form. The edges are composed of points equally dis- tant from the center, and thus our attention is usually drawn to the centrality of the circle. Symbolically the "centeredness" implies self as well as dependency. Certainly

Figure 4. Circular Scribble by Debbie, 2 years.

the child of two begins to stress himself as a self-entity. It seems that all we must do is say "yes" and he will say "no!" We call him and he runs the other way. He spins in circles, falls down, ands lays there to watch the whole world whirl around himself. But the child, while seeking to be a physical entity, is very much bound up emotionally with the mother. The circle is a primary feminine form.

What we have just stated has set the stage for what we all know to be true—two-year-olds are impossible people! We even speak of the "terrible twos." The child is in a tremendous paradox. He wants to be physically independent but remains emotionally dependent. Just watch him get frustrated at trying to button his shirt and then try to help him! That will almost always boil him over. But a few minutes later he may cling to mother when something has frightened him. We must encourage him to be physically independent and at the same time provide the reassurance of emotional security.

By two and a half the child may burst out of his tight circle and recognize other self-entities. In figure 6, we may observe such an expression in what Pasto calls a "burst into life." It is important that the child feels the love of the parent at two years. Unless the child is accepted and fulfilled by the parent, he will continue to seek that basis of identity. It is also important to emphasize that the parent must encourage the child to do as much as he can by himself and be independent. One of the greatest problems of our day is parents who absorb the personality of their children and thus fulfill their own need for affection in the child rather than in each other.

We begin to note a dramatic departure from the circular form when the child is around three years of age. He discovers the vertical line. At first he will repeat it over and over as if it were a new toy. Often, as in figure 7, it will appear in conjunction with the circle. The vertical line is rather obviously the first symbol for a human figure (figs. 8 and 9). One of the most interesting records of a child that a parent may collect is that child's figure concept from the first vertical line to the full, detailed figure (figs. 10–13).

The strong paradoxical dilemma of the child who is three and a half is revealed by the vertical-horizontal line drawings of the child. Symbolically the vertical is masculine, and the horizontal now represents the feminine principle. The child between three and fours years is attempting to work out a sex-role identification. His models are the parents, and it is important that they play their roles well.

Figure 21. ''Humpty-Dumpty. He Is Crying'' by Debbie, 5 years. (Notice the mandala-like quality.)

subject as the child moves into a search for representational symbols which will suffice to express his concepts. The child is now in Lowenfeld's pre-schematic stage.

If we consider the total development of the child up to four and a half to five years, we realize the tremendous tasks which he has encountered and has attempted to surmount. He has sought to see himself as an entity apart from his mother, he has attempted to resolve a self-sex role, and he has begun to form ego-closure by identifying with self in respect to a large and often confusing real environment. If he has been to some degree successful in these tasks, we may expect him to express drawings which indicate such a "wholeness" or "unification." A mandala-like figure or form is often just such a form, and it may be drawn as a total abstraction, or it may be linked to a subject concept. At this point we may truly say that the child has entered the "golden age" of his art expression.

Aesthetic Quality and Spatial Organization

Between five and six years of age, a wonderful gestalt organization of space accounts for high aesthetic quality in the child's art expression. As the child begins to richly describe experiences through his continuously developing form concepts, he also moves ahead in recognizing his position in respect to the world about himself. In figures 22 and 23 we note the emotional relationship of the self to another object or person. We

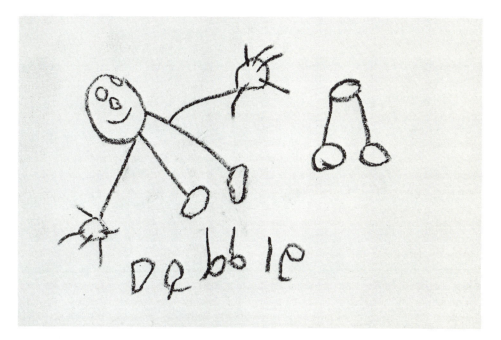

Figure 22. "Debbie Running After Sara to Hurt Her" by Debbie, 5 years 2 months. (Note: Debbie's self-image has large hands—they are significant to inflict harm. Sara's body is composed of just a "body" with legs—they are necessary for running.)

Figure 23. "I Am Playing with My Blocks" by child 5 years.

must note here that the earliest spatial relationships are therefore physically and emotionally significant. The child expresses in regard to what is his own or what he may want and will then organize the space around the immediate self-image upon that basis.

In figures 24 and 25 we note the great development in spatial organization which occurs between five years of age and seven years of age. Both children drew in response

Figure 24. In the hospital to have my tonsils out, 5 years.

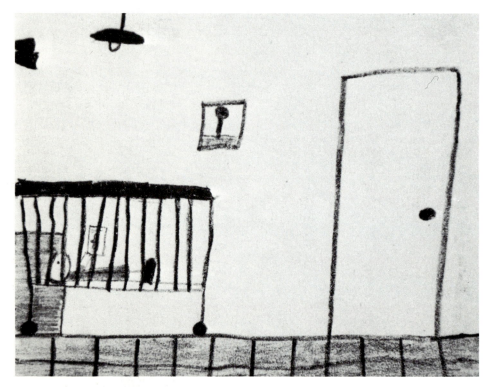

Figure 25. In the hospital to have my tonsils out, 7 years.

to "Being in the Hospital Overnight to Have My Tonsils Out." The five year old experiences her body in the immediate proximity of the bed alone, the "bars" being particularly significant. The seven year old has developed an identity in the total space of the reality about herself.

As the child's world opens to new possibilities of meaningful relationships, he begins to structure and organize more fully. His games may be excellent examples of this desire because they are of a spontaneous and natural character (fig. 26).

Figure 26. A driveway chalk game, 5 years.

Figure 27. "Boxes." Tempera painting by child 5 years.

Figure 28. "My Brother Is in the Crib" by child 5 years. (He has been organized—put in his box or place—where he belongs.)

While the child at four was seeking to be told "how things are," he now may become indignant at times and attempt to force his own will upon others. He will be preoccupied with the rectangle as an expression of putting everything, including people, in place. The parent may experience the child's sassing him and calling him names. Such behavior should meet with firm resistance in order to provide the child with the security of reinforced relationship which he is ultimately seeking. Such a "game" may prove puzzling and disturbing to the naïve parent. The parent who "plays the game" well will learn to accept the child's behavior in terms regarding the underlying need and not be unduly ruffled by the outer show of insolence. It is natural that such outbursts and difficulty will appear in greatest strength when traveling, entertaining, or otherwise out of the normal routine.

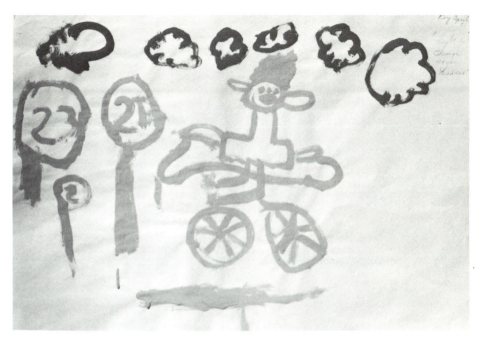

Figure 29. "I Am Riding My Bike" by boy 5 years.

Figure 30. A 5-year-old's painting depicting a schematic space. (Note the umbilical tie to the house, which symbolizes the mother.)

By five and a half to six years the child will begin to "fit in" and become a cooperating member of society. He will, in short, learn to "give" as well as "take." This will be expressed in his art by a baseline upon which objects finally settle. In every respect it relates to the child's taking an active social part in the space-time (motion) world.

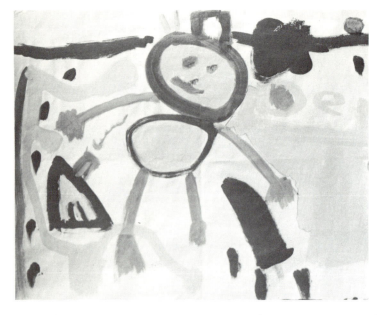

Figure 31. Tempera painting by child 5 years. (High aesthetic quality.)

Figure 32. ''Myself'' by Sara, 5 years.

Through this "golden age" it is very evident that the total organization of the child to his environment is reflected in his harmonious distribution and handling of line, form, and color on the surface of his drawing or painting. He is a naïve and natural

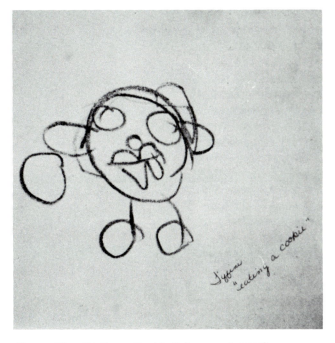

Figure 33. "Eating a Cookie," 4 years, 1 month. **Figure 34.** "Myself With Measles," 4 years, 10 months.

artist, for it is from such a source that true art is expressed. Very often the older exceptional person who continues to grapple with these same early needs will express in the same wonderful manner.

Sensitizing Development of the Body Schema

During this period of development in which the child is searching for representational forms to express his concepts it is important to sensitize him by strong physical-emotional stimulation. Enrichment of the child's non-verbal language in its formation will lead to a stronger reference for expression when such development of schematic form has been fully attained.

As we have seen in earlier discussion, the physical body is the channel for touching the emotions, and, it is through emotional sensitivity that we best enrich the developing conceptual content of the young child's mind. Painful experiences may be reactivated by strong verbal means, as we see in the following cases. Here a four year old girl was strongly motivated during a nine month period beginning with "Eating a Cookie" (fig. 33). In figure 34 we note the same child's response to measles at the end of the nine month period. The human figure schema has been greatly enriched by continuous sen-

Figure 35. "A Mexican Red-Riding Hood Spilling Chili Beans on the Way to Grandmother's House" by boy 8 years.

sitizing to body parts—pinching fingers, running nose problems, buying new shoes, combing the hair, etc. From behavioral terminology it may be stated that both positive and negative reinforcers have been richly activated to enrich the child's body schema.

Schematic Storytelling

By seven years the physical-emotional motor-space experience, which was responsible for high aesthetic products, is now subjugated to rational and social forces in the development of the child. Verworn stressed the rational factor in his term *ideoplastic,* and Piaget regards the same force through his term *concrete-operations.* The child has now arrived at a full nonverbal concept language, or *schema,* which encompasses form and space. The *idea* of things becomes predominant, and while he has not by any means lost his motor-space feeling, his principal efforts are directed at storytelling. His art, as observed by Burt, is essentially *descriptive symbolism.*

The story may be called linear at first as the child treats space-time by moving from left to right along a baseline. Such a linear storytelling ability is one of the best tests of reading readiness, for he is indicating now a capacity for identifying symbols moving on a common line from left to right. It is interesting to note that Lowenfeld finds the origin of the baseline to be kinesthetic. How important the physiological-emotional identification is in providing a foundation for rational development and expression!

right: **Figure 36.** "Eating Lunch" by boy 7 years.

below: **Figure 37.** "Fold-over" view, girl, 7 years.

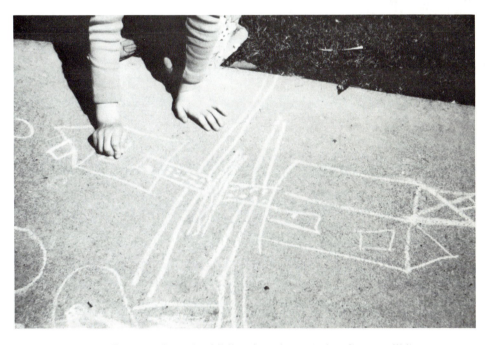

Most appropriate literature in early childhood, such as Mother Goose, will have a strong rhythmical, and thus physical, basis.

The linear storytelling may be puzzling at times because of its basic conceptual characters. In figure 36 we note two people eating lunch together at a round table. The table itself serves as the baseline. To understand the drawing as the child conceived of it, we must consider the figures and table cut from the paper and the figures folded down at the point where their wrists touch the table. Then the figures will "sit up" to the table. Lowenfeld calls this a "fold-over" view and considers it a deviation from the child's normal schematic space. In figure 37 a child is drawing a fold-over view involving both sides of a river. By positioning one's self in the river and looking both ways with the houses "folded up" from the baselines the drawing becomes conceptually logical.

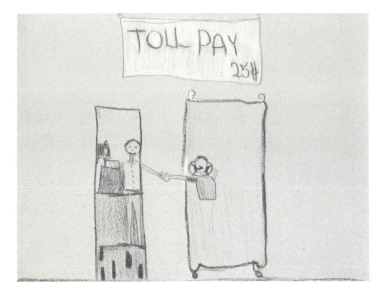

Figure 38. "At the Toll Station" by boy 8 years.

Figure 39. "Jonah in the Ship."

In figure 38 we note a similar fold-over view as a man drives his car to the toll station and pays his fee. The car itself, in this case, is folded up on end. The inside of the toll booth was extremely significant to the child so he left the exterior wall off. Lowenfeld calls this type of space deviation an "x-ray" view.

Through the schematic period we often notice how successful the child is in essentially and vividly telling a story. In figures 39–42 we find various children responding to the familiar episode of Jonah. Each child seemed to find a different portion of the experience especially important as he identified with Jonah. An interesting x-ray view was drawn of Jonah asleep in the hold of the ship. In another child's drawing, Jonah is thrown overboard during the storm into the mouth of the waiting whale. A third child drew an x-ray view of Jonah all tangled up in seaweed inside the whale. The whale finally spits him out on dry land after he decides to obey God and go preach at Ninevah.

As a rule the child may be sensitized best, at this age, by story motivation that tends to recall vivid imagery. Such stimulation may be attributed to the initial efforts of Cizek. Many children do, of course, have powerful experiences which highly motivate

Figure 40. "Jonah Thrown to the Whale"

Figure 41. "Jonah in the Whale"

Figure 42. "Jonah Spit Out"

Figure 43. "Teacher Got Mad" by girl 8 years.

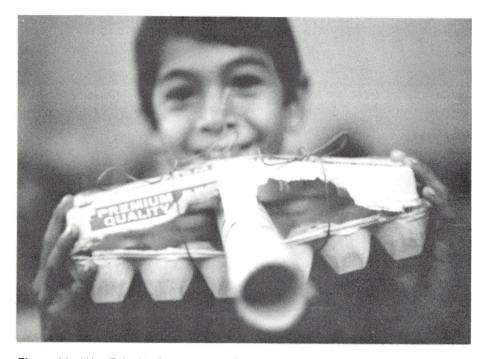

Figure 44. "You Take My Picture and I'll Take Yours." Construction by boy 8 years.

them for drawing in a "spontaneous" manner. In figure 43 we find a good example of such a circumstance. The girl came home from school and mother simply asked her how things were at school. She said the teacher got mad and yelled at the kids and stamped her feet. After gesturing a few minutes, she got her crayons out and drew the picture of her teacher. This drawing reveals the impact we may have on a child who identifies emotionally with us—perhaps when we are the least aware of our influence. This same teacher, who motivated art without knowing it, may be a poor stimulator

Figure 45. Drawing by girl 9 years.

of art when she consciously directs her efforts to that end. This should emphasize to us that children need teachers who are themselves flexible and who can act out emotionally. This teacher, of course, was *not* acting.

Because the child begins to become set in his ideological processes, he must be provided with material experiences which will reactivate and encourage flexible exploration and inventiveness. In figure 44 we see just one result from a group experience with scrap materials. The class was simply given towel tubes, egg cartons, boxes, string, and tape, and the children were encouraged to "make something" after they had been sensitized to the characteristics of the materials.

Social Self-Concept of the Older Child

An increased awareness of self in the social environment becomes very evident with many children by nine years of age. This will be especially true for the extroverted child whom Lowenfeld calls *visually oriented* and Witkin labels *field-dependent*. The spatial depth factor will be evidence of such a perceptual tendency, and a type of realism will begin to appear in the art product. A use of "meaningful surface" between baselines and a relative positioning used in conjunction with it will often be the early suggestions of this visual-social dependency (fig. 45). In a short time some individuals will draw with a strong illusion of spatial depth through the surface plane, relative positioning, relative size, overlapping, and atmospheric effects (fig. 46).

The introverted child, whom Lowenfeld calls *haptic,* will retain a flat, decorative quality in the drawing product, and there will be a very apparent lack of motion (fig. 47). Such a child would be labeled "field-independent" by Witkin.

Along with the spatial factors which reveal social-perceptual orientation, we now note a growing stress on sexual identification in the human figure drawings. The gang development of this age is based upon such an identity. In figure 48 we see a typical

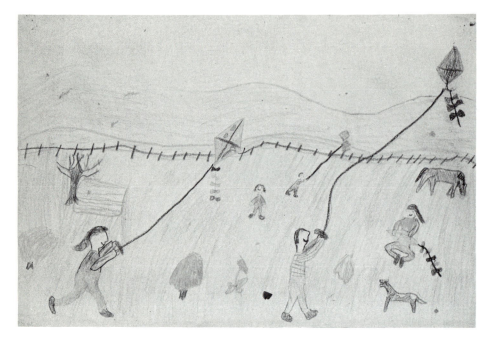

Figure 46. "Kite Flying" by girl 10 years.

Figure 47. "Kite Flying" by girl 10 years.

stress on the hair as a virility symbol, and this emphasis will be noticed among both sexes. Details, in short, are added as social-emotional factors of sexual identification at this age. The human figure, from a stress upon such identity, can be expected to be highly distorted and even bizarre among the boys (fig. 49) or highly idealized and glamorous among the girls (fig. 50).

right: **Figure 48.** ''Playing Ball'' by boy 11 years. (Notice the visual factor of motion in crease behind knees.)

below left: **Figure 49.** Self-image of boy 12 years.

below right: **Figure 50.** Self-image of girl 11 years.

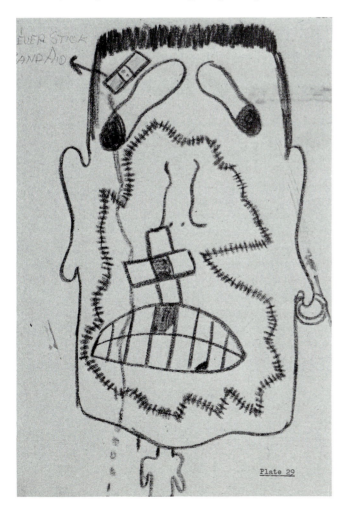

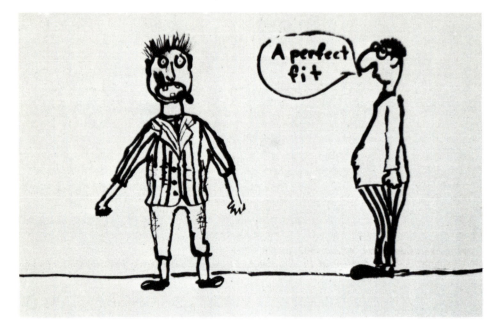

Figure 51. "A Perfect Fit" (buying a new suit), male, 13 years.

It is important to encourage the drawing of the human figure as the individual moves in and through adolescence, for it will offer the opportunity for the resolving of discrepancy between the sexual-ideal and the acceptance of the sexual self. Physical growth and development in adolescence literally force a new body-image and destroy that which we have known to be a child. The psychical pain produced by dramatic changes in the body may become highly threatening to the ego. Humor may appear as the individual copes (fig. 51) with the "storm and stress" of adolescent development. This is especially true for the male for in our culture "strong men do not cry." Freud termed humor a "last ditch defense of the ego" because of its essential masochistic roots.

Summary

From infancy to adolescence the child passes through numerous phases of development which are reflected in art expression. Earliest experiencing is of a sensori-motor character. Much can be done by the adult at this time to encourage the child to explore and thereby develop his visual-motor skills.

The early forms produced by the child not only represent developing visual-motor skills but they relate symbolically to very basic life tasks, as well, which are imperative to resolve for a healthy adjusted personality. The circle indicates that the child is identifying as a physical entity apart from the mother while remaining bound to her in emotional dependency. The cross form indicates the dilemma and resolving of a sex-role identity from parental models. The rectangle reveals the ego-closure task of the child as he attempts to clarify his individuality in the context of his environment.

By six years of age the child begins to settle into the real world and become a social part of its interrelationships. He previously has accumulated details in his drawing as he grew, and they reflect his intellectual growth, but now he arrives at a full rational reference of schematic form and space by seven years of age. The rich aesthetic quality of his physical-emotional reference in the early years is now subordinated to ideological storytelling. Perceptual types become evident in the art of the nine-year-old child as he matures socially.

The child will be a social-perceptual extrovert and thus visual and field-dependent in his art, or he will be a social-perceptual introvert and be haptic and field-independent in his art. He will in either case, and to some degree, be gang-oriented from a need to identify more deeply with a self-sexual role. Such identification will lead the boy to exaggerate in bizarre images of self-protection, while the girl will tend to idealize herself in the image of a glamorous, mature female.

References

Arnheim, R. *Art and Visual Perception.* Berkeley, CA: University of California Press, 1954.

Baldwin, J. *Die Entwicklung des Geistes Beim Kinde und bei der rasse.* Berlin, 1898.

Barnes, E. "A Study of Children's Drawings." *Pedagogical Sem.,* Vol. 2, 1902, pp. 283–294.

Bender, L. *Child Psychiatric Techniques.* Springfield, IL: Charles C. Thomas, 1952.

Britsch, G. *Theorie der Bildenden Kunst.* Munich: F. Bruckmann, 1926.

Burt, C. *Mental and Scholastic Tests.* London: P. S. King and Son, 1921.

Clark, A. "The Children's Attitudes Toward Perspective Problems." *University of California Studies in Education,* Vol. 1, 1902, pp. 283–294.

Goodenough, F. *Measurement of Intelligence by Drawings.* New York: Harcourt, Brace and World, 1963.

Hartlaun, G. F. *Das Genius im Kinde.* Breslau, 1922.

Jaensch, E. R. *Uber den Aufbau der Wahrnehmungswelt und Ihre Struktur im Jugendalter.* Leipzig, 1923.

Kellogg, R. *What Children Scribble and Why.* San Francisco: Golden Gate Nursery School, 1955.

Levenstein, S. "Kinderzeichnungen biz Zum 14ten." *Lebensjahr.* Leipzig, 1904.

Lichtwark, A. *Die Kunst in der Schule,* 1887.

Lowenfeld, V. *The Nature of Creative Activity.* London: Routledge and Kegan Paul, Ltd., 1939.
————. *Creative and Mental Growth.* New York: The Macmillan Co., 1947.

Lukens, H. "A Study of Children's Drawings in the Early Years." *Pedagogical Sem.,* Vol. 4, 1894, pp. 79–110.

McCarty, S. *Children's Drawings.* Baltimore: Williams and Wilkins, 1924.

Mira, E. "Myokinetic Psychodiagnosis: A New Technique for Exploring the Connotative Trends of Personality." *Proceedings of the Royal Society of Medicine,* Vol. 33, 1940, pp. 173–194.

Pasto, T. *The Space-Frame Experience in Art.* New York: A. S. Barnes and Co., Inc., 1965.

Piaget, J. *The Psychology of Intelligence.* London: Routledge and Kegan Paul, Ltd., 1950.

Read, H. *Education through Art.* New York: Pantheon Books, 1958.

Ricci, C. "L'art de Bambini. Bologna, 1887, Leipzig, 1906." *Pedagogical Sem.,* Vol. 3, 1894, pp. 302–307.

Schaeffer-Simmern. *The Unfolding of Artistic Activity.* Berkeley, CA: University of California Press, 1948.

Seeman, E. "Development of the Pictoral Aptitude in Children." *Character and Personality,* Vol. 2, 1934, pp. 209–221.

Stern, W. "Spezielle Beschreibung der Ausstellung Freier Kinderzeichnunger aus Breslau." *Bericht uber den Kongress fur Kinderforschung.* Berlin, 1908.

Sully, J. *Studies of Childhood.* New York: D. Appleton and Co., 1895.

Verworn, M. "Kinderkunst und Urgeschichte." *Korrespondenz der Deutscher Anthropologische Gesselschaft,* Vol. 27, 1907, pp. 42–46.

Viola, W. *Child Art.* Peoria, IL: Charles Bennett Co., 1944.

Witkin, H.; Lewis, H. B.; Hertzman, M.; Machover, L.; Meissner, P. B.; and Wapner, S. *Personality Through Perception: An Experimental and Clinical Study.* New York: Harper and Brothers, 1954.

PART TWO

**Art for the
Exceptional Child**

The Mentally Retarded Child and Art

2

In this chapter we will discuss retardation for three groups of children: the mildly retarded, the moderately retarded, and the severely retarded. These three groups will be considered separately in respect to: their characteristics and educational programming, strategies for art programming, and suggested art media, materials, and activities. Drawings of mentally retarded children will be discussed based on the developmental structure of artistic development presented in Chapter One: Development of the Normal Child in Art.

Definition and Classification

In the past, the most generally accepted approach to classification by educators was to use a system that divided the mentally retarded according to their educational needs: Educable (IQ of about 50–75) and Trainable (IQ range of about 25–50). This classification system has been criticized because the cutoff level is high and because the lines separating one group from another is so rigid that they deny borderline individuals the opportunity to learn skills within their intellectual grasp.

The American Association on Mental Deficiency (AAMD) the major organization for professionals in the field has recommended a classification that uses the terms Mild, Moderate, Severe and Profound. These terms avoid negative stereotyping. There is also a lower cutoff IQ (69 or 68) depending on the tests that are used for classification. Based on surveys it is determined that about 3 percent of the population can be considered to have an IQ that falls within the range of mental retardation.

The IQ range for each group based on the AAMD classification is the following: Mildly Retarded (IQ range 50–70); Moderately Retarded (IQ range 35–49); Severely Retarded (IQ range 20–34).

These criteria are defined in terms of IQ levels and general levels of adaptive behavior. They have to be viewed with critical judgment. For example, a child's IQ could place him above a classification category, but because of his poor adaptive behavior the child is placed in the category. The terms provided by the AAMD attempt to describe the functioning ability of the child. Not only is there an overlap among IQ categories, but different sources may use different terminology or a different range of IQ quotients for each classification group.

In the early years before adequate assessment may be made through IQ tests and other forms of testing, information was gained about a questionable child by asking the following:

1. Did the child develop an awareness of the mother's face by four to six weeks?
2. At six weeks was the child able to hold his head up for a few seconds when held horizontally on his stomach?
3. Was he attentive to objects and sounds at three months?
4. Had he stopped drooling at one year?
5. How old was he when he first rolled over? Sat up? Stood?
6. Was he able to walk at two years old?
7. Did he speak in short sentences at three years?

The definition currently accepted by most authorities in the field of retardation is the one used by the AAMD. It was first presented by Heber in 1961 and then revised by Grossman in 1973:

> Mental retardation refers to significantly subaverage general intellectual functioning existing concurrently with deficits in adaptive behavior and manifested during the developmental period" (cited in Hallahan & Kauffman, 1982, p. 40).

To be classified as mentally retarded, an individual must be well below average in both measured intelligence and adaptive behavior. A person must meet three criteria in order to be considered retarded:

1. SUBAVERAGE INTELLECTUAL FUNCTIONING, generally determined by individual test performance of at least one standard deviation below the mean.
2. ONSET DURING THE DEVELOPMENTAL PERIOD, refers to anytime before the seventeenth year which is regarded as the period during which intellectual potential is determined.
3. IMPAIRMENT IN ADAPTIVE BEHAVIOR, refers mainly to the rate of the sensory motor development (sitting up, walking, talking) during pre-school years. It refers basically to academic achievement during the school years and to social and economic adjustment at the adult level. All three factors—MATURATION, LEARNING, SOCIAL BEHAVIOR—are considered important as indicators of ADAPTIVE BEHAVIOR at every age. (Hewett, 1974, p. 76)

Note that the AAMD does not mention that mental retardation is incurable or a condition that an individual is stuck with for life, or is it viewed as a disease. Instead, according to current understanding "a person may be retarded at one time in his life, but not another." (Hallahan & Kauffman, 1982, p. 40)

Hallahan & Kauffman (1982, p. 39) provide some facts about mental retardation that can clarify our notions about this condition:

1. The level of mental retardation does not have to remain stable, particularly for those individuals classified as mildly retarded.
2. An individual can have a measured subnormal IQ and still have adequate adaptive skills. This depends upon the particular person, training, motivation, experiences, the social environment, the support systems, etc.
3. Many studies demonstrate that the learning characteristics of the retarded, particularly the mildly retarded do not differ from the normal population. Retarded children go through the same developmental stages but at a slower pace.
4. The diagnosis of mental retardation due to brain injury may be of importance to the medical profession, but it holds little value for the educator. A diagnosis of brain injury does not lead automatically to development of special education strategies.
5. Since the vast majority of retarded children are mildly retarded and because infant IQ tests are not as valid or reliable as those used in later childhood, and intellectual demands on the child are not made until the child goes to school, many retarded children are not identified until this time.
6. As a result of some of the changes in attitude about retarded children (i.e., the terminology in reference to this population is less stigmatizing—terms like *feeble minded* are no longer used), the delivery of services has been affected. The concept of mainstreaming children into regular classes had its origin in the area of mental retardation.

General Developmental Strategies for the Young Retarded Child

Large motor games should be stressed for all mentally retarded children, but especially in the early years. Lateness of motor development is one of the first indicators of mental deficiency and motor experimentation is crucial to discovering form and space.

The child actually learns to time objects and experience form in space by moving his own body through space by moving his own body through space. Experiencing his own body in space is also imperative to the child's most rudimentary self-identification, for the idea of self is only gained by interaction with other things and people in the environment. Because the mentally retarded child may lack an energy level necessary for this exploratory experiencing, we must urge it upon him in such a way that he must or will react.

The small infant may be rocked and thus experience passively a kinesthetic activity. Later we may swing him or roll with him in playing on the floor. He will have to be encouraged to shred paper, pull things out of boxes, and do many other things that normal children do without encouragement. (In fact, normal children are usually disciplined for such great things!) Care must be exercised in our efforts with the mentally deficient child, however, *that things move at a rate which allows him to follow or take part.* The more we can entice him to initiate in the activity, the greater its value will be to him.

Manipulative games which involve the visual senses are the best early games, for as we have seen, visual perception develops from motor activity. Holding a rubber ball in one's hand and then rolling it back and forth on the floor is a very meaningful experience. Eventually, watching it bounce will allow the child to "time and space" it with his own body.

Objects which are suspended from the ceiling will move and thus be watched, and it may be possible that the child could move or hit them himself.

Walking and running are normal rhythmic functions of the body, and games may be structured to encourage a more sensitive identification in such activities of bodily motion. Playground devices such as swings, seesaws, and climbing bars are excellent, but even walking on a stone wall or jumping across the cracks in the sidewalk may be a great game with mentally retarded children.

Playing the games will not only sensitize the child perceptually, but it will also begin to give him emotional confidence and build a healthy bridge between the child and the parent. Too many mentally deficient children cling to the parent physically and emotionally with no distance between for a bridge.

Along with the games, the child should be encouraged to scribble with a heavy black crayon on a typing-size paper. The drawing activity will provide one more kinesthetic reference and will also provide a very fine record of his progress.

The mentally retarded child may be expected to remain in the scribbling stage far beyond the norm for his chronological age. This should be looked upon as a greater opportunity to strengthen the physical confidence and the emotional security of the child.

The child also needs to own things and be responsible for them. Owning and taking care of a dog or cat is a wonderful experience for any child, but it is particularly significant for this type of child. He will tend to identify in and through the pet, and his experiences with a pet will often act as a strong emotional reference for the space outside his own body.

Characteristics and Educational Programming

Mentally handicapped children present a range of intellectual capabilities and adaptive skills from the highest functioning group: (Mildly Retarded) to the lower functioning (Moderately Retarded) to the very low (Severely Retarded). Not only is there a continuum of abilities and overlap from one category to another, but the children in each classification are as different from each other as normal children. To insure adequate and appropriate educational programming, it is necessary to individualize instruction to meet each child's strengths, weaknesses, best style of learning and interests. Key to teaching these children is realistic knowledge and acceptance of their present level of functioning (intellectual and adaptive behavior) and to build learning experiences from this point.

Characteristics

The following are the behavioral characteristics generally associated with the school-age mentally retarded child:

1. Learns at a slower rate than his normal peers.
2. There is little carry over from one learning situation to another. Concepts or skills must be taught anew in each task.
3. Has difficulties drawing generalizations from a series of specific and related learning experiences.
4. Learns better with concrete, rather than abstract materials.
5. Learns better when tasks are broken down into small increments that are presented systematically and sequentially and that progress from the simple to more complex.
6. Demonstrates an inflexibility and a resistance to change and new learning situations.
7. Needs reinforcement in learning through repetition with slight variation.
8. Has a short attention span and frustrates easily when tasks are too complex or instructions are not understood.
9. Needs success experiences for improvement of his self-image and a sense of control of the environment.
10. Is limited both in intellectual functioning and adaptive behavior.

Mildly Mentally Retarded

Mildly retarded children learn at a rate ½ to ¾ of that of normal children. Many of them begin school in a regular class, but low achievement and poor adaptive behavior makes it necessary to have them placed in special classes. At the elementary school level, there is a two- to three-year academic and a one- to two-year social gap between these children and their average peers. This increases to three to four years at the junior high level. For example, at ages 12 to 14, their mental age is that of 7- or 10-year-olds or on the third grade academically. This may increase to a five or six year difference at the high school level (Insights, 1981).

Higher functioning children are able to be mainstreamed (placed in regular classes) for part of a day or for an entire day if they receive supplementary instruction in a resource room (remedial reading and math). Special education classes for the mildly retarded at the level (ages 6–9) focus on oral language development, sensorimotor development, social adjustment, self-awareness, safety, self-care, work habits, gross and fine motor skills, and reading readiness. Academic tasks are not emphasized except for beginning to count and recognition of letters or words. By the elementary level (ages 9–13) reading, writing, spelling and math have been introduced. Units in basic social studies and practical science are integrated with basic skill subjects so that skills can be applied, reinforced, and practiced (Hewett, 1974).

The secondary school level emphasizes consolidation of the basic subjects learned earlier, but with increased stress on preparation for work and home-living. At the end of their school years, mildly retarded students may be in a work-study program, a vocational training program or have a trial job on a part-time basis. As adults most will be capable of working at unskilled or semi-skilled jobs, while those who function at a lower level will be in sheltered workshops and need assistance socially and economically (Hewett, 1974).

In summary, the educational goals for mildly retarded children are: 1) development of basic skills, 2) social competence, 3) personal adjustment, 4) occupational adequacy. (Important in the achievement of these objectives are opportunities for decision

making, problem solving, memory training, associative thinking. The visual arts which involves decision-making and problem solving can help fulfill these needs.)

Moderately Retarded

Unlike the mildly retarded, moderately retarded children's developmental problems are usually identified in infancy or pre-school years. Many of the children have physical or sensory impairments and look different in terms of facial features or physical characteristics. They suffer from delayed and poor motor development. Moderately retarded children have the learning potential of ¼ to ½ of that of normal children. They usually reach a mental age of six to eight years or a maximum mental age of eight to nine years in adulthood (Hewett, 1974).

Educational placement for moderately retarded children is in a special class within a public school or in a special private day school. The goal in the education of these children is to have them function more independently within the family and in the immediate neighborhood environment. Their education focuses on self-help skills (toileting, dressing, grooming, eating habits, personal hygiene) and socialization skills (getting along with others, engaging in recreational activities). School activities include practice in listening, following directions, communicating with others, language development, reading or recognizing familiar labels and signs, counting and telling time (Hewett, 1974). Older children are taught prevocational skills so that they can eventually work in sheltered workshops. As adults, the moderately retarded can be expected to live at home or in adult homes for special populations. Special education prepares them to work and function in these situations.

Severely Retarded

With the passage of Public Law (PL 94–142) The Education for All Handicapped Children Act of 1975, it is required that handicapped youngsters from infancy through age twenty-one receive a free appropriate education and an equal educational opportunity. Because of this law, classes have been set up in public schools for the severely mentally handicapped (ages 5–21). Some children attend these classes in the public schools, whereas others because of health, poor adaptive behavior, or other reasons may be in day treatment centers or institutions.

The severely retarded are a dependent group and not considered capable of achieving total self-care, socialization, or vocational skills. Compared to normal children their physical functioning is quite poor and underdeveloped. Many have no language or very rudimentary language skills. Some can say a few words and simple sentences—capabilities which develop late. The emphasis in the education and training of this group is on skills that will make them more independent and easier to care for in any environment in which they may be placed. School activities include practice in communication skills: attending to and understanding simple messages, and responding with messages about their needs through verbalization, gesturing or signing. Social behavior training focuses on having them react to other people and at more advanced levels having them interact to any degree with others. Many severely retarded children "tend to be apathetic or locked in their own worlds" (Blake, 1981, p. 366). Self-help skill training stresses teaching them to dress, wash, and feed themselves, independent toileting, hygiene and other self-care skills. Many of the children when they begin school have not acquired any of these skills or have achieved them to a minor degree. Adaptive physical education emphasizes using muscles in meaningful ways such as walking, climbing, running, jumping through their performance of simple physical activities. Children who develop better adaptive skills in this program may be transferred to a class for the moderately retarded.

Figure 52. "Person" by Charles, 9 years.

Figure 53. "House" by Charles, 9 years.

Figure 54. "Person" by Russell, 21 years.

Figure 55. "Bride" by Ann, 5 years.

Mental Retardation and Art Expression

The House-tree-person, (H-T-P) drawings of mentally retarded children generally reveal simple form concepts produced with good motor coordination. The specific intelligence of the child may readily be assessed, according to its function, by use of the Goodenough-Harris Scale. A general guess by an experienced observer, however, will often come close enough for general practical purposes. In figures 52 and 53 we see the person and house drawings of Charles. He included a "lollypop" tree and flowers with his house. Charles is nine years old and has excellent motor coordination. His speech is good, but he is not very flexible or inventive. To the contrary, he is typically slow, fixed in his ideas, and highly dependent. Notice his emphasis upon the mouth (possibly oral dependency) and the umbilical dot on the house. The house, which may be a mother symbol, fills his world, and he strongly stays by her side whenever possible. The figure concept is typical for a child of three and a half to four and a half years of age, and therefore his IQ would be in the 40–50 range at best. He is severely retarded in development. The triangular form of the roof top however, involving oblique angularity more typical of six years, does leave the door open for a higher assessment.

In figure 54, a drawing typical of Russell, an institutionalized twenty-one-year-old male, is shown. His person drawing is at best that of a typical five-year-old. Note the extreme contrast between his figure and the "Bride" drawn by Ann who was five years at the time and had an IQ in the 130–140 range. Russell was not institutionalized until just before his legal birthday. In his home neighborhood he had made many friends and usually spent his days riding his bicycle about the streets or working part time in a sheltered workshop. He is a well-mannered person and reflects a fine home where the family members were aware of his needs and responded in a positive way to meet those needs. He may be expected to act in a responsible manner in any stable environment where some guidance is available.

The general maturation of the mentally retarded child is often clearly evidenced through the form development which we have found typical for normal children. Mentally deficient children progress through the same developmental pattern as young normal children, they progress, however, at a much slower rate and very rarely move beyond the schematic stage of seven to nine years. Figures 56 and 57 are drawings by John, a ten-year-old boy with Down's syndrome. It is evident that he has moved from the circular form into the vertical and horizontal character of the cross form. From his form in art we may suggest that he is resolving tasks and identifying generally with a normal development at three to four years of age.

Gaitskell (1953) noted in a survey of the drawing characteristics of mentally retarded children, who were all over six years of age, that the most severely retarded (IQ to 22) were generally completely passive when given crayons. A couple of these children scribbled after some encouragement, and a few others tried to eat the crayons. Those with higher intelligence (IQ 28–43) tended to draw with better control, and a noticeable development from disordered to circular scribbling appeared in their activity. He concluded from his study that only those with an IQ over 40 would really benefit from art activity. Perhaps many teachers and therapists would be in disagreement with his view, as there are evident values in both the swinging arc scribble and the circular scribble.

A general lack of self-identification is typical in the simple figure concept of the mentally retarded child. A poor social adaptation will follow as it is expressed first in a poor gestalt organization of the drawing surface, and then poor or late arrival, at best, of a schematic space. Figure 58 is a "family" drawn by Carol, a severely retarded child of nine years. Her figures tend to spatially "float" in a manner typical for a normal child of five to six years of age. It indicates that at nine years she has not as yet fully resolved the task of ego-closure and of becoming a social participant in her environment. It also indicates that she is not ready to read even though great stress is placed upon that task in her classroom.

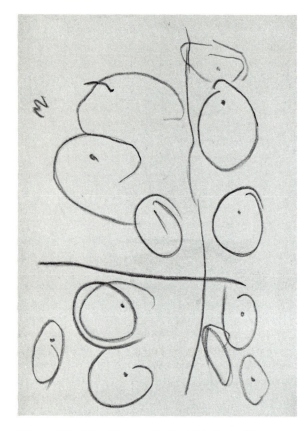

Figure 56. "Our House with Daddy's Room" by John, 10 years.

Figure 57. "Man" by John, 10 years.

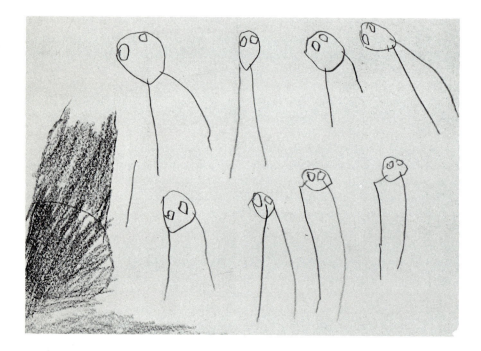

Figure 58. "Family" by Carol, 9 years.

Figure 59. "My Family" by Carl, 12 years.

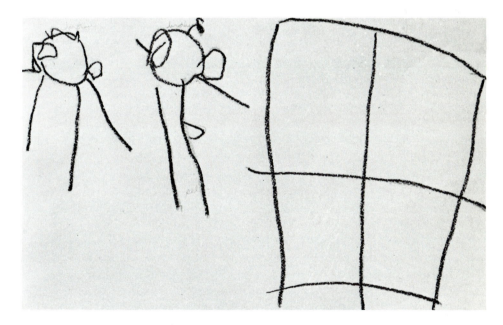

Figure 60. "Me and My Brother" by Carl, 12 years.

In figures 59 and 60 we see the "family" drawn by Carl, a twelve year old mentally retarded boy whose brother is also retarded. On one side of the paper he drew, from the left, father, grandfather, mother, and sister. His grandfather obviously is more important due to the larger size and general emphasis. On the other side of the paper he drew himself and his brother. They feel somewhat "left out" from the rest of the family and the rectangular "grid" to the right indicates a desire to become organized in identity with the rest of the family. We see here how profoundly the exceptional child experiences his role within the family structure.

Dorothy, a moderately retarded child of ten years, drew the landscape in figure 61. Her art behavior is characterized by strong repetition of subjects with only slight variation. The space of her picture indicates a schematic development, and she will be

Figure 61. Landscape by Dorothy, 10 years.

capable of "educable" tasks in the classroom. She will probably remain in a strong schematic character all of her life, and her art will continue to be typically haptic. At best it will become more decorative and rhythmical with proper motivation. It is seldom found that any mentally deficient individual will develop a capacity for expressing spatial depth or motion. Relative positioning or overlapping may be found with a few, but even they will never discover relative size and linear perspective. Our basic approach to encouraging these children in art must be through their haptic perceptual means and through the physical and emotional methods typically employed in work with younger children.

Recognizing the characteristics of mental deficiency in art behavior presents little difficulty. The child may express much of the following to a greater or lesser degree:

1. A retarded rate of growth but a normal pattern of growth.
2. Simple or primitive form but good motor coordination.
3. Primitive and mature features may coexist in drawings of the human figure (e.g., single lines for limbs, detailed treatment of eyes).
4. Lack of cohesion among the elements of a picture (e.g., trees, houses, figures located on different levels of a drawing).
5. Lack of relationship between body parts in drawings of the human figure.
6. Representation of forms may be more stereotyped than those of normal children (note the stereotyped treatment of trees, house, birds in figure 61).
7. Lack of experimentation expressed in perseveration of form and subject.
8. Poor spatial gestalt characteristics indicating a lack of energy expended for association in the perceptual task.
9. Haptic-type experiencing as expressed in:
 a. A body-self centering of viewpoint regarding the space of the drawing or painting.
 b. Piece-method approach to modeling.
 c. Lack of spatial depth in drawing or painting.
 d. Bold, continuous-line character in drawing.
 e. Emotional exaggeration, omission, or distortion of form when motivated with a particular experience.
 f. Emotional use of color.
 g. Expression of tactile and kinesthetic awareness.

From these characteristics of the mentally retarded child's art we may note his basic needs in all areas of experiencing: 1) a need to be sensitized to form and space; 2) a need for enrichment of concepts; 3) a need for more flexible use of concepts; 4) a need for deeper emotional sensitivity; 5) a need for social confidence.

Strategies for Art Programming

General Principles

Art programming will be discussed for three distinct groups of mentally retarded children: the mildly retarded, the moderately retarded, and the severely retarded. General principles for working in art with the retarded child (knowing the child; assessment; executing art activities; adaptation) will be described prior to discussion of art programming strategies for each group.

Knowing the Child. Although a child may be classified as mentally retarded, he is an individual and different from other children. Individual differences, needs and interests must be taken into account for appropriate art programming and development of art activities.

Knowing a child means being informed about his level of development across several dimensions: cognition, perception, motor skills, socialization and communication skills, behavioral characteristics, and preferred mode of learning. This information can be derived from the child's file, conferences with special education personnel, other teachers, and observation. Unlike art programming for the unimpaired child which may focus primarily on the child's making "aesthetic decisions" learning about "the structure of art and how to evaluate art" (Anderson, 1978, p. 51), art for the retarded child starts with his needs and present abilities. Using this as beginning point should not in any way diminish the development of authentic art experiences.

Art programming should also draw upon the child's strengths, interests and, when appropriate, chronological age. Mentally retarded children have labeled some activities "babyish," especially when the activities were selected solely for their success value. Art programming for the retarded means utilizing the child's existing skills and experiences, yet avoiding demands for performances above the child's capacities.

Assessment. To determine the nature and level of art activities that are to be incorporated in the art program for retarded children, it is necessary to assess the child's artisitic developmental level: (e.g., representation of the human figure in drawing and modeling and skills with art materials and tools (clay, brushes and paint, pasting, knowledge of colors). A comparison can be made of the retarded child's artistic development with that of the normal child (refer to Chapter 1: Development of the Normal Child in Art).

Anderson (1978) suggests that a checklist be used for assessment of the child's art skills as the starting point for an art program. Three columns: *Yes, No, Sometimes,* are used for assessment of basic skills such as the child's ability to use paint and brushes, hold scissors, cut paper, use glue, name and identify three colors, hold a crayon and know how to clean up (p. 21). It is important to record each child's level of art functioning and progress, either in this form of checklist or with notations on anecdotal records.

Execution of the Art Activity. It is crucial when working with the mentally retarded child, that the teacher/therapist execute the art activity or lesson prior to the time it is introduced. It is at this time that the complexity, appropriateness and needed adaptations of either the art activity as the materials become apparent. It is also necessary to break down the activity to its component parts and identify, list and sequence

the steps involved. Further, it is important to determine the subskills (e.g., cutting, pasting).

Adaptation. Adaptation is a key concept in working with the retarded child, as with all other exceptional children (Anderson, 1978). For the retarded child, adaptation may mean structuring the art activity into separate operations that are taught one step at a time and completed before the child goes on to the next step. This will prevent the child from having to remember lengthy procedures and consequently causing confusion and frustration. Poor memory recall is one of the characteristics of mentally deficient children. Since the retarded child's attention span is short, it is advisable to structure lessons of short duration. Adaptation may also mean substituting art materials (e.g., styrofoam meat trays for printmaking plates instead of linoleum blocks or poster paints in lieu of finger paints for the child who does not respond positively to the medium). Adaptation may mean simplifying the art activity, extending the exploration period with materials, or if necessary, increasing the number of activities based upon a particular skill, theme or process. Whatever the adaptation, it stems from knowing the individual's needs, abilities and interests. Successful and appropriate art programming for the retarded child is dependent upon the teacher/therapist's sensitivity, flexibility, patience and respect for the abilities of the child.

Mildly Retarded

The mildly retarded child, like the normal child, begins the artistic process by manipulating materials. Unlike the normal child, however, this child may be more reluctant to explore with new materials, will not make discoveries incidentally, and will need the encouragement and guidance of the teacher/therapist to become more comfortable with new media. The mildly retarded child learns slowly, needs many repetitions and opportunities for practice with the same skills, processes and materials for learning to take place and to feel secure. Repetition, simplicity, and consistency of approach are guiding principles when working with this type of child.

For the young retarded child (ages 6–8), emphasis in the art program should be on sensory experiencing (all the senses), motor experiences, manipulation of concrete materials, and exploration through two- and three-dimensional activities. Skills such as painting with a brush should be demonstrated step by step, with the child completing each procedure before going on to the next one. (These procedures are also applicable to the art program for the moderately retarded child.) It is advisable to limit the choice of paint to one color until the child has mastered use of the paintbrush. In working with any retarded child, it is necessary to determine the objectives for each art activity and not to introduce more processes or procedures than the child can handle successfully at one time.

When the child has reached the symbolic stage of representation, experiences which extend the sense of self (body concept) should be introduced. A series of activities with different materials and situations, but which remain consistent to the theme "Myself," can expand the child's sense of himself and also add to his knowledge of art skills and processes (Anderson, 1978). Themes can later incorporate familiar experiences with friends, family, and the environment.

Integrating several arts areas (e.g., art and movement) can provide stimulation, help link concepts through several arts areas and bridge fine and gross motor activities (Gaitskell, Hurwitz & Day, 1982). For example, after taking a position with their bodies, the children can then draw or paint themselves in the same position. Through this kind of experiencing there is a direct transfer from the kinesthetic to the graphic representation of the body position.

Integrating art and other subject areas is also helpful in reinforcing learning. For example, art activities which incorporate lines and shapes have a direct relationship

to art and math. Explorations and activities with colors and textures extend the child's art knowledge, while at the same time familiarizing him with the environment (social studies). Thematic units such as "My Neighborhood" can reinforce reading, writing, math skills *and* art. A mural or three-dimensional model of the neighborhood can reinforce academic learning and increase communication and socialization skills through group work.

For mildly retarded children functioning at the upper elementary level, most art activities of the regular art program can be introduced (drawing, painting, collage, puppetry, sculpture, pottery, weaving, stitchery). The approach to these activities must keep the learner in mind and may have to include simplification of concepts and skills or possible substitution of materials. Activities should be sequential, moving from the simple to the more complex, building on previously learned skills and allowing ample time for practice and repetition of processes.

Moderately Retarded

Art programming for the moderately retarded children should be similar to that of a preprimary art program (nursery, kindergarten) with the emphasis on heightening sensory awareness, fine and gross motor skills, learning basic art skills (proper use and care of art media, tools and materials) (Anderson, 1978).

Ample time should be allowed for manipulation activities to familiarize the child with the properties of materals (bending wire, exploring clay, handling and selecting textured papers and materials), practice in the use of tools (drawing: felt tip pens, crayons, cray pas), processes (painting with a brush) and learning the art elements (identification of shapes, colors, lines, textures). Each of the aspects of art learning may of necessity have to extend over a long period. Once the child can control basic art media, these skills can then be used for art expression. Anderson (1978) recommends that a limited choice of materials be made available but that some choice be given with every art activity. Because the child has a limited attention span and poor memory recall, it is necessary that activities be of short duration. By structuring an art activity into small manageable operations, taught one at a time, and allowing some choice in materials, the child will be able to make decisions and build needed confidence through success.

Use of art materials such as paint may be difficult at first for some moderately retarded children. Toilet training and self-feeding problems combined with their parents' stress on cleanliness may make use of art materials synonymous with "getting dirty." In cases where this fear is initially present, preliminary explorations with nonart materials (rice, scraps of colored wood, shaving cream, puddings, syrup, small boxes, feathers, fabric scraps, buttons, beads) is suggested (Gitter, 1975). Explorations should include opportunities for smelling, tasting, banging, squeezing, raking, and picking up the materials. These kinds of activities not only make the transition to art materials easier, but also strengthen finger and hand manipulation. Explorations with the materials should then move to more structured activities, such as construction and collage.

Once structured activities have been introduced, it is suggested that there be a contiuum of experiences within a specific area (e.g., printmaking) or medium (tempera paints). Freasier (1971) in an art program with trainable retarded children introduced a hierarchy of sequentially structured printmaking activities over a three-month period for a 30-minute arts and crafts perod daily. The 149 individual experiences included body printing activities, gadget printing, simple relief printing, silk screen, tie dying, and other related activities. Printmaking was selected because it was a form of concrete use of materials and concepts acquired in printmaking which were applicable to other curriculum areas: concepts of shape, size, directionality, space, number, motor skills and socialization skills. A similar approach can be used with drawing, painting, modeling, construction or simple puppetry.

When concepts are first recognized in the drawing of simple representational forms, we must begin to carefully sensitize the child to his body-self in order to enrich the developing schema with more details. A painful experience may provide an opportunity for verbally motivating a drawing. A cold, a toothache, a stubbed toe, a cut finger— any one of a number of these common experiences may provide a basis for sensitizing the child to a richer bodily concept. Notice in the work of Larry, a retarded nine-year-old boy, what simple verbal motivation can effect. In figure 62 we note his typical figure concept. It is a simple person with no torso and few details. In figure 63 we see the result of simple motivation concerning combing his hair in the morning and putting his new boots on. After a number of motivated drawing experiences we find his figure concept has become very rich in details (fig. 64).

Finally, for successful functioning of the art sessions, classroom management (storage of supplies, distribution and collection of materials) and operational procedures (use and care of tools, clean-up) should be consistent, clearly outlined, and physically demonstrated. Understanding operational procedures enables the child to begin working on a project more independently (Freasier, 1971).

Severely Retarded

The immediate goal in working with severely retarded children is to "expand their sensory, perceptual and motor horizons through the manipulation of materials" (Wilson, 1977, p. 87). What distinguishes the art of the severely retarded child from higher functioning children is that his graphic representation may remain for an indefinite period in the random scribbling stage and then move slowly to controlled scribbling. Some of these children may, in fact, never achieve the level of symbolic representation.

Because of serious developmental lags in combination with a lack of early stimulation in the home, many of these children cannot effectively integrate or respond to experiences from the internal or external environment. Progress for these children may be slow, at times imperceptible; what is crucial is for the art experiencing to begin on the level on which the child is functioning.

While one child may begin to be able to make marks on a paper with crayon, another may begin on the sensorial level by placing the crayon in his mouth. With clay or other modeling material one child may actively be able to lightly touch or squeeze the clay, while another may be passive in the handling of the material or make accidental forms. The objective of the art experiencing for this child is to have him move to a more conscious manipulation of the clay into simple three-dimensional forms.

Experiences with color may start on the same unconscious level, or there may be a preoccupation with one color. The objectives for color learning in this case would be to use different colors to designate different meanings of the scribble or symbolic forms.

Severely retarded children respond to art materials in different ways: some are unwilling to try materials such as clay or finger paint (possibly perhaps because toilet training has not been fully achieved) (Gitter, 1975). Others are distractible and need a variety of materials during one art session to decide which materials are most satisfactory. Sometimes making minor variations, such as changing a color, rather than changing the medium may be satisfactory (Wilson, 1977).

The withdrawn, passive child may be reluctant to try materials such as finger paints and will have to be moved in progressive stages from playing with soapy water to sand play, to sand and water to tinted water, and to the finger paints (Wilson, 1977, p. 89).

The role of the teacher/therapist is the most active on a one-to-one basis with the severely retarded child. Interventions may include modeling what is to be done, telling and showing the child what he has done through verbal responses and gesturing so that connections can be made between the visual and motor activity. For example, the child may be shown how to use the finger paints; after he has worked with them briefly, the teacher/therapist reviews what the child has accomplished.

Figure 62. "Boy" by Larry, 9 years.

Figure 63. "Combing My Hair with My Big Boots On. There Are Muscles in My Arm" by Larry, 9 years.

Figure 64. "Me Smiling" by Larry, 9 years.

When children are working on the purely kinesthetic level of random scribbling with no control of motion or a conscious approach, only encouragement should take place. When, however, the child begins to see a relationship between the visual and motor activity, talking and showing the child what he has done may help integrate actions with perceptions (Lonker, 1982).

When a new medium or technique is introduced, it may be necessary to start by placing the child's hand on the teacher/therapist's and then changing to positioning the teacher/therapist's hand on top of the child's so that eventually the teacher/therapist's hand can be removed and the child work independently. At other times, when the teacher/therapist feels that the child is ready to begin a new stage (for example, the circular stage), the intervention may consist of drawing some circles and having the child complete work on the same drawing. The expectation is that the forms will be copied and then produced independently. Lowenfeld refers to this technique as closure (1957). The key to knowing when and how to use intervention requires time, patience and the understanding of the individual child.

In order to be prepared and to understand a child's possible response to art media, it is necessary for the teacher/therapist to be aware of the quality of the materials to be explored, such as the temperature, texture, fluidity, consistency, smell and sound (Lonker, 1982).

The art program for the severely retarded child may remain in the manipulation stage throughout and can be considered a precursor or pre-art program which involves scribbling, smearing, exploration, of physical properties of materials. Just as with the moderately retarded, consistency in approach, classroom routines and organization of the classroom are all important components of the art experience.

If the teacher/therapist is inventive, open and willing to accept the severely retarded child at his developmental level of functioning and is not limited to what art should or should not be, "then it becomes easier to perceive of the [severely retarded] child as being creative" (Kunkle-Miller, 1981, p. 15). For "wherever there is a spark of human spirit—no matter how dim it may be—it is our sacred responsibility as humans, teachers, and educators to fan it into whatever flame it conceivably may develop" (Lowenfeld, 1957, p. 430).

Suggested Art Media, Materials, Activities

In this section appropriate art media, materials and activities are suggested for the mildly and moderately retarded child. (Procedures for activities requiring further explanation are given in Chapter Nine: Art Activities and Procedures.)

Explorations

Non-Art Materials	rice, sand, pudding, flour, syrup, cornstarch, beans, shaving cream, crazy foam
Found Materials:	wood scraps, colored pieces of wood, patterned and textured fabric scraps, felt buttons, egg cartons, plastic and wood eating utensils, plastic lids, paper and styrofoam cups
Art Materials:	Drawing: felt tip markers in assorted widths, wax crayons, oil crayons.
	Painting: long handled round and flat bristle brushes, tempera paints, finger paints, paper: 9″ × 12″, 18″ × 24″ manila and newsprint.

Drawing and Painting

Use themes* related to the self, family, friends, pets, home, school, neighborhood, holidays, and special interests or hobbies for paintings.

Collage

Collage activity is an excellent experience for sensitizing the child not only to tactile features of materials, but to the surface space and spatial relationships. Collage materials include: words and pictures cut from magazines, assorted colored papers, textured fabrics, patterned and textured papers, string, wool, assorted beans, macaroni.

Collect and use materials that can teach concepts of similarities, opposites, size, shape, color, and texture. Collage is an appropriate activity for the retarded child because work can be completed quickly, with immediate results seen.

Construction

In working with the mentally retarded child there are many construction projects which may sensitize the child to tactile factors. For example, a box construction may become a "Feeling Box" into which the child may place his hand in exploration to become more aware of the surface textures of materials: soft, hard, rough, smooth. Materials for a "Feeling Box" may include stones, bark, shells, string, and a selection of other materials that are glued or suspended in the box. Limit the number and kinds of materials given to each child for his box. Completed boxes can be shared by the children as they verbally describe their "journey" as they use their hands to "walk" into the boxes.

Construction activities can also help the mentally retarded child learn how to join and glue materials to create a three-dimensional form. Recommended construction materials are: paper tubes, small boxes, egg cartons (whole or in sections), soda caps, toy parts, cardboard shapes, paper cups, and broken pieces of jewelery for decorative purposes. As in all other activities, the number and kind of materials for each construction should be limited so that the children can explore the potential of each material and not become overwhelmed and confused.

Printmaking

Body printing: footprints, handprints and fingerprints with tempera paint on brown paper or butcher paper in long sheets, can help the children become aware of their extremities and be able to identify them. This includes learning the names of these parts. Other simple forms of printmaking that can be introduced are monoprinting, found object stamping, and simple kinds of relief printing such as beadboard meat tray printing and cardboard printing. Tie dying and fold-and-dye activities are simple and provide a large measure of success for the children.

Modeling and Shaping

When the mentally retarded child manipulates a pliable modeling material, he is able to make changes in his work easily and rapidly. He also has a direct feeling experience of the roundness and depth of the material with which he is working and the forms he is creating. Modeling, a tactile experience helps him to better understand, refine, and communicate his understanding of physical forms such as figures, animals, heads, or objects (Herberholz, 1982). Early activities may be used for exploration and manipulation of the modeling material: pounding, rolling, squeezing, making coils and balls and imprinting materials into clay. Finger stamping and incising clay (a three-dimensional variation of finger painting) is recommended to help children learn texture techniques and increase their awareness of their extremities. For the retarded child, repetition with some degree of variation to maintain interest is important in learning.

*For description of the materials refer to An Art Program to Encourage Growth in Perceptual Awareness, Chapter 3: the Learning Disabled Child and Art.

Paper for drawings should be taped to the table and be large enough to accommodate the physical movements of the child. For some children who have involuntary movements, placing the paper in a cardboard or wooden box (three-sided, open top) will help guide their drawing movements. Some children in wheelchairs may prefer working on the floor, while others work more comfortably with a drawing board attached to their wheelchair for drawing and painting activities.

Some of the drawing activities should focus on expanding awareness of the body and its parts. Completion drawings which combine magazine cutouts of parts of the body and drawing in conjunction with motivations that activate body functions (such as eating, combing the hair (see figure 63), and holding implements) will improve the children's sense of themselves physically. Hopefully, it will also help them realistically acknowledge and represent their handicaps and compensatory actions in their drawings.

Painting

Round and flat bristle brushes that have been thickened at the handles are recommended. For children who cannot work with regular brushes, a man's shaving brush which can be grasped with the entire hand is suggested for painting large surfaces. A shoe polish dispenser can also serve as a brush when it is filled with tempera paint. Tempera paint should be the consistency of cream to prevent excess dripping for those children who prefer to work at a table easel, instead of on a flat surface. It is advisable that a weight be placed behind a table easel to prevent it being knocked over while the child is working. For children who are unable to move freely over their entire painting surface or who cannot move their papers, they will have to be moved for them. Water containers and paint containers should be weighted (gravel or pebbles can be used) to prevent them from being knocked over. In some cases, special containers will have to be devised to meet the needs of the child, e.g., plastic detergent bottles which have been cut down and weighted can serve as paint or water containers.

Cutting, Tearing, Gluing

Activities may include pictures with precut gummed shapes, texture collages, thematic cut paper activities, explorations with lines and shapes of different materials, and assembled murals. For the shy, isolated child, the shared experience is important for socialization skills.

To use glue for adhering objects to a background, remove the white glue from the bottle and place it in a weighted container (a large plastic container that is cut down for easy access and weighted with gravel is suggested) so that the glue may be spread with a brush. The objects or paper for a collage are then placed on the prepared glued surface, rather than having to paste each object or paper individually.

Puppetry

Puppetry provides a wonderful avenue for having even the most inhibited or shy child come forth. "Behind a puppet, the child expresses, communicates, and socializes. He laughs, cries, fights, sings, and rejoices" (Anderson, 1978, p. 186). Simple puppets such as those made from children's drawings or found objects and construction paper, paper plate puppets, paper bag puppets and a host of other simple puppets can be easily made and used.

To help orthopedically impaired children acknowledge and accept their disabilities and to help normal children learn to understand and accept physically handicapped children, handicapped puppets can be made and used. Ingrid Crepeau, a professional puppeteer created handicapped puppets which she called "Kids on the Block." Each puppet is approximately three feet tall and dressed in real clothes: one carries a cane, another uses a wheelchair. Several nonhandicapped characters participate in the

sketches. (See reference section for details.) It is not suggested that children attempt to make professional-level puppets, but that the creation of a physically disabled puppet made by a child may help him recognize and accept his impairment.

The suggestions given for art activities in this section are just a sampling. Further ideas for art activities are given in Chapter 9: Art Activities and Procedures. It is particularly important that the teacher/therapist execute each art activity before introducing it to orthopedically impaired children to determine the physical skills needed and the possible adaptations that may have to be made for specific disabilities. In some instances, the teacher/therapist may find it inadvisable to include an activity, necessary to substitute the materials, or to simplify the procedures.

Included in art programming for the orthopedically impaired should be opportunities to learn about artists and art through museum trips. Prior to a visit to a museum, personnel at the site should be contacted to determine what accessibility measures have been made for the orthopedically handicapped.

The Neurologically Impaired Child

Physical problems in children may be the outcome of damage to or deterioration of the central nervous system—the brain or spinal cord. The brain damage may be so mild that it is undetectable as far as the child's functioning is concerned or so profound that it severely reduces the child's ability to function. Brain damage may be focused in one area which is defined and very specific, causing special effects on the child's behavior. In contrast, it may be diffuse, involving a large or poorly defined area, often causing generalized behavioral effects (Hallahan & Kauffman, 1982).

A brain damaged child may exhibit a variety of behavioral symptoms, including mental retardation, learning problems, perceptual problems, incoordination, distractibility, emotional disturbance, and speech or language disorders. (It is important to understand that a child may show any of these behavioral characteristics and not have brain damage.) Other symptoms that indicate brain damage or dysfunction are poor motor coordination, paralysis, or certain types of seizures.

Although a person's brain may be intact and functioning properly, because of damage to the spinal cord, he may be neurologically impaired. Because nerve impulses are sent to and from the body's extremities by means of the spinal cord, "any damage to the cord may mean that the child will lose sensation, be unable to control movement, or be unable to feel or move certain parts of the body." (Hallahan & Kauffman, 1982, pp. 326–327)

Neurological impairments have many causes, including infectious diseases, loss of oxygen, poisoning, birth defects and malformations, and physical trauma due to accidents. When children have nervous systems that are damaged, regardless of the cause, muscular weakness or paralysis is almost always one of the symptoms. Because these children have limited mobility, they typically require special equipment and facilities for their education. Some specific kinds of neurological impairments are Cerebral Palsy, Epilepsy, Spina Bifida.

Definitions of Neurological Impairments

Because of the basic art focus of this book, detailed definitions, descriptions, and discussion about specific kinds of neurological impairments is not possible. However, each of the neurological handicaps introduced will be briefly described.

Cerebral Palsy: refers to a condition characterized by paralysis, weakness, incoordination, and/or other motor dysfunction due to brain damage. Cruickshank (cited in Hallahan & Kauffman, 1982) indicates that it may also cause psychological dysfunction, convulsions, or behavior disorders due to organic damage.

Epilepsy: is categorized as a convulsion disorder. The traditional classifications of epilepsy include grand mal, focal (or partial), and petit mal. "In a typical major motor or grand mal seizure, the child usually lets out a cry, loses consciousness, and goes through a brief period of muscle rigidity followed by a period of involuntary muscle contractions of the extremities, trunk and head." (Hallahan & Kauffman, 1982, p. 331) A focal (partial) seizure involves a discharge in a limited portion of the brain and causes only a limited motor or sensory effect. Some focal seizures are sensory: they are visual, auditory, or other sensations, without much convulsive motor activity. Petit mal seizures are characterized by brief (one second to half a minute) lapses in or clouding of consciousness. Although they are less severe than grand mal seizures, they may occur more frequently (Hallahan & Kauffman, 1982).

Spina Bifida: refers to a congenital midline defect resulting from the failure of the bony spinal column to close completely during fetal development; the defect may affect areas anywhere between the head and the lower end of the spine (Hallahan & Kauffman, 1982).

Adaptation of tools, processes and art activities are based upon the severity of the child's condition, motor incoordination, weakness, and/or paralysis. Strategies for art programming for orthopedically impaired children and learning disabled children (see discussion in the section The Learning Disabled Child) may be appropriate to the needs of the neurologically impaired children. Art materials, methods, and activities described for both these groups (the orthopedically impaired and the learning disabled) are also appropriate.

The Learning Disabled Child

Definitions and Classification

The field of learning disabilities is the newest category of special education. The term learning disabilities was proposed by Samuel Kirk in 1963 (cited in Hallahan & Kauffman, 1982) to describe children with relatively normal intelligence who were having learning problems. Prior to this time these children were likely to be referred to as being minimally brain-injured, minimally brain-damaged, slow learners, dyslexic (an impairment of the ability to read), or perceptually disabled. Terms like "brain-injured" or "brain-damaged" were virtually useless because the condition was difficult to determine. Also, while the diagnosis of brain injury (when it is diagnosed) is important to the medical profession, it does not offer useful information for educators who are responsible for planning and implementing treatments and educational programs. The term "slow learner" describes the child's performance in some areas, but not others. Besides the results of intelligence tests indicate that there is an ability to learn. "Dyslexic" as a definitive term for these children with learning problems is not particularly helpful because dyslexia is a symptom that can be caused by a variety of reasons from brain injury to environmental disadvantage. Describing these children as having perceptual problems is also not an adequate explanation for difficulty in learning. While perceptual problems are more frequently seen in learning disabled children than in normal children, many learning disabled children do not show perceptual problems.

Following the meeting with Kirk, a group of parents formed the Association for Children with Learning Disabilities (ACLD). Several years later, professionals officially recognized the term "learning disabilities" and formed the Division for Children with Learning Disabilities (DCLD) as part of the Council for Exceptional Children (CEC), the major professional organization concerned with the education of exceptional children.

Although there are a number of definitions of learning disabilities, there are common threads that run through them. Hallahan and Kauffman (1982) cite the major ideas contained in them: 1) there is academic retardation; 2) an uneven pattern of development exists; 3) the individual may or may not have nervous system dysfunction; 4) learning problems are *not* due to environmental disadvantage; 5) learning problems are *not* due to mental retardation or emotional disturbance.

Academic Retardation

This means that the children with learning disabilities are not achieving up to their level of intellectual capabilities. This is usually measured by standardized intelligence tests.

Uneven Pattern of Development

According to many definitions of learning disabilities, these children have a wide range of abilities and disabilities. The standard way of measuring these imbalances is to compare the scores on different achievement tests (reading, spelling, arithmetic) or to compare scores on the subtests of the same tests.

Central Nervous System Dysfunction

This is the area that has caused the greatest debate in the field. Most of the theoretical concepts and teaching methods associated with the field of learning disabilities grew out of earlier work with brain-injured and mentally retarded children. When the field of learning disabilities was first established, it was noted that children with learning problems exhibited similar behaviors to children diagnosed as having brain injury (distractibility, hyperactivity, perceptual problems). The difficulty was that although some of the learning disabled children showed these behaviors, there was little neurological evidence to confirm that damage had occurred to the brain. Some practitioners, on the basis of these behavioral characteristics alone, attribute brain damage to learning disabled children.

Currently, however, the trend is *not* to consider a child brain damaged until there is a positive prognosis of brain injury as a result of a neurological examination. According to Cruickshank (1983) with the continuing development of neuroradiological instruments, the incidence of diagnosed, rather than inferred brain dysfunction will occur. Developments in computerized axial tomography (CAT scan), in positronemission tomography (PET scan), in nuclear magnetic resonance (NMR) are examples of devices not being used to diagnose central nervous system dysfunction.

Environmental Disadvantage

Although most definitions state that learning disabilities are not attributed to enviromental disadvantages, more and more educators are questioning this position. Since a positive relationship between learning disabilities and brain damage is difficult (sometimes impossible) to establish, professionals such as Hallahan and Kauffman (1982) believe it is illogical to exclude economically disadvantaged children from being considered learning disabled when they may manifest learning problems similar to middle class children.

Mental Retardation and Emotional Disturbance

Most definitions distinguish between learning disabled children and mentally retarded or emotionally impaired children. However, mentally retarded and emotionally disturbed children frequently have learning problems and behavioral characteristics similar to learning disabled children. Teaching strategies for all three groups (including art programming) are comparable in many ways. Despite the fact that some profes-

sionals recommend that emotionally disturbed and mentally retarded children who manifest similar behavioral characteristics be included within the definition of learning disabilities, the official federal definition retains this exclusion.

The Federal Definition of 1977 states that:

> "Specific learning disability" means a disorder in one or more of the basic psychological processes involved in understanding or in using language, spoken or written, which may manifest itself in an imperfect ability to learn to listen, think, speak, read, write, spell, or do mathematical calculations. The term includes such conditions as perceptual handicaps, brain injury, minimal brain dysfunction, dyslexia, and developmental aphasia. The term does not include children who have learning problems which are primarily the result of visual, hearing, or motor handicaps, of mental retardation, of emotional disturbance, or of environmental, cultural, or economic disadvantage. (Federal Register, December 29, 1977, p. 65083)

Since that time numerous definitions have been advanced by professionals in the field of learning disabilities in an attempt to redefine the definition so that it is acceptable to a broad segment of professionals involved in the field such as psychologists, neurologists, pediatricians, special educators and researchers. In 1981 a new definition was presented by the National Joint Committee on Learning Disabilities which emphasizes the severity and heterogeneity of this population of developmentally disabled learners. It redirects attention to the internal nature of learning disabilities, but eliminates the focus placed on psychological processing included in earlier definitions. The linguistic, academic, and cognitive aspects of learning disabilities are stressed. Further, it clearly states that although learning disabilities may occur at the same time as other handicapping conditions or environmental influences, it is not a causal relationship.

> Learning Disabilities is a generic term that refers to a heterogeneous group of disorders manifested by significant difficulties in the acquisition and use of listening, speaking, reading, writing, reasoning, or mathematical abilities. These disorders are intrinsic to the individual and presumed to be due to central nervous system dysfunction. Even though a learning disability may occur concomitantly with other handicapping conditions (e.g., sensory impairment, mental retardation, social and emotional disturbances) or environmental influences (e.g., cultural differences, insufficient/inappropriate instruction, psychogenic factors), it is not the direct result of those conditions or influences. (Hammill et al., 1981, p. 336)

Hallahan and Kauffman (1975; 1976; 1977) offer a completely oppositional view when they state that "there is no reason why a child who is also mentally retarded or emotionally disturbed could not also be viewed as learning disabled" (cited in Hallahan & Kauffman, 1982, p. 95). They also believe that the classification of "learning disabled" should not rely on causal explanations. Hallahan and Kauffman propose that a learning disabled child is simply one who is not achieving according to his potential. He may be at any intelligence level; his learning problems may stem from any number of reasons, some that are perceptual, some that are not, and he also may or may not have emotional problems. (1982) With this definition, many more children would be considered to have learning disabilities than would be the case if the more traditional definitions were used. The two foregoing definitions of learning disabilities clearly highlight the state of flux, change, and growth the field is in—it can be described as anything but static.

Learning Disabilities: A Neurological Dysfunction

Cruickshank (1983) gives support to the theory that learning disabilities are the result of central nervous system dysfunction and clarifies the relationship between learning and neurological function. The definition of learning disabilities, Cruickshank states, is based upon certain givens: 1) "all learning is neurological" (p. 28); 2) "learning is conditioning" which itself is immersed in the neurological system (p. 28). Aspects of learning such as memory, sensation, perception, emotional responses are all neurologically based. In short, "any environmental stimuli penetrations into the human organism which result in a response—motor, subliminal, autonomic . . ." (p. 98) have occurred through the neurological system.

Perceptual processing (interpretation of sensory information) is of great importance in learning. When some sort of trauma occurs to the central nervous system, particularly the brain, the upper brainstem, or the basal ganglia, then perceptual processing becomes a perceptual processing deficit. Learning as conditioning is also immersed in the neurological system through among other factors, the efferent and afferent nerves, structures called synapses, and actions within the cortex, cerebellum, or thalamus. Problems in any of these brain areas or systems will affect the child's ability to learn effectively (Cruickshank, 1983).

Psychological and Behavioral Characteristics

The following characteristics are generally associated with children with learning disabilities. Not all children will experience all, many or even several of these problems; if they experience them at all, the degree will vary according to the child's age and the "predilections of the labelers." (Bryan & Bryan, 1978, p. 34)

1. Hyperactivity (motor behavior which is not called for by the situation or the task involved).
2. Perceptual-motor impairments (difficulty in coordinating a visual or auditory stimulus with a motor act. For example, seeing a shape and being able to copy it).
3. Emotional liability (sudden emotional outbursts for no apparent reason).
4. General coordination problems (clumsiness).
5. Attentional problems such as *distractibility* (tendency to be easily drawn away from the task at hand and to focus on extraneous stimuli of the moment); *perseveration* (continuing with a particular response after it is no longer appropriate, e.g., the child may draw a shape and continue to draw it unless he is stopped. There is an inability to shift from one center of focus to another).
6. Impulsivity (behavior which seems to reflect little thinking concerning its consequences or sufficient forethought).
7. Problems of memory and thinking (difficulty in remembering material that should have been learned, short and long-term memory, or difficulty in understanding abstract concepts).
8. Specific learning disabilities (inability to learn or remember reading, arithmetic, spelling, or writing).
9. Difficulty in *receptive language* (understanding or remembering spoken language), deficits in *expressive language* (poor articulation of speech or expressing self verbally, using appropriate grammar and vocabulary).
10. Equivocal neurological signs (neurological signs which are not clearly associated with particular neurological problems, but which are not clearly within the normal range of functioning. (Bryan & Bryan, 1978)

Equivocal Neurological Signs

The greatest danger in considering the neurological aspects of learning disabilities is to attribute as fact, the existence of brain injury based only on the presence of equivocal neurological signs or "soft signs." Soft signs refer to characteristics such as poor fine motor coordination, impaired visual coordination, poor balance, clumsiness, crossed eyes, incontrollable movements, and poor speech. Such signs are considered "soft" because unlike "hard" signs of classical neurology, the "soft" signs are "slight, inconsistently present, and not clearly associated with localized neuro-anatomical lesions. Dysfunctions such as clumsiness may represent "normal" variation and be totally unassociated with central nervous system pathology. Wender (cited in Hallahan & Kauffman, 1982, p. 115). Too many parents when their children have been labeled "minimally brain injured" based on "soft signs" alone have become needlessly alarmed. This term makes parents feel that their children's problems are severely and frighteningly serious. Fortunately, learning disabled children can be helped and many of their problems corrected with careful special education strategies and programming.

Classroom Behaviors

Many learning disabled children because of social/emotional problems find it difficult to get along with others. Their irritability, restlessness, jitteriness, their emotional explosions at the smallest provocation and tendency to continue their anger long after the reaction is appropriate makes other children reject learning disabled children. Social interaction is particularly problematic for the learning disabled child. The inability to perceive and act on subtle cues, often causes him to misread situations and thus incur the anger of other children. Memory problems might also prevent the child from remembering other situations that caused displeasure or anger. The inability to generalize from one situation to another can prevent him from seeing the relationship between situations, therefore causing the child to repeat old and negative social behaviors. Teaching socialization skills is a necessary part of the learning disabled child's education.

Problems in basic literacy skills: listening, speaking, reading, writing, and spelling, understanding and using written and spoken language not only affect learning in basic subjects but in other content areas such as science, social studies, art, and music. Problems in perceiving, memorizing, conceptualizing, generalizing, and thinking (psychological processes) affect learning in all areas as well. This in combination with hyperactivity, being unable to attend to tasks, and a short attention span, are factors that make learning in the traditional manner difficult for these children. Some of the children have deficits in all academic areas; others have problems in only one or two academic subjects. Reading disabilities are probably the most prevalent problem area for learning disabled children.

Brain Dysfunction and Art Expression

Since the awareness of the body-self is most basically affected in neurological handicap, it is to be expected that the projected body-image in art will again hold clues for an exceptional condition.

Pfister (1934) noted that heavier line pressure was applied in the drawings produced by organically involved patients. This was later supported by Buck (1948) and Jolles (1964). Bender (1940) found that a Goodenough score two years or more below the Binet score would make the individual child suspect for neurological handicap (see figs. 73 and 74). Bender also noted that the inability to draw the human figure may not extend to other subjects. Buck (1948), Jolles (1964), Machover (1949), Vernier (1952), and Hammer (1955) all suggested criteria in the H-T-P drawing technique for neurological handicap. Much speculation, debate, and retesting of the criteria followed, and much conjecture remains today from some of these proposed diagnostic criteria. Most subsequent study lends credibility or clarification to the use of the H-T-P as an appropriate and valuable tool for assessment of neurological handicap. Especially significant is its use for screening purposes and then as a diagnostic part in test batteries.

Michal-Smith (1953) compared H-T-P drawings of adult patients with normal electroencephalographic tracings to those with abnormal tracings and found that "line quality" was a valid criterion. It is later mentioned in study by Cohn (1960) as "linear perseveration" or redrawing. Reznikoff and Tomblen (1956) found five criteria to differentiate between emotionally disturbed patients and patients who were organically impaired: weak synthesis, parts misplaced, shrunken arms and legs, parts other than the head and extremities distorted, and petal-like or scribbled fingers.

In 1960 Cohn made perhaps the most extensive study of drawing characteristics for judging neurological handicap. His population numbered 8,000 subjects, and his results substantiated many of the earlier proposed criteria. His criteria were as follows:

1. Distortion 3. Perseveration
2. Asymmetry 4. Simplification

Figure 73. Person by Jim, 6 years. Verbal IQ 126 and Performance IQ 106.

Figure 74. "Tree Hit by Lightning" by Jim, 6 years.

He notes that distortion involves a disproportionate configuration or "disarrangement" of body parts. His term *perseveration* regarded redrawing so as to "represent by intertwining and overlapped repetitions of line where a single line would usually suffice." This, of course, would suggest the use of erasing as well. His term *simplification* concerned a more primitive figure and not just a stick man. It was wise of Cohn to tell his subjects to draw "the picture of a person, front view, the entire person." Imbalances are thus easily seen.

In drawing upon the previously stated writings and from other conducted research, this writer (1969) has concluded that the following criteria are of benefit in discerning neurological handicap in children through their drawings:

1. Assymmetry in the projected body-image
2. Distortion and rotation of form
3. Redrawing and erasing (perseveration)
4. Weak synthesis of parts
5. Heavy line pressure
6. Primitive wholes.

The final criterion would apply basically to the more severely involved children. Personal familiarity with the drawings of known cases of neurological handicap is perhaps most beneficial, as even here, in our attempt to be objective, we must realize the strong subjectivity which naturally comes into play with each observer.

In figure 75 we note a person drawn by Robin, a six-year-old girl with very poor motor coordination. The erratic line production and poor closure of shapes are typical for the neurologically handicapped child.

Figure 75. Person by Robin, 6 years.

Figure 77. ''Best Boy'' by Steven, 7 years.

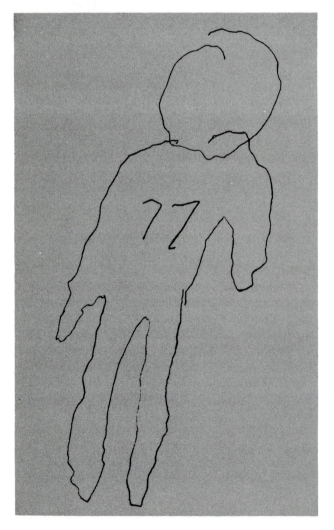

Figure 76. Football player by Jack, 16 years.

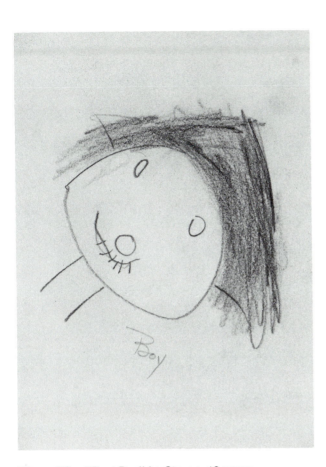

Figure 78. "Best Boy" by Steven, 10 years.

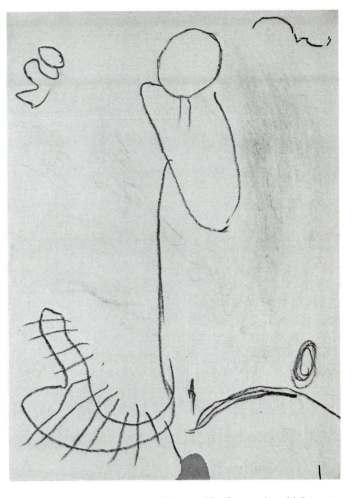

Figure 79. Person by girl 6 years.

Diabetes insipidus was responsible for the high fever which caused brain-damage to Jack (fig. 76). At sixteen years he was attempting to draw a football player. Notice again the poor motor coordination and the poor line closure.

At seven years Steven drew his "best boy" in figure 77. He was an aphasic child with no speech but good motor coordination. A high fever during a case of the measles caused his condition. At ten years of age he again drew a "best boy" (fig. 78) and little change can be noted. He expresses himself in primitive mandala-like figures which rotate to a considerable degree.

The six-year-old girl who drew figure 79 expresses extreme confusion of the body-self. She is severely impaired in the perceptual process, and most of our drawing criteria may be evidenced in her human figure drawing. Many today prefer to call the neurologically handicapped child by the term *perceptually handicapped*. The term is very appropriate, for as Laura Lehtinen states, "This damage has changed the way in which he perceives the world."

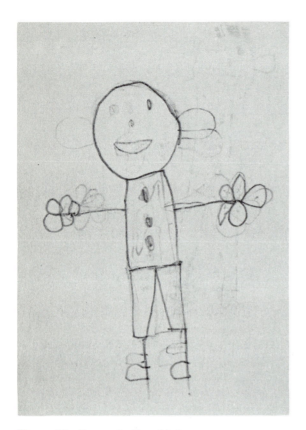

Figure 80. Person by Donald, 9 years.

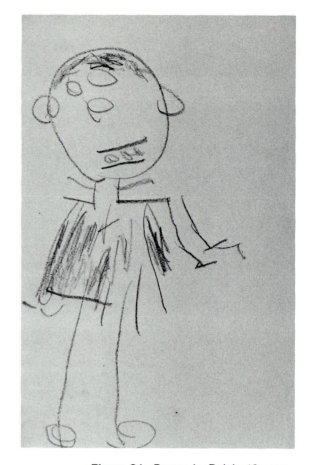

Figure 81. Person by Ralph, 10 years.

In Donald's human figure drawing (fig. 80) we note the tremendous drawing and redrawing which often occur in the projection of the body-image. He is an extremely hyperactive boy in spite of heavy medication. His reading is poor. Like most children with neurological handicap, he has his "good days" and his "bad days." He verbalizes well but is extremely poor in motor tasks. Ralph's figure drawing (fig. 81) reveals a very weak synthesis of the body parts and asymmetry in the projected body-image.

We sense that the left projected side is practically "shredded" in some way. A similar adult body-image projection viewed in figure 82 makes this factor clearer and emphasizes the fact that one half of the body may be quite intact from the standpoint of the subject's awareness while the other side may be almost completely fragmented.

The age factor is often highly significant in recognizing slight neurological dysfunction through the body-image projection and this becomes obvious only when we collect the human figure drawings over the years as a longitudinal study. In figures 83, 84, and 85 we see one's subject's body-image projections at seven years, twelve years, and seventeen years. She had suffered minor neurological injury at two years of age in an auto accident. The earlier this type of minor dysfunction is noticed, and treated, the more successful will be the effect of corrective measures.

The figure drawn by Ray (fig. 86) was actually his fourth try. The third try is erased on the same plate. In figure 87 we note his first try and second try. He was twelve years old at the time and had been referred for psychological testing due to his undisciplined manner in a normal classroom. Notice the "step" similarity between Ray's first try and Diane's first human figure (fig. 83).

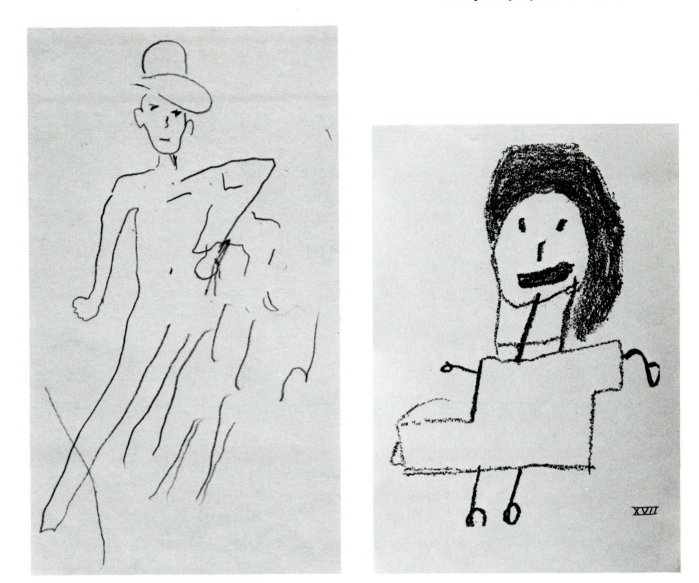

Figure 82. Adult brain-injured body-image.

Figure 83. Self-portrait by Diane, 7 years.

The person presented in figure 89 is by Ted, a sixteen-year-old boy. Here we notice strong asymmetry in the body-image. It seems that he does not know how long his right arm and leg should be. The brain injury in his case was localized in the left hemisphere which controls the right side of the body.

Peter, a bright ten-year-old boy with very minor dysfunction, drew the person and tree in figures 88 and 90. Notice the static projection of the left arm. His injury was localized in the right cerebral hemisphere.

Effects of Medical Therapy on NH Art

Since neurological handicap is a basic physical impairment, it is logical to first consider for the child therapy benefits from the field of medicine. In a few cases we might find a physician recommending surgery, but for the most part various medications are prescribed. Two typical cases of neurological handicap will be reviewed as a means for describing the child, recognition of his impairment, and the effects of medication in producing H-T-P drawings.

Figure 84. Self-portrait by Diane, 12 years.

Figure 85. Self-portrait by Diane, 17 years.

Figure 86. Person by Ray, 12 years.

Figure 87. Person by Ray, 12 years.

Figure 88. Person by Peter, 10 years.

Figure 89. Person by Ted, 16 years.

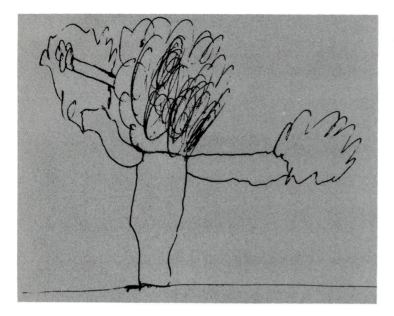

Figure 90. Tree by Peter, 10 years.

Steven

At seven years of age Steven was a puzzling child to both his parents and his teacher. He was a well-mannered boy who came from a fine home. His parents were college graduates, and he undoubtedly had a fine intelligence. Yet he was having extreme difficulty in reading, and his motor coordination was poor enough that he was noticed to be "clumsy." It was noted that he often could not recall simple words that were spoken just the day before, and his thought pattern seemed to be quite unusual. He was referred to the school psychologist who stated, "Steven's problem is an atypical one and so far remains undiagnosed. It may be a late maturing characteristic, or something more obscure. . . ." He was noted to have gross perceptual difficulties when copying the Bender figures.

The first H-T-P figures Steven drew are seen in figures 91 and 92. The projected right arm is elongated, and the same factor is even more exaggerated in the tree limb which moves out the upper left corner of the drawing surface. The figure is basically a "primitive whole" and, in this regard, below what we would expect for his age and intelligence. The house form in figure 92 indicates motion perception difficulty through poor line closure. Even the placement of the house on the paper is unusual. The facial features on the human figure were difficult for Steven to produce. In the drawing task he used his left hand, but it was evident that he preferred his right hand for other activities.

An electroencephalograph test was arranged for Steven, and the tracings indicated the following:

Diffuse irregular continuous mixed alpha-theta wave activity of moderate high to moderate and low voltages with a generous amount of bursty high voltage delta waves occurring in all leads . . . temporal asynchrony . . . hyperventilation—increased the delta activity with some showing associated abortive spike potentials.

The diagnosis was as follows:

Diffuse dysrrhythmic EEG mildly abnormal for a seven year, 9 month old subject. Tracings are not specific but convulsive susceptibility is suggested.

Steven was placed on a three-quarter grain of dilantin for six weeks as a beginning to drug therapy. At the end of that period of time Steven drew another H-T-P series.

While the second series of drawings were produced in crayon, a noticeable change in the projected body-image has occurred (figs. 93, 94, and 95). The improvement in

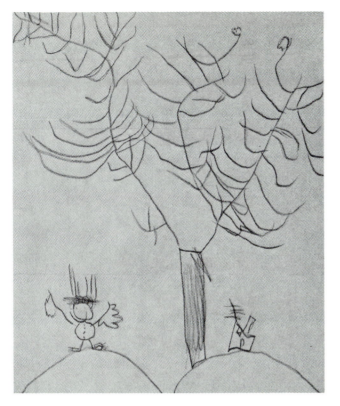

Figure 91. Combined H-T-P by Steven, 7 years.

Figure 92. Person and House by Steven, 7 years.

Figure 93. House by Steven, 7 years.

Figure 94. Tree by Steven, 7 years.

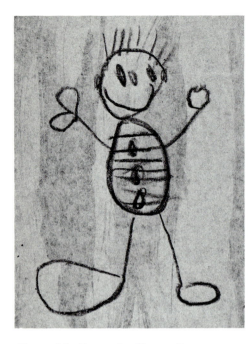

Figure 95. Person by Steven, 7 years.

Figure 96. House by Bruce (1st H-T-P).

a stable feeling of symmetry is obvious. The right foot of the human figure is larger than the left foot, but otherwise the placement and integration of body parts is excellent. If medication is continued, Steven probably will be much improved in his total referencing and achievement in a few months' time.

Bruce

The etiology of Bruce's problem is a difficult one to trace. As an infant he was extremely passive. At six months he would do little more than turn his head. Testing at nine months indicated a normal intelligence but subnormal large motor activity. No physical problem was evident. He gradually became more active until at the age of three years he was described as a "human dynamo." His activity often resulted in injury which could possibly cause permanent damage to the cerebral cortex. When he was three, his sister chased him against a car and fell on him. He was unconscious for some time after the accident. Later on in school he was soon labeled for his hyperactivity. His noise and abuse of other children made it necessary to isolate him often from the rest of the class. Teachers' comments in his cumulative folder from the third grade through the sixth grade indicate the continuous overt behavior of Bruce: "Will push and pick on other children on the playground, seeks attention by misbehavior. Fails to cooperate in games. Shows temper if he doesn't get his way." "Still possesses his aggressive traits. Not inclined to be accepted by classmates." "Explodes now and then." "Has a long way to go yet."

His extreme behavior was the basis for further testing in the sixth grade. The report of the testing disclosed an IQ of 112, but the scores were found to be very uneven at the various mental levels—he missed many easy items at lower levels and more difficult items at the higher levels. Oral expression was very superior, but nonverbal areas and basic problem-solving tasks were concluded rather poorly. He was noted as being highly nervous with a low frustration tolerance. The WISC Performance Tests showed slight difficulty with visual-motor coordination, and during the Bender Test he rotated the paper even though his directional tendencies appeared adequate. He gave the examiner the feeling that "he would really like to be able to control himself better."

Bruce's H-T-P drawings (figs. 96, 97, and 98) were picked from a group as a suspect of neurological handicap. The teachers' comments and the cumulative folder data supported the observation. He was eleven years old at the time. A conference was arranged

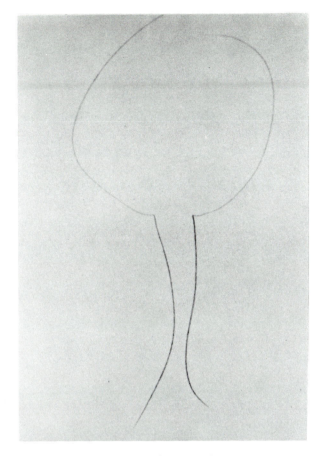

Figure 97. Tree by Bruce (1st H-T-P).

Figure 98. Person by Bruce (1st H-T-P).

with the mother, who had been at wits end for years with "his incessant thumping." She said he would often reverse words in his speech with such comments as, "No one can else do it." His mother was given a letter of referral for her family physician, and neurological tests were scheduled in San Francisco.

Bruce's H-T-P had revealed several significant signs of very minor neurological handicap. His attempt at drawing a house with a geodesic dome (fig. 96) was unusual, but only the emphasis on the porch was considered a possible imbalance. The tree drawing (fig. 97) suggests strong, impulsive character in the quickness of linear stroke, but the lack of match in the two sides indicates imbalance in the body-image. We might simply say that the left side is shorter. The difference in feeling for the two sides of the body is even more apparent in the human figure drawing (fig. 98). Here the left leg is noticeably shorter, and he drew a line beneath it in emphasizing that fact. The head is moved over on the axis of the body. A great deal of redrawing and erasing is evident in the original drawing. The shoelaces are prominently drawn and are an emotional symbol of castration. This could be considered somewhat typical for a prepubescent boy.

In the early neurological testing Bruce was given an arm deviation test which is a manual test of placing both arms in an extended forward position with the eyes closed. The task is to keep both arms and hands in a parallel horizontal position. Bruce would not even attempt the test without placing both thumbs together for a guide. The following EEG Test indicated "Spiking in the right temporal and associated bioccipital area more on the right." Bruce was started on dilantin which is one of the older and more predictable psychotherapeutic drugs. One month later he produced a second H-T-P series (figs. 99, 100, and 101).

The house (fig. 99) is quite well organized with no unusual characteristics of asymmetry. The two ends of the house do indicate the strength of the mother in the home.

Figure 99. House by Bruce (H-T-P).

Figure 100. Tree by Bruce (2nd H-T-P). **Figure 101.** Person by Bruce (2nd H-T-P).

His tree (fig. 100) still has a shorter left side in the body-image projection. A swing, however, appears to balance this shortness or compensate for it. The human figure (fig. 101) is most interesting, as here we see a decided change in attitude. He has strengthened the edge of the face or self-image and the expression is that of a perplexed feeling. At this point Bruce had ceased to drum on things continually, and his efforts at throwing a tantrum often "fizzled out." The left leg in the projection is still shorter.

Figure 102. House by Bruce (3rd H-T-P).

Figure 103. Tree and Person by Bruce (3rd H-T-P).

By the end of the seventh-grade year his cumulative folder for the first time contained some positive remarks: "Has improved greatly this year. Peers have remarked at his improvement." He began to do a bit of cartooning, and when a third H-T-P series was obtained a year later, the figures were almost rigid in their stylized character (figs. 102 and 103). They do appear wll formed and balanced.

Two years after medication was initiated, a final H-T-P series was obtained from Bruce who was now very irritated at the request. It was learned that he had not taken his medication for some time, and the drawings support this fact (figs. 104, 105, and 106). The porch of the house is back along with the two ends. There are curtains in the windows suggesting a strong effeminate identity—his paranoid reaction is also good evidence of such an identity. The tree without foliage now suggests the barren state of his life, and the broken branch suggests a defeat. The squirrel indicates his dependency upon the mother. The human figure drawing (fig. 106) once again includes the shoelace emphasis. The body is overclothed, and the hands have short, impulsive fingers.

He was encouraged to continue his prescribed medication but became more belligerent with time. He stole autos and was sent to a facility of the California Youth Authority. He attempted suicide several times in subsequent years. Finally, at the age of eighteen, he attempted murder by stabbing another boy during an argument. He was again placed in a penal institution where he now resides. His case points up the importance of early and continued therapy. Early frustrations due to a slight neurological impairment slowly developed attitudes and values which carried Bruce outside the bounds of normal society.

We have noted that medication does offer a means for therapy and it does certainly affect, to some degree, the basic body-image character as we have seen it reflected in projective drawing. There are, however, many other avenues of aid, especially in art,

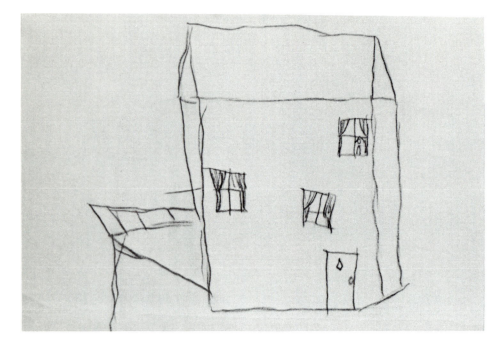

Figure 104. House by Bruce (4th H-T-P).

Figure 105. Tree by Bruce (4th H-T-P).

Figure 106. Person by Bruce (4th H-T-P).

Figure 107. Drawing by Betty, 16 years.

where specific materials and activities may help correct the basic perceptual distortion which the neurologically handicapped child suffers.

Specific Perceptual Problems and Art

We know that the perceptual difficulties of some neurologically handicapped children make art activities of a two-dimensional type almost impossible. The fragmented type of rambling which we see in figure 107 is typical of the drawings of severely impaired children with neurological handicap. It is imperative that we understand exactly what is disturbing the perceptual process, and then structure material activities which will, at least in part, correct the child's perceptual experiencing.

We know that motor incoordination and poor motion perception are often characteristic of the impairment. The matter of poor motion perception originates from a poor identification of physical awareness in one's own body, and improvement will come by a greater sensitivity to one's own bodily mass, weight, and positioning. Some of the same motor games which we previously mentioned with the mentally deficient child will be an aid in establishing such a sensitivity. Beyond these factors we must recognize other difficulties in perceptual experiencing.

We might note that the child, to begin with, tends to have greater sensitivity toward a surface *per se* since he cannot follow the motion of an object, or line, in relationship to its background. Ruben (1915) was the first to speak of the optic field in regard to object-ground relationship. Strauss and Werner (1942) devised tachistoscopic, visuomotor, and tactual-motor tests to study normal and abnormal object-ground reactions. They found the child with neurological handicap uses a general "incoherent" approach perceptually, while the endogenous child uses a "global" approach. In a gestalt sense they were simply stating that the child with neurological handicap suffers from an inability to organize the perceptual field into a good gestalt configuration. This results in a fragmented or disorganized aesthetic pattern in the drawing surface when he tries to express himself in art. Werner and Thuma (1942) in their study of the space-time abilities of the child through flicker-frequency experiences also noted that his abilities to perceive motion are highly impaired. It would seem from these studies that *art materials used with the severely impaired child who has neurological handicap must be basically surface-oriented.* One study by Werner and Strauss (1942) noted this factor.

Figure 108. Person by Ray, 8 years.

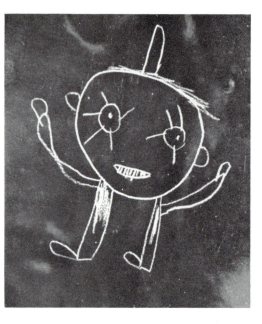

Figure 109. Person by Ray, 8 years.

They experimented with the gait of the child and found that the perceptually impaired child who could hardly walk in daylight could take almost normal steps by looking at his white shoes as he walked in the darkened room. He apparently could perceive the motion of a white or "negative" figure by its character as a "hole" in a dark or "positive" background.

This background of study has led us to investigate the effect that white drawing and painting materials may have on the neurologically handicapped child when they are used in combination with a dark surface. In figure 108 we note the person drawing by Ray, an eight-year-old boy with neurological handicap. The eyes slant to the right and the hair to the left. The figure is so imbalanced that it looks as though it may be dancing. In figure 109 we note his person drawing which was produced by using white crayons on a black paper. The human figure concept is more stable and richer in details. After several months of using white material on black surfaces, Ray was painting some fine pictures and thoroughly enjoying the experience (fig. 110). They were very rich in aesthetic quality.

As a result of this success, a study was formed to test the effect of such material combinations on a group of severely impaired children. Seventeen spastic cerebral-palsied children from four to nine years of age were selected as typically impaired in their perceptual abilities. They drew H-T-P figures with black crayon on twelve-by-eighteen-inch white paper and then with white crayon on black paper. The results were judged and statistically analyzed with a significant improvement noted in the second set of drawings at the one percent level of significance. In figures 111, 112, 113, 114, and 115–116 we see the comparison pairs of black-on-white and then white-on-black human figure drawings of children from the study.

A child with a Sturge-Weber syndrome problem was tried subsequently with the same materials and the same results (figs. 117, 118, and 119). In figure 117 we note his attempt to draw a tree (lower left), a house (lower center), and a person (lower right). In figure 118 we note the improvement in the human figure by using white crayon on black paper and in figure 119 the improved house.

Figures 120 and 121 provide one more example of the effect of using white-on-black material for drawing the human figure. In this case a girl by the name of Miriam produced the drawings and she suffers a minimal neurological dysfunction.

Figure 110. "Snowman" by Ray, 8 years.

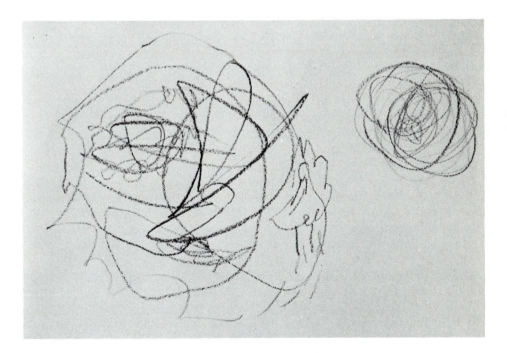

Figure 111. John, Human Figure, Black-on-white.

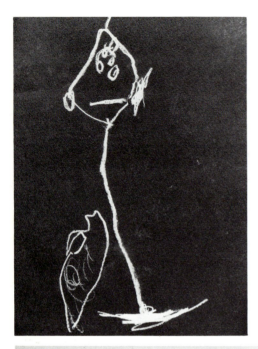

Figure 112. John, Human Figure, White-on-black.

Figure 113. Marc, Human Figure, Black-on-white.

Figure 114. Marc, Human Figure, White-on-black.

Figure 115. Sally, Human Figure, Black-on-white.

Figure 116. Sally, Human Figure, White-on-black.

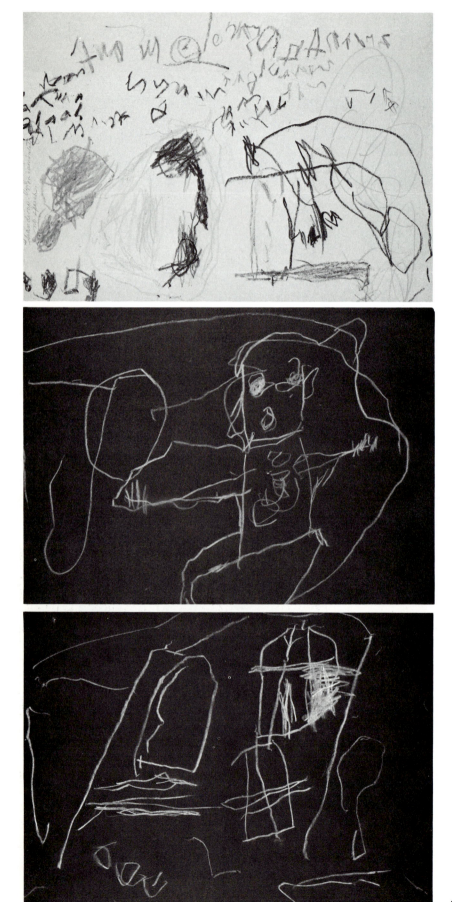

Figure 117. H-T-P figures by Charles, 7 years.

Figure 118. Person by Charles, 7 years.

Figure 119. House by Charles, 7 years.

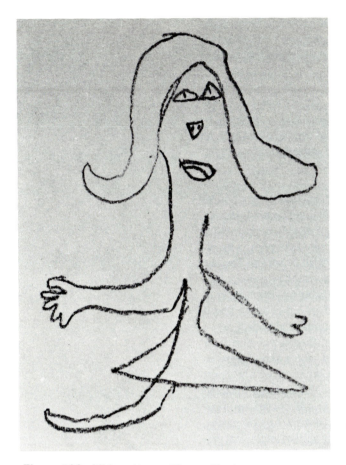

Figure 120. Miriam, Human Figure, Black-on-white.

Figure 121. Miriam, Human Figure, White-on-black.

Two-dimensional activities which emphasize the relationship of shapes to space (collage, stamping, drawing and painting activities which focus on foreground-background), and three-dimensional activities which incorporate manipulation of forms (construction, modeling) will increase spatial awareness.

Visual discrimination: the ability to recognize and differentiate one form from another can be helped through activities which build skills in categorizing, sequencing, matching, sorting, selecting, and organizing according to similarities and differences (e.g., size, shape, texture). Painting, drawing, collage, construction and printmaking activities can all be developed to focus on these elements.

Figure-ground perception: the ability to pay attention to one aspect of the visual field, while seeing it in relationship to the rest of the field can be improved through collage, stitchery, drawing, painting, mural activities which emphasize foreground and background.

Visual closure: the capacity to recognize or identify an object when part of it is missing can be improved through two- and three-dimensional activities that begin with a visual stimulus. For example, visual clues—heads, objects, can be pasted on to a paper for children to complete in drawing or painting; objects to simulate a head (e.g., plastic lid) can be pasted onto cardboard for the start of a relief figure. Geometric shapes can also be used to be the starters of a complete form (boat, car, animal).

Object recognition: involves the ability to identify an object. This skill can be developed through any art activities where the child is required to select tools, materials and objects. For example, instructions to "find a smooth shape, find a red triangle, two small boxes, or the large square shape" involve the skill of object recognition.

Memory: the capacity to recall has three components: short-term, immediate, and long-range memory. Review and recognition are ways of reinforcing memory skills, as is having the child verbalize the procedures at the beginning and completion of an art activity. Asking evocative questions and using active motivations to introduce an activity can activate associations and memory. Themes such as "our walk in the neighborhood today" or "swimming at the beach" can activate the immediate and long-term memory.

Visualization: the capacity to create a mental image of something seen or imagined in the "mind's eye." Being able to visualize is an important element in the creative process and necessary for expressive productions. Children whose sensory experiences have been insufficient or distorted may lack these skills. Visual imagery develops from the sense of touch (tactile and kinesthetic) to the visual and from single to multiple images. Activities to strengthen visualization skills should begin with touch (feeling a shape) and then drawing it, proceed to forming shapes with the body (drawing or modeling it), and finally to viewing a shape and drawing it from memory. Drawing, painting and modeling activities can be used to build these skills. As the children begin to visualize more freely, several objects can be given at one time (Petitclerc, 1972).

Adaptations

Learning disabled children may present behaviors that prevent them from successfully executing art tasks. In this section, adaptations to meet those needs will be described.

Hyperactivity-Hypoactivity

For children who are hyperactive, allowing them to move around or stand during an art activity may be helpful as long as the boundaries of their movement and work areas are clearly designated. Children who are hyperactive may also suffer from short attention span, distractibility and inhibition. They should be given activities of short duration with follow-up activities they can work on when each is completed. The objective is to keep them busy, focused and involved in a series of limited experiences.

Hypoactive children in contrast are slow movers. They may have to be stimulated before they can begin work. Physical motivations (e.g., jumping, moving the body into different positions) or having them stand for a short while before they begin to work may be helpful.

Distractibility

Children who are distractible have their attention drawn by stimuli. Limiting new stimuli around the room or on the walls may aid in their ability to remain task-oriented. For example, after demonstrations models should be put out of sight, excess storage boxes removed from tables and new exhibits on the walls limited. Other children may tend to perseverate on a task; when this occurs the teacher/therapist must help the child shift attention to another aspect of the activity.

Perceptual-Modality Preference

According to the theory of perceptual-modality (still highly controversial) (Lerner, 1981), children have major differences in the way they learn. Some children learn best by seeing (visual modality), some children learn best by listening (auditory modality), and others learn best by touching and/or performing an action (tactile-kinesthetic modality). Introducing art activities through all the senses is a way of meeting the needs of children with varied perceptual preferences. For example, in the demonstration of a process or a step in an activity, children should be able to see, touch and manipulate the materials to be used. By following a teacher demonstration with a cooperative group demonstration (one child participating at a time), all the senses can be activated as well as the procedures being reviewed and reinforced. Besides verbal instructions, written instructions can be written on a large wall sheet and/or printed for individual use (accompanied by illustrations for poor readers), and a tape of the instructions can be made for those children who need auditory reinforcement.

The long range goal of teaching is to strengthen all the modalities, but to use the stronger modality initially in the learning experience. Unfortunately, multisensory learning can provide difficulties for some learning disabled children. Their inability to receive, process and interpret information coming from several sensory systems at once can cause "sensory overload" and result in their not wanting to do the task, retrogression, poor attention or poor recall (Lerner, 1981). Some children fortunately who experience this problem are able to adapt their behaviors to screen out more sensory input than they can handle.

The adaptations described are based on the characteristics most often associated with learning disabled children. As stated earlier, not all the children will present these behaviors; those who do will have them in varying degrees.

Suggested Art Media, Materials, Activities

In this section we will discuss 1) General materials and approaches; 2) Materials and approaches for severely impaired children with neurological handicaps; 3) An art program to enhance the body image; 4) An art program to encourage growth of perceptual awareness.

General materials and approaches (source: Gonick-Barris, 1976, pp. 68–73)*

Clay:

Prepare the clay to the proper consistency prior to the time the children will work with it. For early experiences, limit the amount of clay to be worked with (e.g., a ball the size of a tangerine). Each child should receive the same size ball of clay. Work

*Paraphrased with special permission from the *American Journal of Art Therapy*.

directly on the table, rather than on newspaper, tiles, or plaster bats, to prevent distraction from the task. Begin with very structured group experiences, describing and demonstrating exactly what the children are to do.

At the end of the session, each child is given the same size and color sponge to clean the surface of the table and clay is collected. The same routines for distribution, collection, and clean-up should be maintained.

Early activities with clay may include pounding the clay, building it up and smashing it down, etching the clay with toothpicks and nails, folding, squeezing, learning how to join pieces of clay for sculptural purposes. Early products may be food or masks (the clay flat and etched). Once the children have mastered skills in working with clay, more clay can be distributed at each session. At a point when the children can decide for themselves how much they need, they can cut the clay from the 25-pound blocks by themselves. Later projects may include complex figures such as animals, people, or pottery.

Clay can be a very threatening material for children from a conceptual, tactile and expressive standpoint. Children who are learning disabled will want to make very complicated and realistic structures without being aware of the limits of their skills or the medium. The key to working with clay with this population is to move slowly: from structured explorations to more expressive activities, from the highly structured to the more open-ended activities, from a limitation of materials to freedom in selection based on the project.

Paint:

Paint is a difficult medium to control and demands good eye-hand coordination. The consistency of tempera paint for early experiences should be like buttermilk—thinner paint requires more control. After the children get used to working with paint, it can gradually be thinned. Establishing routines for the distribution of materials and cleaning up is important. Because color brings such excitement to a lesson, begin with blander ones: for example, first green, then yellow. An early palette could consist of green, yellow and white. When children are at ease with the paint, the paper, the brushes, and the mixing process, colors such as blue, red and black can be added. Red, an evocative color (blood and guts), should not be added too soon. Painting activities, as with the clay, should move from the structured, e.g., painting lines or geometric shapes on the board with water and a half-inch brush, to the more exploratory level, and finally to more expressive activities. Children should begin by working on their desks on small papers and then moved to the floor with larger sheets; choice of paints and brushes at first should be limited to one and become more freely available as the children gain control in handling the tools and materials.

Three-Dimensional Design and Collage:

Three-dimensional design and collage present problems for learning disabled children because these activities involve skills of cutting, folding, fastening and gluing. To be able to present expressive activities in these forms, time must be set aside to develop the basic skills involved. Materials should at first be limited (each child given the same kind and amount) and the activities uniform to reduce stimuli and confusion. Activities can move from one plane (pasting paper to a base), to more three-dimensional sculptural effects (twisting, folding paper strips). In introducing paper sculpture techniques, devote each session to another technique of shaping paper. When the children have acquired a number of shaping and construction skills, when they are all able to cut, paste, roll, and fasten paper, a full range of colors and materials (straws, textured papers) can be made available. Because of the nature of collage and construction, even the most uniform activities will result in the unique expression of the individual student, due to preferences in colors, shapes, textures, and the overall effect. Once the

children have established routines and basic skills involved with collage, a nature collage can be introduced. This can heighten not only their abilities to design collages, but an awareness of the environment, sorely needed by these children.

Group Work: Murals:

After the children have had basic independent experiences with clay, paint, three-dimensional design and collage, cooperative group activities can be introduced. A mural in which all the children participate can help build a sense of the group and social interaction abilities. For early activities, have only two children work on the same mural paper, but keep them far enough apart as they work to prevent problems. Beginning murals may be designed by having the children cut out figures and paste them to the background. Themes such as "Friends" allow partners to work with each other.

Two or three children can then create an environment, (e.g., the picnic; the party, or the beach) and draw, cut and tack large figures to the background. When the children have adequate experiences with mural making and have a greater feeling for background-foreground concepts, figures can be drawn spontaneously into the scenes. At this point, three or four children can work together on one mural, each with his own box of colored markers. Colored markers are recommended as drawing material as they lend themselves into the production of free-flowing lines without the muscular tensions produced when using a material such as crayons. The transition from the pasted figures to the drawn figures, from partners to groups of three or four should only occur when the children have a greater understanding of spatial relationships and a better social interaction with others.

(Permission to paraphrase material from this program has been received from *The American Journal of Art Therapy.*)

Materials and Approaches for Severely Impaired Children

Materials should be of a large size with tactile character and activities should incorporate the use of white or light figures on a dark ground or surface.

A salt-flour mixture (see recipe section in Chapter 9) can be transformed into a dark materials for mosaics by stirring in dark food coloring or india ink. After being packed into a shallow container (two-pound coffee container lid or cottage cheese lid) light-colored objects such as buttons, shells, or stones can be applied to produce a mosaic design.

Raised white drawings on a black surface can be produced by drawing with a bottle of white glue on black paper. Sprinkle white salt (fine or coarse) on the surface of the glue before it dries. The salt will adhere to the white glue and produce a relief drawing. This same glue technique can be used to produce a string or wool relief drawing.

Collage activity could include the use of light or white objects (buttons, beads, cut or torn pieces of textured paper or fabric, scraps of wood, yarn or string) to be glued to a dark cardboard surface.

Stitchery with white yarn on dark burlap or felt is an excellent activity. White yarn could also be pinned to a dark sheet of Celotex.

Crayon etching, in which light areas are scratched from a dark surface provides an exciting activity. The crayon should be heavily applied over a white tagboard surface and then powdered with cornstarch and painted with india ink before scratching through.

An Art Program to Enhance the Body Image

The art program consists of three phases: Phase 1: *Body Schema;* Phase 2: *Body Image;* Phase 3: *Body in Space. Body Schema* focuses on individual body parts, their functions, and their actions. Most of the activities are planned so that they can be executed in a single session. *Body Image* focuses on integrating and building upon

concepts learned during the Body Schema phase of the program. In this phase, the body is viewed holistically rather than focusing on individual body parts and their actions. Phase 2 also includes more expressive activities than Phase 1; some of the activities are planned to extend over several sessions. *Body in Space* (Spatial Awareness) focuses on the body in relationship to objects and the environment.

Each new activity is introduced with a motivation and culminates with a review of what has been accomplished. The motivation period includes sensory stimulation, improvisations, kinesthetic and movement experiences, visualization and memory activities. Movement games and activities may also be introduced when appropriate to stimulate awareness of the body in action. For some of the motivations, actual objects are used, such as, books, balloons, spoons; at other times, objects are presented and the children are asked what they can simulate in sculpture (for example, a lollypop can represent a balloon). This technique is to heighten children's creative thinking and imagination. In other instances, to heighten the imagination, the children are asked to pretend to be in an environment or to hold objects.

The primary objectives for the motivational period are to reinforce concepts pertaining to the body and to stimulate and extend the children's imagery. It is assumed that through stimulations prior to the onset of an activity, meaningful perceptions about the body will become integrated with past sensations and memories, thus giving the child a better frame of reference when approaching new activities related to the human figure.

The art program to enhance the body image is presented in three tables (see pages 101–103):

Table 1. Art Activities for Phase 1—Body Schema
Table 2. Art Activities for Phase 2—Body Image
Table 3. Art Activities for Phase 3—Body in Space

Procedures for art activities in the program requiring extended explanations will be described in Chapter 9: Art Activities and Procedures in the section titled *Body Image Activities*.

The art program to encourage growth in perceptual awareness is presented in table 4 (pages 104–105).

Weeks 1–3 include the themes: Self, Family, Friends
Weeks 4–8 include the themes: Animals, School, City and sensory activities: Hear and See, Touch
Weeks 9–12 includes sensory activities: Taste and Smell. elements: Space and Shape and activities to heighten the sense of self

Procedures for art activities in the program requiring extended explanations will be described in Chapter 9: Art Activities and Procedures.

The Visually Impaired Child

Definition and Classification

Visually impaired children are classified quantitatively (degree of visual acuity) and functionally (visual efficiency). Quantitative classifications are used for medical-legal purposes, functional classifications primarily for educational purposes. According to a medical definition, blind children are those who have a

visual acuity for distance of 20/200 or less in the better eye with best correction or visual acuity of more than 20/200 if the widest diameter of field of vision subtends an angle of not greater than 20 degrees.
The partially seeing are defined as persons with a visual acuity greater than 20/200 but not greater than 20/70 in the better eye with correction.
(The National Society for the Prevention of Blindness Fact Book, 1966, p. 10)

TABLE 1
Art Activities for Phase 1—Body Schema

Art Activity	Materials	Sessions
Figure completion using visual clues—3 levels of activity (Focus on body) 1. Static figures—adds arms and/or legs 2. Figure completion—single visual clues—hat, ball, etc. 3. Action figures—sports' photos—add arms and/or legs in action position	Pencils, magic markers (thin and thick)—also scented; 9″ × 12″ paper, visual clues from magazines and pattern books	1
Fantasy action figures using visual clues (focus on elbows and knees—how they function)	Same materials as Session 1	1
Relief figures using found objects (focus on body parts and their function) Session 1—Large found objects to form body Session 2—Smaller found objects to add details	Session 1—large boxes, plastic spoons, plastic forms, styrofoam, wood scraps, sponges, paper, tape, glue, etc. Session 2—Wool, toothpicks, magic markers, wood scraps, wire, textured paper, etc.	2
People cookies (focus on reinforcing concepts of previous lessons—body parts and limbs and their function)	Cookie dough (different textured doughs—peanut butter and sugar dough, semi-sweet chocolate bits, silver balls, colored nonpareils, sprinkles, and toothpicks for incising. Cookies baked at researcher's home	1
Director-actor game—(focus on body part identification, specific actions and imaginary experiences)—worked with two children at a time	Instamatic camera (children are photographers)	½
Tracing life-sized figures—same partners (focus on awareness of similarities and differences of individuals)	One color magic marker, craft paper	½
Painting of life-size figures; cutting out of life-size figures; photographing students with their life-size figures	Tempera paints, brushes, scissors; instamatic camera	2
Face cookies (focus on facial features)	Reproductions of portrait sculpture, cookie dough, toothpicks (no other materials, used to encourage modeling of features); mirrors	1
Pre-lesson preparation for full-size puppet heads for rod puppets (Polaroid portrait photographs of each child)	Polaroid camera; mirrors	½
Discussion of puppets	*Bill Baird Book of Puppets*, small hand puppets	½

(De Chiara, 1982, p. 402)

Source: De Chiara, E. A Visual arts program for enhancement of the body-image. © *Journal of Learning Disabilities*, Aug./Sept. 1982, *15* (7), 399–405. Reprinted by special permission of The Professional Press, Inc.

TABLE 2
Art Activities for Phase 2—Body Image

Art activity	Materials	Sessions
Design of a life-size puppet head using a wig form as the core. (focus: perceptual goal—reinforcing concepts related to human figure; expressive goal—developing a puppet character)	Sessions 1 and 2—styrofoam, cotton, egg cartons, paper cups, scraps of wood, etc., to form cores of facial features; pariscraft (modeling material), scissors	2
Painting and elaboration of the puppet head.	Sessions 3 and 4—Tempera paint, shellac, materials for adding details	2
Design of a paper marionette in various action poses. Rubbing of the marionette in an action pose (focus: the cutting out of body parts to create an integrated and proportioned figure; placement of the figure in various poses with the limbs in the appropriate places and in correct relation to each other, based on the selected theme)	Oak tag, scissors, magic markers, crayons, manila paper, movable dolls (to manipulate and pose before starting activity)	1
Action figure drawings using director-actor photos as the stimulus; same topic for drawing as used for photo (focus: using the photo as memory reinforcement—role-played and pose taken for photograph in game; using a physical action taken as the source for an action figure drawing)	Photos of each child, pencils, magic markers, manila drawing paper	1

(De Chiara, 1982, p. 403)

The figure 20/200 means that the child can distinguish at 200 feet what the sighted child can see at 20 feet. The restriction of the visual field to an angular distance of twenty degrees or less is sometimes referred to as "tunnel vision."

According to functional definitions for educational purposes the blind are those children who must use braille for reading and writing and who are unable to rely on vision for learning. Their education must be primarily through the other senses. The partially sighted are those children who are able to use vision as their main avenue in learning, and can be taught to read print through enlargement and magnification devices. Some partially sighted children can read regular print under certain conditions (Telford and Sawrey, 1977). The ways a child uses his eyes (visual efficiency) is more important for educational purposes than his measured visual acuity. There is not a direct relationship between a child's measured visual acquity and his ability for educational performance (Kirk and Gallagher, 1979).

Children who are visually impaired are as different from each other or more different than children who are sighted (Kirk and Gallagher, 1979). For example, blindness caused by an accident to the eyes only, will not affect intellectual ability, whereas blindness caused by a disease like rubella may often result in blindness *and* mental retardation. A child who has only peripheral vision will have very different learning

Table 3
Art Activities for Phase 3—Body in Space

Art activity	Materials	Sessions
To model a clay figure holding or relating to a stimulus object. (focus: to become aware of what happens to body and body parts when holding or relating to an object, e.g., bat, ball, box, etc.)	Self-hardening clay, found objects to simulate balls, bats, etc. (beads, sticks, wire, etc.)	1
To model a clay figure in relation to a large object, e.g., bed, boat, chair, table, etc. (focus: to become aware of what happens to the body in relating to large objects)	Self-hardening clay, found objects to simulate furniture (boxes, wood, beads, etc.)	1
To model a figure involved in an activity using stimulus objects (focus: transforming objects, e.g., lollipops, Easter-egg candy, candy coins into imaginary props for sculpture; conceptualizing an imaginary theme and representing it through an art experience; creating an environment for the modeled figure)	Colored plasticene clay, candy for stimulus objects	1
Modeling clay figure and placing it in a photographic environment (focus: further reinforcement or relating a figure to a specific environment)	Colored plasticene clay, colored environmental photos from *National Wildlife* magazine	1
Modeling an action figure in aluminum foil; creating a figure for an imaginary theme and designing the environment as well	Aluminum foil, found materials	1
Unstructured art activity; limitation: theme must include human figure	All materials available	1

(De Chiara, 1982, p. 403)

experiences and needs than the child with only light perception. The degree of blindness, age, home background, difference in intelligence are some of the factors that necessitate than an individualized educational program (IEP)[1] be developed for each child.

About 85 percent of what is learned is through vision. The blind child must shift from vision to learning through other sensory channels: hearing (auditory), touch and manipulation (tactual), body sensations (kinesthetic). Braille, the most efficient and useful means of reading and writing for the blind is from one-fourth to one-third slower than visual reading. (Blind high school students read approximately 90 words per minute in braille) (Telford and Sawrey, 1977).

The blind have difficulty with the development of spatial concepts. There is also some evidence that they do not use abstractions to the degree that sighted persons do and that they tend to think on a concrete level (Telford and Sawrey, 1977). Devel-

1. An individualized education program is plan of instruction for each handicapped child developed by appropriately prepared persons. It includes a statement of the child's present level of functioning, specific areas needing special services, annual goals, short-term objectives, and method of evaluation. It is required for every child receiving special education services under the conditions of PL 94–142.

opment in all areas of motor coordination, socialization, speech, and mobility will be slower in blind children than in sighted children unless they receive special training (Anderson, 1978). The popular notion that the blind have special talents in music, are endowed with greater sensitivities in sound or touch, or have superior memories are unfounded (Telford and Sawrey, 1977). It is more likely that blind people make better use of their other senses.

The education of partially sighted children stresses the use of vision to read, write and learn; and for them to make full use of their residual vision. Some adaptations and devices may have to be used to improve learning conditions, but otherwise the partially sighted child's education is not different from the sighted child's. He does not learn braille, nor are his spatial orientation and concept ability different from a sighted child of the same age and level. The more severely visually impaired child will need books in large type and magnifying devices.

Visually impaired children do not show any more emotional problems than sighted children do. However, Rubin and Klineman (1974) in an exploratory art program discovered that many of the blind children (ages 5–13) had powerful negative feeling which they had limited ways of expressing and understanding. The art program provided ways of channeling these feelings by accepting all of their feelings and fantasies and establishing that there were no right or wrongs in art or in inner thought. Visually impaired children also have potential problems in social interaction because of their inability to imitate through seeing and their lack of, or use of, perception of nonverbal communication, such as facial expression and body language. (Facial expressions and body language can become the source of art experiences.)

Visually impaired children may also have problems in self-motivation. They need opportunities to function independently and to execute activities despite their handicaps. Over protection on the part of adults causes them to feel helpless (Blake, 1981), leading to feelings of anger, which in turn is suppressed, because the children feel they need the adults' protection (Rubin and Klineman, 1974).

The majority of visually impaired children in local day schools are assigned to a regular class for most of the day and receive special instruction in a resource room or from an itinerant teacher. Multiply-handicapped blind children: deaf-blind, blind-speech defective, blind-mentally retarded, are placed in self-contained special education classes.

It is important for visually impaired children to develop their imagery abilities. Through imagery, they can grasp concepts which cannot be presented concretely or with actual models (Anderson, 1978). Studies have demonstrated that the visually impaired use visual imagery more than imagery in another form, e.g., auditory imagery. Those students who were the *least* blind had *more* visual imagery than the sighted students (Kirk and Gallagher, 1979).

Another study pertaining to the cognitive abilities of young blind children (ages 5–7) also has relevance for art programming. The children were asked to name the parts that should be included in drawings of a child and a house. The blind children revealed less knowledge of the body parts and house components than sighted children. The results suggest that the way blind children process personal and environmental information appears to result in fragmented and distorted concepts. It also indicates that these children have had a "narrow range of experiences and interactions with their environment." (Kirk and Gallagher, 1979, p. 245) Body image and environmental learning provide a source of content for art experiencing that has value beyond the art classroom.

Visual Impairment and Art Expression

Lowenfeld (1957) has best clarified the two types of perceptual experiencing, appropriate to a discussion of the blind, through his terms *visual* and *haptic*. We are indebted to him as well for the basic understandings which will form our discussion of the blind child's art.

A visual person, we previously noted, was seen to be extroverted toward his environment and therefore *can be emphasized as a person who places great energy into the matter of organizing, in his mind, a total image of himself in respect to his immediate surroundings.* We can say, in short, that his self-image and feeling of identity are more dependent upon such interaction and organization. Essentially, the visual person will depend upon his eyes basically as a means for perception. If vision is destroyed, however, he will still tend to perceive *in the same manner* but will rely upon the other senses for perceptual communication. We must keep in mind, as Lowenfeld has noted, that "the blind individual can perceive objects that are larger than his hand only by moving his hand over the object." Loss of vision, it would appear, would therefore greatly impair the visual person. It does slow him down, and yet we must again recognize that he is putting tremendous energy into the task of integrating and organizing his perceptual space or field. As a result, the more visually-minded blind individual will usually have a better idea of total space when we compare him to his haptically-minded blind brother. The visual blind merely utilize nonvisual sensory communication for a visual-type perceptual experiencing, and as a result, they often adjust very well to their impairment.

The haptic blind do not place energy, to a high degree, into the task of discerning their own body in space. As a result, they poorly function in unifying their separate sensory communications to form a total idea or concept. Their view of space-time factors, necessary for motion perception, is often highly impaired. An experiment by Flores (1968) has pointed out the significance of this fact. The more haptic blind child in his study was found to be much slower in arriving at a total concept of the human figure and had great difficulty in integrating the parts of the figure in drawing. Some had to practice even a simple circular scribble at length before achieving the ability to draw a circle.

In Flores's study (1968) the visually-minded blind child often was highly successful in drawing a human figure after mild motivation. In figures 122, 123, 124 and 125 we note the successive improvement of such a child in drawing a person. The evidence recalls Lowenfeld's words: "What the blind individual cannot always, or can only seldom achieve in life, he can do in art: out of the many partial impressions he builds up a 'whole' and arrives thus at a synthesis of his image." It is important for blind children to draw as well as model. In fact, Lowenfeld found that the younger children did not even know they were impaired and simply developed as any normal child would develop in the early physical-emotional experiencing of life. It is with age, after we have conditioned the perceptual needs of the child, that he may first realize the atypical character of his impairment and thus become handicapped.

Our treatment of the blind child is critically important in the early years. He must be led into experiencing which will help him to be independent and secure. *Such experiencing will be built through motor manipulation which will encourage exploration of space and time, factors necessary to the development of concepts of motion and form. This, as we have mentioned over and over again, is a basic foundation for all children, but especially for all exceptional children.* The blind child needs the boxes, and the balls, and the cups, and all sorts of stuff, presented in a meaningful way that it might encourage rather than overwhelm him.

Figure 122. Visually-minded boy's drawing of a person—1st attempt (from Flores).

Figure 123. Visually-minded boy's drawing of a person—2nd attempt (from Flores).

Figure 124. Visually-minded boy's drawing of a person—3rd attempt (from Flores).

Figure 125. Visually-minded boy's drawing of a person—4th attempt (from Flores).

Figure 126. "Having a Root Beer" by Carol, 11 years.

While we have been speaking generally of the congenitally blind child, some attention should be given to the partially sighted child. Little difference in the process of perceptual experiencing is noticed with such individuals. Lowenfeld carefully noted, however, that as a rule the visually-minded child will benefit by any remnants of vision that he may have, while the haptic-minded child will be hampered by such capability to see. In figure 126 we see a crayon drawing by Carol, a partially-sighted girl of eleven years of age. Carol drew herself with a friend having a root beer at the drug store. Her visually-minded perceptual process is evident in the spatial depth and general realism of the drawing. Yet she took over a week to draw the picture and held her face almost to the paper as she drew.

Strategies for Art Programming

Visually impaired children have the potential to be as expressive in art as seeing children if they are encouraged to draw upon their own perceptions and experiences in their own way and if their results are respected. It isn't necessary that an art work please sighted adults or children, but that the visually handicapped child finds it meaningful. (It takes conscious effort not to direct the child in subtle ways to get more visually pleasing results.) It is not necessary that these children use materials in the same way or even that they use the same media.

There are various problems associated with being visually impaired in relation to art. Perceptions that are usually derived from the visual sense must now be built from nonvisual senses, particularly the sense of touch. The process of exploring with the hands is much slower and also prevents the child from getting any picture of a totality at once—it is built up by a series of touch impressions. There is also a lack of access to experiences that provide a source of ideas for art, particularly a visual impression of the environment and objects within it. There are also problems in evaluating work when the child is visually handicapped.

Various strategies can be used to help the visually impaired child expand his knowledge of himself in relationship to his environment in preparation for art activities. Visual experience tends to unify knowledge as a totality. Visually impaired children cannot get this unification unless they are presented with learning activities that expand their limited perceptions. The choice of appropriate art activities is crucial if their perceptions are to be expanded.

Adaptations of Art Activities

To select appropriate art activities or to determine adaptations, it is necessary to know the capabilities of the visually impaired children with whom the teacher/therapist is working. It is also important to be aware of individual differences in development and abilities. The following is an example of an art activity designed for sighted students that has to be adapted for visually impaired children. It has been selected to demonstrate the thinking process that the teacher/therapist has to experience in order to make adaptations for children with special needs:

Sighted children are able to participate in an art activity which involves the construction of a three-dimensional model of a store, e.g., a fruit store. The store would be composed of boxes, the fruits, of clay and found materials. Sighted children because of first-hand experiences with this type of store would be able to mentally reconstruct an image of a fruit store given imaging activities, proper motivation and directed questions to ellicit memory recall. The mental picture of the store in combination with the recalling of first-hand experiences would prepare the ground work for this kind of activity.

For visually impaired children, particularly those with very limited sight or blind children, the task as it was originally designed would be inappropriate. To determine what adaptations would be necessary, the teacher would have to do a task analysis posing the following questions: "What knowledge does the child have to have in order to construct a fruit store in respect to the physical attributes of the store and the merchandise sold?" "What art skills are needed to construct the model of the store?" The results of such an analysis may prompt the teacher to scrap the activity or to develop a related, but less complex alternative. A possible substitute activity may be to have the children model fruits and/or vegetables, rather than construct the store and equip it with this merchandise. Each child may model three different kinds of fruits and/or vegetables and contribute his products to boxes that have been prepared (by the teacher or other students) to simulate bins in a fruit store. Prior to the actual modeling activity, the children would participate in preparatory activities such as (a visit to a fruit store, multisensory experiences with fruits—tasting, smelling, eating, touching, and improvisations rehearsing working in a store). In addition, for several days, a *fruit store* with boxes of real fruit and/or vegetables (contributed by the students) could be set up in the back of the classroom, so that the children may actually experience fruit grouped in a box. Through this kind of activity, the differences between the same kind of fruit could be learned first-hand.

The art activity could then be reinforced by the classroom teacher in language arts and social studies. Signs for the fruit bins could be made; the origin and distribution of the fruits/vegetables discussed, etc. The idea is to infuse the children with a myriad of activities related to the same subject so that a totality and unifying concept can be built.

Adaptations of the Physical Environment

The art area should have materials stored and furniture arranged consistently and with enough space between, so that the impaired children can have maximum mobility and independence in functioning.

Children's work areas should be far enough apart to insure that the children do not confuse their neighbor's tools with their own. Work areas can also be set up by using shallow trays or boxes in which the needed materials for an art experience have been placed. This not only provides working boundaries but it helps the child keep track of the materials being used.

Children who are restricted need a sense of freedom to move within a structure. Providing boundaries like trays allows the visually impaired child free hand motion without the fear of losing control. Fluid art materials such as clay or finger paint may

cause anxiety initially in visually impaired children. It is suggested that these materials be introduced slowly; the provision of boundaries (the trays) may reduce their anxiety and allow them to work without fear (Rubin and Klineman, 1974).

Adaptations for painting activities include the use of consistent shapes or sizes of containers for different color paints or the placement of paints in clearly-marked braille weighted containers. To give the child an orientation point on his paper, a dab of white glue or torn paper may be helpful. Both the tray and the drawing or painting paper should be firmly secured to the table with masking tape or a C clamp (Anderson, 1978).

Suggested Art Media, Materials, and Activities

Activities

Two important criteria for choice of art media and materials for visually impaired children are the amount of satisfaction the children derive in working with the materials and their ability to work with them. Although three-dimensional and textured media will be the major part of art programming, drawing and painting experiences should also be included. Since an individualized approach is to be taken in art with the visually handicapped, the choice of materials and method of working will be tailored to the child's interests and needs.

Concepts pertaining to the body image, and spatial awareness, as well as concepts related to academic subject areas such as arithmetic, social studies, and science can be developed through concrete experiences in art. For body image activities (see the section: Learning Disabilities: Art Media, Materials, Activities, p. 97)

Spatial awareness can be developed through collage and construction activities. In introducing any new material or concept, it is important to provide a number of experiences that progress sequentially. For example, when teaching the concept of shape, a series of activities should focus on one shape at a time, e.g., the triangle. A number of activities can be introduced with triangles of different sizes, weights, and textures (clay: modeling or incising activities; construction: building with slotted cardboard triangles; collage: textured fabrics or papers cut into triangular shapes; reliefs: cardboard triangles).

It is impossible within space limitations to describe art activities to develop concept learning in all subject areas. We can only suggest the process: begin by looking at the suggested curriculum for each subject area, determine which concepts can be developed through concrete experiences in art, review source books* and the art activities and procedures described in Chapter 9 for art activities that will meet these objectives.

Materials

Painting:

Painting can be a satisfying medium for children who have enough vision to see colors. Tactile painting can be devised by adding sand or other materials to the paint to give it texture. In texture painting, the color becomes secondary and the tactile quality the primary focus. For severely visually impaired children, providing different kinds of textured materials: salt (fine and coarse, sawdust, sand, and other kinds of granules) which are mixed with white glue and adhered to a background, provide a satisfactory kind of textured painting. Boundaries for different textures can be determined by incising lines in the board with a tool such as a ball-point pen. Lisenco (1972)

*C. D. Gaitskell, A. Hurwitz, and M. Day, *Children and their art: methods for the elementary school (4th ed.)* (New York: Harcourt Brace Jovanovich, 1982). The chapter relating art to the general curriculum is recommended. B. Herberholz, *Early childhood art* (2nd ed.) (Dubuque: IA: William C. Brown, 1979), is recommended for younger children.

Figure 127. ''Talking'' by Charles, 8 years.

Figure 128. A Mosaic Picture by Ann, 8 years.

Figure 129. "Having a Root Beer" by Harry, 11 years.

The current approach used in communicating and teaching the hearing impaired uses a combined method: finger spelling, signs, speech reading (lip reading), speech and auditory amplification at the same time. Special education procedure for these children include: instruction in the use of hearing aids, auditory training (teaching listening skills), speech reading, speech remediation, speech development, language development including finger spelling and sign language, reading and other school subjects (Kirk and Gallagher, 1979).

Hearing Impairment and Art Expression

The drawing and painting expression of the deaf child often indicates his feeling of isolation. In figure 127 Charles painted himself talking with his hands. We would expect the exaggerated character of the arms from the type of subject. Notice, however, the heavy black line about the head which suggests his "bound in" self. It almost appears that the personality has been pushed into a can. Very often, as in his painting, the head is drawn extra large. It seems to be an emphasis upon the self-entity ego-circle. In another example, figure 128, a deaf girl was asked to make a picture out of black triangles (a mosaic picture). She made a central face, indicating her egocentricity, with the rest of the spatial surface left in a chaotic jumble. We again feel strongly the isolation which she experiences.

In the work of Harry (fig. 129), a boy of eleven years with total loss of hearing in one ear, we notice a strong feeling of isolation. He was in the same class as Carol (fig. 126) and also was responding to the motivation concerning a root beer with a friend in the drug store. Everyone at the counter sits stiffly and separately apart. There is no expression indicating conversation as in Carol's drawing.

Deaf children need the physical games in the early years which would enable them to better identify and interact in the world of space and motion. They need to be drawn out emotionally to "unload" their feelings in art—feelings which are not verbalized.

Strategies for Art Programming

In working with hearing-impaired children, it is suggested that instructions be given at a normal rate of speed and at a normal voice level. Short sentences with an instructional vocabulary geared to the children's language level should be used. Words should not be mouthed or lip movements exaggerated. Teacher/therapists who sign have an additional level on which to communicate; those who cannot, can make full use of facial expressions, gestures, visual and concrete demonstrations, and written instructions. To facilitate communication, it may be necessary to look directly at the hearing-impaired child, sometimes at close range and not to begin speaking until eye contact has been established. It is also recommended that the light be on the teacher/therapist's face when she is speaking so that the child who speech-reads, can see clearly.

The artistic abilities of hearing-impaired children are comparable to hearing children their own age and level (Anderson, 1978). Some studies indicate that deaf children lag behind hearing children in originality, imagination, and abstract thinking. Silver (1978) disputes this contention and attributes the findings to evaluation on verbal responses rather than with nonverbal instruments. She also adds that deaf children are not given ample opportunities to exercise their imagination through art. When they are given the chance to engage in free drawing, many of them spontaneously produce imaginative themes.

The deaf may also have greater interest potentially in the visual arts than the hearing, because it gives them the opportunity to express and communicate ideas through their strongest modality—the visual. Besides providing the deaf with a source of enjoyment, art can open up vocational possibility, particularly crafts.

Art and language are both symbol systems. The hearing child uses language symbols to pin down perceptions, organize experiences and to understand and control his environment. By labeling experiences with words, the hearing child can use them over and over again. Language also provides a way of receiving information either directly or through the experiences of others (Silver, 1978). Hearing-impaired children are unable to link their experiences with either language or sounds; their need for nonverbal means of labeling experiences is crucial. Expression through art can provide this means. Through art experiences, hearing-impaired children can represent experiences (actual and imaginary) and perceptions which they cannot adequately express through language and speech.

Art activities can also serve to reinforce, activate, and extend language. When a child represents an event which is linked to a word or concept he has all but forgotten, the graphic representation may activate the word, e.g., poison (Silver, 1978). When words are linked to an art process or concept, e.g., small, large, rough, twist, bend, vocabulary is reinforced; when what has appeared in a picture becomes linked with a word, e.g., "desert," the word becomes more meaningful and may extend the context of the word for the child. The connecting of word symbols with visual symbols appears to be important to the hearing-impaired. Silver (1978) reports that many hearing-impaired children include words or phrases in their pictures or in some cases ask for the word that fits the picture. She attributes this to the fact that language is uppermost in their minds and that the labelling of experience is important to them.

Drawing or painting an event involves both the *memory* of the event and the *organization* of the experience into pictorial terms. Organizational skills are also reinforced every time the child organizes elements in a painting, collage or construction or executes the procedures in a process. Although art in and of itself is an important expressive outlet for hearing-impaired children, its potential reaches into other areas of intellectual functioning.

Art activities may be motivated and introduced through imitation (modeling), dramatization, or actual experiences. Modeling a procedure (e.g., demonstrating how to use a brayer or an inking plate) and having the children imitate what has been demonstrated helps them learn a process without the complication of words. However,

when the modeling activity results in a completed product (either the teacher/therapist's or child's), the children are inclined to copy (imitate) what they have seen. This may occur especially when children do not understand a process (Anderson, 1978). Perhaps by following a teacher demonstration with a group demonstration, the process will be understood more clearly and it will prevent the deaf child's need to copy someone else's model. The children should always be encouraged to work independently; the selection of open-ended activities is a way of fostering personal and unique interpretations.

In dramatization, the children act out an experience (e.g., rowing a boat or fishing). This is then followed by having the children represent the event through an art activity (drawing, painting, sculpture). Basing the art activity on an actual event, refers to having the children do something (e.g., make-up and dress as a clown) to be followed by artistic representation (e.g., drawing, painting, collage or modeling of a clown).

In summary, art programming for the hearing impaired is in most ways identical to that for hearing children. Differences occur in the communication of instruction and the linkage of visual and verbal concepts—language development.

Summary

Physical impairments have very diverse effects upon the individual. We have noted how orthopedic problems *really* cripple the child when they are not consciously accepted. Neurological impairments have numerous effects upon the child but they particularly produce problems in perception, which we have noted can be treated medically, and which we have noted can also be at least partially corrected by using a reversal of the typical figure-ground media (use white-on-black rather than black-on-white).

In regard to the blind child it has been pointed out that visually-oriented children often have almost no practical impairment due to their loss of vision while non-visual or haptically-oriented blind children may very poorly identify and move about spatially. There is a paradox here in that such findings suggest that we attempt to make the blind child dependent upon the parent that he may become more visually oriented.

Deaf children have been viewed as more highly handicapped than the blind as they lack sensory abilities to experience the total body space, and, in their lack of ability to adequately and immediately communicate feelings. We need to provide them with art media and motivations which draw out their feelings and encourage them to look upon art as a viable channel for their emotions.

References

Anderson, F. E. *Art for all the children.* Springfield, IL: Charles C. Thomas, 1978.
Bender, L. *Child psychiatric techniques.* Springfield, IL: Charles C. Thomas, 1952.
———. Postencephalitic behavior disorders in childhood. In J. Neal (Ed.), *Encephalitis, a clinical study.* New York: Grune & Stratton, 1943.
Blake, K. A. *Educating exceptional pupils.* Reading, MA: Addison-Wesley, 1981.
Bryan, T. and Bryan, J. *Understanding learning disabilities* (2nd ed.). Sherman Oaks, CA: Alfred, 1978.
Buck, J. *The H-T-P. technique: qualitative and quantitative scoring manual.* Monograph of Journal of Clinical Psychology, October 1948.
Carter, L. Art therapy and learning disabled children. *Art Psychotherapy,* 1979, *6,* 51–56.
Centers, L. and Centers, R. A comparison of the body-image of amputee and non-amputee children as revealed in figure drawings. *Journal of Projective Techniques,* 1963, *27,* 158–165.
Cohn, R. *The person symbol in clinical medicine.* Springfield, IL: Charles C. Thomas, 1960.
Cruickshank, W. M. Learning disabilities: a neurophysiological dysfunction. *Journal of Learning Disabilities,* January 1983, *16* (1), 27–31.
De Chiara, E. *A visual arts program for enhancement of the body-image.* Unpublished doctoral dissertation, Teachers College, Columbia University, 1976.
———. A visual arts program for enhancement of the body image. *Journal of Learning Disabilities,* August/September 1982, *15* (7), 399–405.
Federal Register, U.S. Department of Health, Education and Welfare, Office of Education: Part III, December 1977.

Fukurai, S. *How can I make what I cannot see?* New York: Van Nostrand Reinhold, 1974.

Goldstein, K. *After-effects of brain-injuries in war.* New York: Grune & Stratton, 1942.

Gonick-Barris, S. E. Art for children with minimal brain dysfunction. *American Journal of Art Therapy,* April 1976, *15* (3), 67–73.

Gruenberg, E. M. Some epidemiological aspects of congenital brain damage. In H. G. Birch (Ed.), *Brain damage in children.*

Hammer, E. *The H.T.P clinical research manual.* Beverly Hill, CA: Western Psychological Services, 1955.

Hammill, D. C., Leigh, E., McNutt, G., and S. E. Larsen. A new definition of learning disabilities. *Learning Disability Quarterly,* Fall 1981, *4* (4), 336–342.

Head, H. *Aphasia and kindred disorders of speech.* New York: Hafner, 1963.

Hebb, D. The effect of early and late brain injury upon the test scores and the nature of adult intelligence. *Proceedings of the American Philosophical Society,* 1942, *85,* 275–292.

Herberholz, B. *Early childhood art* (2nd ed.). Dubuque, IA: William C. Brown, 1979.

Insights. *Art in special education* (2nd ed.). Millburn, NJ: Art Educators of New Jersey, 1981.

Jolles, J. A. *A catalogue for the qualitative interpretation of the house-tree-person.* Beverly Hills, CA: Western Psychological Services, 1964.

Kirk, S. A. and Gallagher, J. J. *Educating exceptional children* (4th ed.). Boston: Houghton-Mifflin, 1979.

Kirk, S. A. and Kirk, W. D. On defining learning disabilities. *Journal of Learning Disabilities,* January 1983, *16* (1), 20–21.

Koppitz, E. A. *Psychological evaluation of children's human figure drawings.* New York: Grune & Stratton, 1968.

Lerner, J. *Learning disabilities: theories, diagnosis, and teaching strategies* (3rd ed.). Boston: Houghton Mifflin, 1981.

Lisenco, Y. *Art not by eye.* New York: The American Foundation for the Blind, 1972.

Lowenfeld, V. *Creative and mental growth.* New York: Macmillan, 1957.

Machover, K. *Personality projection in the drawings of the human figure: a method of personality investigation.* Springfield: Charles C. Thomas, 1950.

Martorana, A. *A comparison of the personal, emotional and family adjustments of crippled and normal children.* Unpublished doctoral theses, University of Minnesota, 1954.

May, D. C. The effects of color reversal of figure-ground drawing materials on the drawing performance of cerebral palsy and normal children. *Exceptional Children,* 1978, *44* (4), 254–259

Michal-Smith, H. Identification of pathological cerebral function through the H-T-P. technique. *Journal of Clinical Psychology,* 1953, *9,* 293–295.

Moores, D. F. *Educating the deaf: psychology, principles, and practices.* Boston: Houghton Mifflin, 1978.

National Advisory Committee on Handicapped Children. *Special education for handicapped children.* First Annual Report. Washington, DC: U.S. Department of Health, Education, and Welfare, January 1968.

Petitclerc, G. *The 3-D Test for Visualization Skill.* San Rafael, CA: Academic Therapy, 1972.

Resnikoff, M. and Tomblen, D. The use of human figure drawings in the diagnosis of organic pathology. *Journal of Psychology,* 1956, *20,* 467–470.

Rubin, J. and Klineman, J. They opened our eyes. The story of an exploratory art program for visually-impaired multiply-handicapped children. *Education of the Visually Handicapped,* 1974, *6* (4), 106–113.

Silver, R. A. *Developing Cognitive and Creative Skills Through Art.* Baltimore: University Park Press, 1978.

Smith, S. L. *No Easy Answers: Teaching the Learning Disabled.* Boston: Little Brown, 1979.

Strauss, A. and Lehtinen, L. *Psychopathology and Education of the brain-injured child.* New York: Grune & Stratton, 1947.

Telford, C. W. and Sowrey, J. M. *The exceptional individual* (3rd ed.). Englewood Cliffs: Prentice-Hall, 1979.

Uhlin, D. The basis of art for neurologically handicapped children. In I. Sakab (Ed.), *Psychiatry and Art, Vol. 2: Art Interpretation and Art Therapy.* Basel/New York: S. Karger, 1969.

Uhlin, D. and Dickson, J. The effects of figure-ground reversal in H.T.P. drawings by spastic cerebral palsied children. *Journal of Clinical Psychology,* 1970, *26,* 87–88.

Vernier, C. *Projective Test Production: I. Projective drawings.* New York: Grune & Stratton, 1952.

The Emotionally Disturbed Child and Art 4

Definition and Classification

In this chapter the term *emotionally disturbed* refers to a group of children who exhibit maladaptive social and emotional behavior. Their behavior is so markedly different from other children their own age and from similar backgrounds that they are considered to be socially and emotionally deviant. Emotionally disturbed children are found in every social class and a variety of types of families. Their marked deviation from age-appropriate social and emotional behavior interferes with their own development, the lives of others or both. Their behavior may range from aggressive, acting-out to immature, withdrawn behavior. Although it is easy to recognize these children, it is difficult to pinpoint the cause of their emotional disturbance.

Behavior may be influenced by biological factors (genetic, neurological, biochemical), family factors, school factors, and other group influences or by combinations of these which interact in diverse ways. If any set of causes operated singly, it would be easier to identify the cause and concentrate on treatment. However, it is believed that multiple causation determines a child's behavior. Theories differ as to how this interaction happens. Essentially, the child acts on the environment and the environment acts back on the child. Further, unconscious processes which operate below the level of awareness, contribute to behavior and to the problems emotionally disturbed children experience.

Emotional and social behavior are linked together: our emotional responses influence how we get along with other people and conversely our social experiences affect our emotional status. Children who are emotionally disturbed have both social and emotional handicaps.

The purpose of this chapter is to help teachers/therapists and other personnel develop an understanding of this population of children so that they will be able to develop appropriate strategies for working with them in art situations.

Definition

There is no generally accepted definition of emotional disturbance. Professionals and theorists concerned with this group of socially and emotionally disordered children have selected definitions which meet their own purposes. Hallahan and Kauffman (1982) attribute the lack of consensus regarding a definition for emotional disturbance to:

- Lack of an adequate definition of mental health
- Differences among conceptual models of emotional disturbance
- Difficulties in measuring emotions and behavior
- Variation in both normal and disturbed children's emotions and behavior
- Relationship between emotional disturbance and other handicapped conditions
- Differences in the functions of socialization agents who categorize and serve children
- Differences in social and cultural expectations regarding behavior.

(p. 144)

Labels frequently found in the literature to describe emotionally disturbed children are: psychologically disordered, emotionally handicapped, socially maladjusted, *behaviorally disordered,* and *emotionally disturbed* (the two latter terms the most frequently used). Although the terminology used may differ, there is general agreement that emotional disturbance refers to: behavior that is extreme, not just slightly different from the usual, a chronic problem, not one of short and/or temporary duration, and behavior that is socially and culturally unacceptable (Hallahan and Kauffman, 1982).

According to the Federal definition outlined in PL94–142, serious emotional disturbance is considered a condition which exhibits one or more of the following characteristics over a long period of time, which to a marked degree adversely affects educational performance.

- An inability to learn which cannot be explained by intellectual, sensory, or health factors
- An inability to build or maintain satisfactory interpersonal relationships with peers and teachers
- Inappropriate types of behavior or feelings under normal circumstances
- A general pervasive mood of unhappiness or depression, or
- A tendency to develop physical symptoms or fears associated with personal or school problems.
The term includes children who are schizophrenic or autistic.
 The term does not include children who are socially maladjusted, unless it is determined that they are seriously emotionally disturbed.
 (Federal Register, Vol. 42, No. 163, August 23, 1977, p. 42478)

Kauffman (cited in Hallahan and Kauffman, 1982) has expressed the opinion that the inclusions and exclusions are "unnecessary and silly" (p. 147) that 'autistic' and 'schizophrenic' children *must be included* and that 'socially maladjusted' children *cannot be excluded"* (p. 147). Recently, however, the U.S. Department of Education has eliminated autistic from inclusion under the category of seriously emotionally disturbed.

Classification Systems

Just as there are problems and a lack of consensus about defining emotional disturbance, there is no universally approved system for classifying these children. In fact, some psychologists and educators have viewed diagnostic labels, categories and classification systems as having limited value when translated into educational intervention. They recommend instead of an individual assessment of the child's behavior and situational factors to determine appropriate treatment (Hallahan and Kauffman, 1982).

Dimensional Classification

One approach that has been proposed in recent years is the dimensional classification. The work of Quay and his associates (1979) is representative of this approach. They used behavior ratings by teachers and parents, children's life history characteristics, and the responses of children to questionnaires to derive the four *dimensions* or clusters of interrelated traits: conduct disorder, anxiety-withdrawn, immaturity, and socialized aggression.

Children whose behavior fits the *conduct disorder* category are likely to exhibit such characteristics as disobedience, destructiveness, jealousy, and boisterousness. In an art situation these children may destroy their own work, be uncooperative and refuse direction, blow-up easily when they do not achieve to their satisfaction, use profane language, and disrupt other students as they are working. The life history characteristics associated with conduct disorder include defiance of authority and inadequate feelings of guilt.

Anxiety-withdrawal behavior is characterized by feelings of inferiority, self-consciousness, social withdrawal, anxiety, depression, and feelings of guilt and unhappiness. These children in an art situation may be hypersensitive to any kind of criticism,

feel their work is inferior and worthless, cry easily when upset, and are withdrawn, secretive, and without friends.

Immaturity, a third dimension, is associated with passivity, clumsiness, absent-mindedness, sluggishness, a preference for younger playmates and other characteristics associated with children who are lagging behind their peers in social development. In an art situation these children appear bored, lack initiative in coming up with ideas, have poor concentration, a short attention span, lack coordination, produce work that is sloppy, or may not even have the perseverance to complete an art task.

The fourth dimension, *socialized aggression,* is made up of characteristics such as associating with and being loyal to bad companions, and belonging to a gang. These are the children who are seen infrequently in the art class and when they do come may be involved in incidents of thefts of art materials and other children's possessions.

Although these dimensions are found with remarkable consistency in many samples of children and may provide a relatively reliable basis for description, "they are not an adequate basis for designing intervention programs" (Hallahan and Kauffman, 1982, p. 151). However, they may be helpful to teachers as evidence of behavior problems, when they recommend children for referral.

As we examine these dimensions, we see two basic trends emerging: children with aggressive, acting-out behavior (conduct disorder and socialized aggression dimension) and immature, withdrawn behavior (anxiety-withdrawal and immaturity dimensions). Before discussing the characteristics of the children in each group (aggressive, acting-out and immature withdrawn) it is necesary to state that a given child under different conditions and at different times might exhibit both types of behavior. Also, these behaviors are commonly seen in *all* groups of disturbed children: those with mild or moderate disturbance and those with severe and profound disturbance.

Aggressive, Acting-Out Behavior

Conduct disorders associated with aggressive, acting-out behavior are hitting, fighting, yelling, refusing to take direction, destructiveness, vandalism and extortion. Children who exhibit this kind of behavior are not popular with adults or classmates (except those who are also socially deviant and belong to their group). These children do not typically respond favorably to well-meaning adults who show their concern for them by trying to be helpful. They tend to mistrust and dislike people they live with and have to get along with, and usually for good reason. Many aggressive, acting-out children have experienced life as a vicious cycle: they behave aggressively, their aggressive behavior is then met with frequent shouting, punishment, and criticism, and their response is to be aggressive and act out. The problem goes beyond the child's behavior, it is "the interaction between the child's behavior and the behavior of other people in his or her environment" (Hallahan and Kauffman, 1982, p. 162).

Aggression has been analyzed from many different viewpoints. For example, psychodynamic analysts view aggressive behavior as a symptom of underlying motivations which may be unconscious. In a series of cases where different children may exhibit the same disturbed behavior (e.g., hostility to the teacher), the reasons may stem from a variety of motivations based on the personalities involved. For one child, the hostility may be in response to rejection from parents, for another child it may be a sign of extended immaturity, and for a third it may be related to modeling other delinquents' treatment of their teacher (Morse, cited in Hallahan and Kauffman, 1982).

Behaviorists and social learning advocates view aggression as a learned behavior. Their studies take into account the past history and experiences of the child and motivational factors based on the anticipated consequences of aggression. They, however, feel that aggression is learned and they work from the premise that it is possible to identify those conditions which result in the negative behavior. They believe children learn many aggressive behaviors from such sources as siblings, friends, television, movies and by observing parents.

The most helpful techniques in teaching these children to respond more appropriately have been techniques that provide examples (modeling) of nonaggressive responses to aggressive-provoking situations, that help the child rehearse or role-play nonaggressive behavior, that prevent the child from getting positive responses to maladaptive behavior, and by punishing aggressive behavior with as little counteraggression as possible. Techniques such as "time-out" or social isolation for a brief period are examples of nonaggressive responses, whereas yelling, hitting, and vindictive punishments continue the aggression cycle. Punishment may actually increase maladaptive behavior when it is aggressive, inconsistent, delayed or when no positive alternative to the child's aggressive behavior is offered. It has also been found that a highly structured and predictable environment is of the greatest benefit to these children.

The behavior of aggressive, acting-out children is a very serious matter; there is a very high probability that the child who is socially unacceptable will later become a social misfit as an adult. "When we consider that conduct disorders and delinquency are highly correlated with school failure, the importance of meeting the needs of acting-out . . . children is obvious" (Hallahan and Kauffman, 1982, p. 163)

Immature, Withdrawn Behavior

Emotionally disturbed children who exhibit characteristics of immaturity and withdrawn behavior are typically infantile in their ways or are reluctant to interact with other people. These children internalize their unhappiness and problems. They are fearful, sad youngsters who are anxious, especially in social and learning situations. Often they are angry, but this anger is not openly demonstrated. Their approach may be termed *passive aggressive*. They exhibit their anger through school failure and noncompliance. Even though they appear quiet, passive and are not troublemakers, they need help. Their refusal to carry out directions, participate in group activities or to accept leadership are demonstrations of noncompliance. They often have severe feelings of inferiority and self-consciousness. Like the acting-out children, they do not establish relationships or interact with others. Often these children are passively neglected or ignored by their classmates and adults.

Some withdrawing children experience school phobia. They do not want to attend school and they appear highly anxious when there. Their anxiety may be expressed through physical symptoms such as vomiting, allergies, dizziness, nausea and the need for an excessive amount of sleep.

Classification by Severity

Children who are emotionally disturbed are also classified by the severity of their disturbance: mild, moderate, severe/profound. Traditionally, children with mild or moderate disorders have most often been referred to as having a neurosis or psychoneurosis; children with severe/profound disorders are usually said to have psychosis, schizophrenia, or autism. According to Hallahan and Kauffman (1982), "the distinction between the mild-moderate and severe-profound levels of disturbance cannot be made entirely clear in any classification system presently being used" (p. 151).

Mildly and Moderately Disturbed Children

Most of the children described as being emotionally disturbed fall ino this category. Surveys of school populations show a relatively low prevalence of disturbance in the early grades, with a peak in the middle grades, and a decline starting in junior high school and continuing through the last years of high school (Morse, Cutler and Fink, cited in Hallahan and Kauffman, 1982). Both aggressive, acting-out and immature, withdrawn behaviors are seen in this group of children.

Mildly and moderately distrubed children can generally be managed by parents and teachers with some special services provided by a mental health specialist such as a clinical psychologist, counselor, family therapist. Some of these children are fortunate to have the services of an art therapist as well. Those with mild or moderate disorders

are taught in regular classes if their teachers receive appropriate consultive help. In cases where it is simply not possible to keep the child in a regular class, the current strategy is to place the child in a resource room for part of the school day, or in a self-contained classroom or special school for a brief period of time. The goal is for normalization and the child's quick integration into the mainstream.

The curriculum for most mildly and moderately disturbed children is the same as for normal youngsters. Basic academic skills such as reading and math are taught, but methods have to be used which will help these children learn more effectively. For some children, the pattern of school failure is so severe and longstanding that they have not developed the skills to handle academic learning. Their recourse is to withdraw and daydream or lash out in anger and frustration. Methods such as task analysis (breaking the material down into steps that are presented one at a time) and lessons of short duration which are sequenced and presented concretely and clearly, may help break their "failure syndrome." Other children may generally understand the content, but they are unable to process it, sometimes because of general anxiety related to the specific content, e.g., the subject animals of which they may be afraid. Alternative approaches to presenting the material may be tried, such as one-to-one instruction or the content may be changed if possible. Each child presents different problems; there is no one technique for everyone or even any foolproof aproaches that are guaranteed to work. Teaching the emotionally disturbed child may to some degree be a process of trial and error.

Of equal importance to academic teaching is the teaching of social skills and affective experiencing. These children cannot be expected to learn such skills without instruction, as it has been seen they have not learned it through the natural process of socialization. How to manage one's feelings and behavior, how to get along with classmates and teachers should be an essential component of the curriculum.

Severely and Profoundly Disturbed Children

Children with severe and profound disorders have been categorized as psychotic, schizophrenic or autistic. These children require intensive and prolonged care. They are most frequently taught in special self-contained classes in special day school or in residential institutions for extended periods of time. Many severely handicapped children are untestable, but when they are given achievement and intelligence they score on a retarded level (Hallahan and Kauffman, 1982).

For the most part, severely and profoundly disturbed children must be instructed on a one-to-one basis because of such difficulties as poor attention, lack of response and poor interactional skills. They may be able to work in small groups after receiving intensive individual instruction. The curriculum for most of these children must be extremely basic, closely resembling the program for severely retarded children. It involves teaching the skills of daily living, language and communication skills, and beginning academic skills.

The trend now is away from placing severely and profoundly disturbed children in residential institutions, but educating them in special self-contained classes in public schools or special day schools. Since the emergence of interventions like behavior modification, more and more educators are convinced that these children can be managed directly and effectively without long years of probing into unconscious motivations or causes for their behavior (Lovas and Koegel, cited in Hallahan and Kauffman, 1982). Realistically, however, even with the most effective interventions, many of these children cannot be expected to progress to the point that they can be mainstreamed into regular classes with their normal peers.

Autistic Children

Some of the characteristics associated with autistic children are: 1) speech deficits, appearing mute or echolalcic (meaningless parroting of speech of others); 2) social deficits: they tend to be unaware of others or else they interact in bizarre ways; 3) lack

example, to get a child to stop shouting in class, the child is not recognized or paid attention to unless he lowers his voice. His attempts at getting attention are not rewarded (reinforced) until his behavior is appropriate (speaking in a normal tone). In this situation the operant (shouting) is controlled by the stimulus (not attending to the child). The application of a positive stimulus (recognizing the child) immediately following a response (lowered voice) is called positive reinforcement. Ordinarily, teachers pay attention to children when they jump out of their seats, disrupt others, or shout, by scolding them. Such behavior may actually reinforce disruptive student behavior because the children are getting what they want: "attention." To change the situation, the teacher must give positive reinforcement when the child is acting appropriately: remaining seated, not bothering others, or speaking in an appropriate tone of voice. This may take several steps and it may be necessary to reward the child at various stages in his behavioral change. Behavior modification requires identifying the behavior that is inappropriate, analyzing the events that are rewarding this behavior, and changing the situation so that the child is no longer being rewarded for maladaptive behavior.

In some cases, social approval by the teacher is sufficient. In other cases (sometimes early in the behavior modification program), a token economy is introduced. In this arrangement, the child is given points or tokens (e.g., poker chips) for appropriate behavior. After the period or class, the child is told how many points or tokens he has earned and specifically how and when it was earned. Later in the day, the points or tokens can be exchanged for rewards such as candy or toys. Tangible (extrinsic) rewards are designed as a motivation to encourage acceptable behavior. When it is established, it is hoped that intrinsic rewards (self-satisfaction, accomplishment) will be all that the child requires for appropriate behavior.

The usual procedure in behavior modification is to establish goals and organize tasks in small steps so that the child can experience continuous success. The child can then receive positive reinforcement for each step or part of the total task as it is completed. As the child completes the task successfully in a specified amount of time, the teacher praises the child (social reinforcement) and gives him a mark, points, or tokens. The theory is that in this way the child will be able to work at assignments for longer and longer periods and to accept more difficult ones.

Academic Achievement

Emotionally disturbed children are—as are children with other handicapping conditions—a heterogeneous group. We may know the general behavior characteristics of children who are behaviorally disordered, but each case must, nonetheless, be considered and treated separately because the existence of certain behavioral patterns does not automatically guarantee other behavioral problems. These individual differences must be kept in mind when generalities about the academic achievement of mild and moderate emotionally and socially handicapped children are made.

As a group emotionally disturbed children do not do as well as their peers who are not emotionally disordered. They usually do not achieve academically on a level commensurate with their mental and chronological age. School behavior such as daydreaming, refusing to do work, or bothering their classmates as they attempt to attend to a task, prevent these children from taking the opportunity to learn what is being presented, to being a participant in instruction, or to understand the content of a lesson. Getting their inappropriate behavior under control is a necessary prerequisite before these children can attend to academic tasks, e.g., spelling, reading, math. Strategies such as behavior modification which rewards the children for positive behavior, e.g., sitting in a chair, concentrating on a task, or completing short assignments, can be used as reinforcement.

Strategies for Art Programming

Art Education and Art Therapy: Differences and Similarities

While the roles of the art therapist and art teacher* are not identical, both have much in common. "Both are trying to develop the growth of an individual to full ego realization, to come to grips with and master techniques which are intimately bound to the inner psyche" (Pasto, cited in Rubin, 1978, p. 207). Also both support the power of art as expressive and integrative. How they attain their goals, however, is somewhat different.

The art therapist may use different kinds of treatment with the emotionally disturbed child, such as psychodynamic, gestalt or existential treatments (Anderson, 1978) within a counseling or classroom setting.† He/she is qualified to interpret the form and content of the art products of these children. On the other hand, although a teacher should be aware of the psychological signs a child's can manifest, "probing [and interpreting] lies outside the province of the teacher" (Shaw, cited in Rubin, 1978, p. 208). The art teacher provides a supportive and therapeutic environment through the introduction of art experiences that develop self-awareness, self-confidence, self-esteem and self-growth (Mattil, cited in Rubin, 1978, p. 208), and by using strategies that meet the needs and abilities of the child. To determine the appropriate strategies, activities, media, and learning environment, the art teacher needs a basic understanding of the child's behavioral patterns.

The difference between the art teacher and art therapist is clarified by Lowenfeld when he states

> It is neither the interpretation of symbols, nor a diagnosis reached by speculative inferences based on certain symbols, with which an art education method deals. *Teachers are neither prepared for this type of diagnosis or therapy nor do they have the proper background for it.* What they should be prepared for is adequate motivations which free individuals from their restrictions in expressing themselves, and that includes the body-image. The question arises as to the kind of stimulation which is used for therapy. It should be stated here emphatically that *a motivation used in an art education therapy only differs from any other art motivation in degree and intensity and not in kind.* . . . art education does not deal with speculative inferences in the interpretations of concepts. (Italics-V.L.) (1957, p. 435)

Anderson further qualifies the distinction between art-making process for therapeutic purposes (as the art teacher uses it) and art for psychotherapeutic intentions or for psychoanalytic diagnosis (as the art therapist may use it).

> The use of art as a vehicle for psychotherapy and the use of art as therapy. Art as therapy implies that the creative process can be a means both of reconciling conflicts and of fostering self-awareness and personal growth. When art is used as a vehicle for psychotherapy, both the product and the associative references may be used in an effort to help the individual find a compatible relationship between his inner and outer worlds.
>
> (Anderson, 1980 p. 20)

A commonly held notion regarding the difference between art therapy and art education is that art education is product-oriented and art therapy is process-oriented. Edith Kramer, an art therapist, agrees that "art therapy is distinguished from art education by a much lower rate of finished work" (1979, p. 37). This occurs not because art therapists do not value finished products, but because of extremely handicapped

*The term art teacher is used to designate any teacher responsible for the teaching of art. For our purposes, it includes special education, classroom, and resource teachers.

†Interpretation of children's drawings is discussed in Chapter Five: Recognizing Emotional Disturbance in Children. Specific therapeutic treatments within the province of the art therapist are described in Chapter Six: Children in the Process of Art Therapy.

children's need to often "endlessly experiment with art materials, vent their anger upon them, or desert their work before it is finished" (p. 37). When, however, the creative process does not falter and the child's work culminates in an art product, art therapists recognize that it "may wield an important influence on both its maker and its audience" (p. 37).

Art Programming for the Mildly and Moderately Disturbed

Objectives

Art experiences can contribute to the emotionally disturbed child's emotional, social, cognitive, and expressive growth. To make art programming meaningful, it should provide:

1) a channel for emotional expression through a concrete art form such as painting, drawing, collage, clay modeling.
2) a constructive outlet for the release of tensions and the expression of emotions through art techniques which incorporate subskills such as hammering, incising, squeezing, bending of materials.
3) a feeling of belonging to a peer group through interaction with peers from sharing of materials to involvement in group activities.
4) a sense of being part of the school environment through the display of work in the classroom, hallway, and school art gallery or main exhibit cabinets and areas.
5) opportunities for social development through the learning of appropriate social behaviors when interacting with peers or adults or persons of authority.
6) opportunities to develop good work habits such as the use and care of art materials, respect for the rights and property of others.
7) opportunities for exploration, experimentation and production of art forms with various media, materials, equipment, techniques and themes.

Creating a Learning Environment

Before children who are emotionally and socially handicapped can participate productively in art activities, it is necessary to set up an environment that is conducive to their learning and functioning. Elements of such environment include strategies for classroom management, behavior management, setting up limitations in all aspects of art programming, and selecting appropriate activities.

Classroom Management

A tolerant, but well-organized and controlled learning environment will help these children establish controls and organization in their own lives. The key to maintaining an organized environment is to develop modes of operation that reduce the children's possible frustration, confusion, and consequent emotional eruptions. Checking to see that all tools are in working order prior to their use in an art activity, having the necessary materials within easy reach at the start of the class and preparing an abundance of extra materials are all examples of strategies for neutralizing the learning environment. The labeling of storage areas for materials and tools for easy access and collection also aids in maintaining the structure of the environment.

Routines and rules should be established at the beginning of the term and consistently maintained so that the children clearly understand what is expected of them. Routines may include getting ready for an art activity, distribution and collection of materials, the working period, as sharing, and clean-up. An example of a class rule may be that everyone has to try the day's art activity for a specified amount of time. After that period, the child may request another art activity or select an activity from several choices. Watching other children work or sitting quietly may be the option selected. It is suggested that a time limitation be given on watching or resting before the child begins an art activity again (Anderson, 1978).

Classroom management can also be maintained by giving clear explanations about what is acceptable and unacceptable behavior, with the consequences for inappropriate behavior explicitly made. Anderson (1978) suggests that a firm, but not rigid, approach be used when working with behaviorally disordered children.

Behavior Management

Emotionally disturbed children who exhibit maladaptive or inappropriate behavior are generally in a program which utilizes the behavior modification or psychoeducational approach. It is important to follow the educational strategy in the art classroom that is being used in the rest of the child's program so that behavior interventions are consistent.

Typical behavior problems and possible behavior management procedures that can be utilized in the art class are suggested:

1) If a child makes distracting noises during an art activity, give the child a point every time he does not make noise during a specified amount of time, e.g., ten minutes. At the end of each ten-minute period acknowledge the child's good behavior and add another point. After accumulating a certain number of points, the child is given a tangible award, or an opportunity to select a favorite art material or technique for the next activity.

2) When a child has a temper tantrum during an art session, place him in a section designated as "time-out" as soon as the tantrum begins. When he has been quiet for ten minutes, allow him to return to his work.

3) When a child pokes another child with an art tool such as a paint brush, ignore the child who does the hitting and go to the child who has been hit. Give positive attention and comfort to this child, instead of scolding the child (negative reinforcement) who has done the hitting.

4) In cases where a child interrupts other children while they are working, allow the child to spend some time observing another child working or resting (e.g., five minutes) with the specification that the child does not bother other children and will return to work after the ten-minute period.

5) When a child responds to an art activity by saying, "I don't want to do this" or "This is baby stuff," he may be trying to establish his position in the group, testing the teacher/therapist, or exhibiting insecurity about the situation. Possible responses are redirection, such as suggesting another medium to work with (pencil instead of charcoal); starting the work for the child after agreeing that it is a difficult assignment; suggesting that when the first activity is completed, or worked on for a designated period of time, the child can have a free choice activity.

Other strategies may be to confront the child with his action—let him know that he is interfering with the class rather than redirect him, to possibly ignore his behavior, and/or gaining his attention by focusing on the positive behavior of another child who is (modeling) more appropriate responses.

6) If a student has a habit of tearing up his own work, be sure to watch him for signs of frustration. At the point when he is about to tear his work, remove the work if possible before the destruction occurs. Encourage his effort, offer him another sheet of paper if it is a drawing activity (indicating clearly that this is the last sheet) or enough materials to try the activity another time. Save each work removed in this way; there may be a time that the work can be reviewed to demonstrate accomplishment in art. Another alternative to giving the child more materials is to have him work on the back of a sheet of paper or to salvage the materials from a destroyed work in progress.

Limitations

Limitations is a key concept in working with emotionally disturbed children. In the art class limitations may apply to materials: limiting the amount, kinds, and choices given; limiting the number of operations or steps for each art activity, or limiting the duration of an art activity. *Choices,* however limited, should be incorporated into each

art activity. They may range from deciding between two colors or materials, or deciding on a theme for a painting or collage. Choices, no matter how limited, require decision-making and the organization of ideas and feelings—factors which contribute to social, emotional, intellectual and artistic growth.

During the early part of the school year or term, activities should be selected that can be completed in one session or within part of the session (about twenty minutes) that have a high success factor. After the children have become accustomed to procedures in the art class (behavioral and expressive) activities can span several sessions. Examples of such activities requiring several sessions are linoleum printing, weaving and stitchery.

Williams and Wood (1977) offer five basic rules for an art group:

1. Children are allowed to talk, but they must do some art work (doodling is accepted as art work).
2. If they use supplies, they must put them back.
3. Children are not allowed to "mess with anyone else's art work" (p. 86).
4. If they mess up their art work, they are not allowed to throw it away. They are instructed to put their names on their work and give it to the teacher with instructions as to whether he/she should show it to the group or put it away. When the children have followed these instructions they may have another sheet of paper. If this procedure is followed, the children may have as many sheets as they need and do as many pictures as they like.
5. Children are clearly instructed that if they want to be "mean" during art time, they can, but not in the art class.

Selection of Art Activities

The selection of art activities should be based on realistic expectations concerning the child's behavior and capabilities. Art tasks should be well within the child's capacity, but still offer somewhat of a challenge. The goal is to have the child experience success and pride in what he has accomplished.

One criterion of the appropriateness of an art activity is the task's complexity. Complexity of an art activity may be determined in two ways: 1) the number of steps or operations needed to complete the task; 2) the complexity of the activity itself. Children who suffer from a short attention span, anxiety, or a low frustration level need activities that are not so complex as to cause frustration.

The number of steps for an art activity may either be decreased or presented in small increments, each increment to be completed before another one is presented. Through the process of task analysis, the steps required to complete the task may be determined.

The number of steps does not always determine the complexity of an activity. Whereas a collage requires several operations (selecting, cutting, arranging and pasting), it is much more of a controlled experience emotionally than painting, for example, with water colors or poster paints and, therefore, can be considered to be a less complex activity although it includes several operations (Lowenstein and Walsh, n.d., p. 90).

As the child's skills develop, his ability to attend to tasks increases, and he becomes more emotionally stable and art activities that are less structured may be introduced as well as those that span several sessions. Generally, activities should progress sequentially from simple to more complex. To maintain interest, yet to reinforce skills, materials may be varied for a series of similar activities. For example, a series of drawing activities may include the use of pencils, markers, crayons, cray-pas; stamping activities may progress from found object stamping to vegetable stamping and finally to designed stamps (cut felt shapes that are mounted on wood blocks). The uses for the stamping activities may vary from book covers, place mats, to wall hangings and personal items such as stamped t-shirts with fabric paint.

Although success, as stated earlier, is an important factor for the emotionally disturbed child, an art activity should provide some degree of challenge and be age-appropriate. Activities that are termed "babyish" because the child feels he is too old for the activity will not inspire him to become involved. As with all aspects of art programming for exceptional children, it is the teacher/therapist's knowledge about the child which will determine appropriateness of activities.

The Teacher/Therapist as Facilitator

In previous sections, we have discussed the objectives for art programming, classroom management, behavior management, limitations, and the selection of art activities. All of these aspects of art programming are essential; however, it is the teacher/therapist who facilitates (orchestrates) their implementation.

While characteristics such as understanding, sensitivity, empathy, flexibility, and patience are important when working with all exceptional children, these traits are *crucial* with emotionally disturbed children. Being sensitive to the needs of the child means being aware of signs that signal frustration, loss of interest, anxiety, or a call for help. Immediate intervention can prevent the child's frustration may lead to an explosive outburst. Despite careful monitoring, the teacher/therapist may not be able to prevent eruptions due to the unpredictable nature of the disturbed child in art.

The teacher/therapist working with the disturbed must be able to tolerate a great deal of unpleasantness and rejection without becoming counteraggressive or withdrawing. Most of the children he will teach will be social rejects; they will probably not respond positively to overtures of kindness and thoughtfulness (if they did, they would not be considered disturbed). Despite the lack of return of caring and decency by children, teachers/therapists must maintain trust in their own values and remain confident in their teaching and interventions approaches.

It is recommended that the teacher maintain a liaison with the child's special education teacher, crisis intervention teacher, or counselor to be apprised of behavioral strategies and the child's progress (or regression). It is quite appropriate in consideration of the responsibilities of the teacher that Hobbs (cited in Hallahan and Kauffman, 1982, p. 173) refers to "teacher-counselor" in reference to teachers in a program for the emotionally disturbed.

Art Programming for the Severely and Profoundly Disturbed

Generally severely and profoundly disturbed children have to be instructed in art individually. They do not work well in a group because of their great difficulty in paying attention, responding and behaving in an interactive situation. The teacher/therapist working in art with severely and profoundly disturbed children must have more than empathy and a desire to help these seriously handicapped children. Special skills are needed in doing art with these children if it is to amount to more than just custodial care. For example, skills in using behavior modification techniques are essential for teachers working with these children (Hallahan and Kauffman, 1982). Art programming for most severely and profoundly disturbed children must be very basic—in many respects it resemble the art curriculum for the severely retarded. Many hours will have to be spent repeating experiences and making what seems to be sometimes imperceptible or small gains. Children who are severely and profoundly disturbed may respond to an art activity with distaste, with a lack of response, or with a general rejection of any intention by the teacher/therapist to reach them. To work with these type of children, the teacher/therapist must be ready and willing to persist.

In the book *Developmental Art Therapy*, Williams and Wood (1977) describe an approach that is suitable for teaching art to severely and profoundly disturbed children in self-contained classes. They recommend a structured environment, a consistent routine, controlled use of materials and a controlled vocabulary. Art activities are designed to arouse sensory-motor learning. The objectives for this stage of art are: for

the child "to trust his own body and skills, to use words to gain needs, to trust an adult sufficiently to respond to him, to respond to the environment with processes of classification, discrimination, basic receptive language concepts, and body coordination" (Wood, cited in Williams and Wood, 1977, p. 15).

The following suggestions are offered for conducting an art activity:

1. The art activity should be extremely short, ending when the child has participated pleasurably to some degree, either on his own or with help from the teacher/therapist.
2. An art activity can begin with short one-step procedures that have instant results. For example, a hand print with tempera paint.
3. A second activity should be planned in case the first one fails.
4. Brief directions with concise visual demonstrations should be made, paired with a controlled vocabulary.
5. During the early weeks of a program, the children should be physically moved through each art activity. A controlled vocabulary should be used to reflect to the child what has been done. (This is similar to the technique described in working with severely mentally retarded children in Chapter 2.)
6. When the children become adjusted to the art routines and the use of materials, they should be shown the materials and asked to name them in order to receive them. For autistic children, who will not speak, eye contact with the material or a gesture should be considered sufficient (with the objective that language should at a later date replace the gesturing).
7. When it is noted that interest in the activity is waning, the teacher/therapist should touch the work and praise the accomplishment. Lack of interest may signal the time to change to another activity or it may mean that the art session should be terminated.
8. During the course of the art program, there should be a change from reflecting to the child what he is doing, such as "Susan is painting" to eliciting responses from the child, for example, "What color do you want, Susan?" or "Who wants another paint brush?".

Although the developmental objectives of the art program are to have the child move from random marks on a paper to intentional scribbles or drawings, from arbitrary sounds or grunts to descriptive words, it is recommended (as it is for mildly and moderately disturbed children) to accept what the child can do and offer verbal, physical or tangible praise.

Some of the materials recommended for working with these children are: Colored markers, tempera paints, finger paints, clay, crayons, cray pas, soap for body painting. For sensory lessons, in taste, materials such as candy, spices, fruit, instant puddings, are suggested.

Some of the materials recommended are:

Art Activities:	colored markers, tempera paints, finger paints, clay, crayons, cray pas, soap (for body painting)
Sensory Activities:	Taste: candy, spices, fruit, puddings
	Hearing: records, lights, clicking
	Smell: familiar foods, soaps, toothpaste
	Touch: fabric, fur, sandpaper, cotton balls

Art Programming for Autistic Children*

To gain an understanding of art programming for autistic children we will review an art teacher's experiences in working with Cory, a ten-year-old autistic boy in a self-contained classroom.

*For discussion of art therapy with autistic children refer to Chapter Six: Children in the Process of Art therapy.

Although each child's involvement in art is different, a description of Cory's attitude and response to art activities will give some sense of the autistic child in an art program. Dianne Le Roy, the art teacher who worked with Cory, stated:

> The first few weeks, Cory expected an edible reinforcer for almost every effort he made in an art activity. As the weeks went by, this tendency did decrease somewhat, depending on the particular activity and the amount of hyperactivity Cory was feeling that day. (1980, p. 27)
>
> When I worked with Cory, I talked constantly, explaining and naming objects, colors and what we were doing. When Cory wasn't interested in what I had for him to do, he would usually go sit near the window by himself. In this instance I would take clay and work next to him. Other times he would find an object, such as a can and twirl it expertly. At these times I would join him with my own can and twirl (not so expertly) near him and talk to him about what he was doing and what I was doing, treating it like a game. Sometimes Cory would stop and watch me twirl my can. (p. 28)

Cory showed little interest in the markers he used for drawing throughout the ten weeks of the program and would stop after each scribble for an edible reinforcer. He showed greater interest in tempera paints (primary colors), although he also wanted an edible reinforcer after he worked with the paints for a short time. His attention span during painting increased from 15 seconds to about 1½ minutes, from a "perfunctory swish of the brush for a reward to a real interest in what was happening" (p. 27). He enjoyed finger painting with shaving cream on black paper more than with regular finger paints. After working for a few minutes, he would wash his hands and come back for more. He would verbalize his desire for more paper by voicing "p-p-p" when it was held up.

Suggested Art Media, Materials, and Activities

The suggestions for the selection of art media, materials, and art activities in this section are planned primarily for mildly and moderately disturbed children and will be presented under the broad headings of *Artistic Development, Social Development,* and *Cognitive Development.* Within these categories, the following topics will be introduced: 1) Selecting Art Media, Selecting Art Activities; 2) Group Art Activities, Environmental Activities; 3) Art Activities and Math, Art Activities and Science, Art Activities and Social Studies. This approach is consistent with the Psychoeducational Approach which recognizes the importance of placing "emphasis on meeting individual needs of the child" and "reliance on projects and creative arts" in the emotionally disturbed child's total curriculum (Hallahan and Kauffman, 1982, p. 169).

Artistic Development

Emotionally disturbed children are a heterogenous group, and as in all aspects of their functioning, respond differently to art media and art activities. In the selection of art media and activities, teachers and art therapists may have different objectives. In a classroom situation, the teacher's objective is to provide the child with the most conducive conditions for artistic expression and to try to avoid situations that will provoke highly emotional responses. In contrast, in a therapeutic situation, the art therapist may gain valuable insights about the child's behavior (such as his responses to a sense of loss of control) through the child's interaction with art media or in his response to an art activity.

This is not to say that art therapists intentionally select situations that will provoke emotional outbursts, or because of their evocative power. But when these occasions do arise, they may not be squelched because they offer opportunities to gain greater understanding of the child's functioning. The decision about what kinds of activities or art media to introduce depends on the type of behavioral or emotive responses that need to be dealt with in therapy.

Laurie Wilson in the introduction to Edith Kramer's book *Children and Art Therapy* describes the process that may go into an art therapy situation:

> In the making of a single object different kinds of functioning may come into play: a child may progress from precursory playful experimentation to formed expression, may regress to chaotic discharge, retreat into compulsive defensive work, and move back again to formed creative work. Although the art therapist's goal is helping people to produce work that is both expressive and formed, there are times when creative work is out of reach and situations when other modes of functioning are more helpful to the individual. (Wilson, 1979, p. xxxix)

Selecting Art Media

Art media may be categorized according to its basic "fluid" or "resistive" qualities (Lowenstein and Walsh, 1978, p. 51). Examples of fluid media are water color, finger paints, tempera paints; examples of resistive media are wood, clay, or chalk on sandpaper.

Fluid media such as water color on wet paper or thinned tempera paints "fosters the awakening of unconscious fantasy" (Lowenstein and Walsh, 1978, p. 51) because the colors flow into one another in imaginative patterns. This may cause a great deal of anxiety to the child who feels a loss of control, may mean not remaining intact. The child who has to maintain a very strong hold on his impulses may attempt to work with a fluid medium such as tempera paints in a very rigid manner, in order to contain and control it. Due to its fluid properties, this is not completely possible. In response to his frustration the child may refuse to continue working, tear up his work, spill the paints, or throw the paint brushes. For these children, drawing rather than painting is suggested until they can deal with art media more neutrally. Pencils, crayons, colored markers are tools which are suitable as the child can carefully delineate the areas and control the material he is working with. Collage activities which incorporate the use of materials which can be methodically and carefully placed on a background may also service the need for control of both the inner and outer experiences.

Children who lack the boundaries to provide inner controls or who have the need to work in a more regressive stage will work with fluid media like paints or even a more resistant medium like clay by smearing it. When these children use paint, they tend to go beyond the edges, do not establish linear boundaries, or use the paints solely for its color mixing properties (which they do directly on the page).

Some media, especially tactile media, tend to encourage acting out, whereas drawing tasks elicit more appropriate behavior and may result in more symbolic expressions (Lowenstein and Walsh, 19, p. 91). Media such as clay or chalk on paper, which required more aggressive energy, may give way to aggressive behavior. The child's early experiences with these media will inform the teacher about the desirability to continue or discontinue their usage.

Selecting Art Activities

For children who are anxious and withdrawn, the choice of the art activity may mean the difference between their working or not. Drawing for these children may inspire anxiety (not knowing what to do, or being afraid to get started), whereas paint explorations or working with collage may be a less fearful experience. To eliminate fear of the blank piece of paper in drawing, another option is using "starter sheets." These are papers which have visual clues pasted to them such as heads, sports equipment or objects. This technique can achieve two objectives: 1) the visual clue can take the initial fear out of starting with a blank page; 2) the visual clue can trigger a host of visual associations and ideas which can then be represented.

Social Development

For the emotionally disturbed child, learning social skills in an art situation is as crucial as developing expressive competencies. In fact, the two are completely interrelated and affect each other. Learning how to manage one's feelings and behavior and

how to interact with peers and teacher are important parts of social development. However, as has been mentioned earlier in this chapter, children with emotional disturbance do not develop appropriate socialization skills naturally during the course of their development; therefore, these skills must be taught directly. Participation in group art activities is one method of building socialization skills.

Before planning cooperative activities, however, it is important for the teacher/therapist to know the emotional make-up and capabilities of the children with whom they are working. For some children, interaction with others may be limited just to the amount of time necessary to ask for more materials or to observing as part of a group, a brief demonstration by the teacher/therapist prior to an art activity. In order to determine the level of interaction a child is ready for, it is necessary to be "in tune" with the child and with the situation. Even with the greatest sensitivity to the child's emotional needs and present capabilities and careful decision-making, it may be necessary, because of the child's unexpected response to group involvement, to revert back to an individual, rather than a group venture. It must be remembered that one aspect of emotional disturbance is unpredictable behavior.

Building the socialization abilities of emotionally disturbed children is an important goal and strategies such as behavior modification in the art class may aid towards its realization. Objectives related to socialization growth can be also incorporated into the child's Individual Education Program (IEP) under an area designated for Art or under a section titled Social/Emotional Behavior. Objectives may refer to such elements as extending the time spent communicating or working with other children, sharing, and/or taking turns.

Group Activities

The transition from individual to group activities must be carefully considered in regard to the kind of involvement the number of students the child interacts with, and the duration of the interaction.

A child's involvement in a group activity may begin in the early stages with his making an individual contribution to a group effort, such as a model or mural with the theme "My Neighborhood." This may later extend to working with a partner and finally to a small group of three or four children. The selection of the group members must be carefully considered in regard to group dynamics. Power plays or clashing of personalities may aggravate the emotionally disturbed and lead to an outburst of anger. Involvement in a partner or small group activity should begin with several minutes (5–10) and based upon the child's response be extended. Prior to the planning of group involvement, it is suggested that the teacher confer with the child's special education teacher or crisis intervention counselor and review the short-range objectives in the child's IEP. The child's behavioral pattern in art situations will also provide a good gauge for the use of group activities as a means of social growth.

Environmental Activities

Aggressive, acting-out children tend to feel alienated from their environment and may partake in activities which focus on defacement or destruction of the environment. These activities include graffiti, marking up billboards and signs, or destroying private or public property. Art activities which involve "acting upon" or changing the environment may help rechannel their energies. Activities may range from individual contributions to school or neighborhood art exhibits to participation in a group sculpture in the schoolyard or local park. Other activities are murals on the facade of the school, neighborhood buildings or fences, or the decorating of local store windows prior to holidays.

Cognitive Development

Art activities can concomitantly enhance artistic growth and reinforce skills and concepts needed in other areas of the curriculum such as math, social studies and sci-

ence. While this is not always possible, the objective is to maximize the opportunities for such integration to be feasible (Anderson, 1978). There are also times when an art as supplementary activity can clarify material being learned in academic areas. Examples are drawing of maps in social studies, drawings in science to graphically demonstrate the stages from a seed to a plant, or diagrams of experiments. In math, the child may develop his own learning materials such as drawing of *sets* to learn math concepts.

Art, math, social studies, science, and language are not isolated aspects of living or learning; fragmenting these subjects also serves to fragment the child's learning process (Anderson, 1978). For the emotionally disturbed child particularly, art activities which reinforce skills and concepts common to both art and academic subjects may be very valuable and facilitate learning. This approach is valid if the teacher/therapist always retains the authenticity of the art experience.

Art and Math

To reinforce math skills such as counting, classifying, sorting, comparing, contrasting, and ordering, art activities which incorporate these skills can be introduced. Activities such as jewelry-making with beads incorporate all the skills mentioned above. Other activities that foster these skills are stamping activities, weaving activities, and collage activities. These activities also strengthen concepts of patterning, odd-even, measurement, proportion and line and shape awareness.

It is impossible within the limitations of this chapter to list many art activities which would foster skills and concepts in math, science, or social studies. It is recommended that the teacher determine the skills and concepts common to art and academic subject areas on which they wish to concentrate and refer to the art activities discussed in this book, particularly Chapter 9: Art Activities and Procedures. Source books suggested at the end of the chapter can also provide ideas for integrative activities.

Art and Science

Attitudes considered important in science are curiosity, inventiveness, critical thinking and persistence (Anderson, 1978, p. 125). These same attitudes are indispensible to expressive and artistic growth in art. In an art activity, exploring the qualities of a new material is an example of curiosity, finding a new way to attach forms in a construction is an example of inventiveness, and staying with the construction until the problem of how to attach forms is resolved is persistence—all examples of the use of attitudes common to art and science. Other behaviors such as exploration, experimentation, inquiry, discovery also take place in art situations.

Art activities can also be developed that not only involve scientific attitudes, but that are more directly related to elementary science curriculum. The design, assembly, and flying of kites can teach concepts about wind changes; stained glass windows which are constructed out of black construction paper and colored pieces of cellophane can be used to teach concepts of color mixing, light, and the differences between opaque and transparent materials.

The use of heat to melt crayons in an activity whereby broken crayons are placed between two sheets of paper and then ironed, illustrates how a change of temperature can affect the change of materials from solid, to liquid, and back to solid. Nature collages and weavings offer opportunities to select, observe, organize natural materials into art forms. Drawings of various plants, leaves, and flowers both strengthen drawing and observational skills.

Investigating animals is part of the elementary school science curriculum. Art activities can be introduced that teach children how an animal moves, how it eats, what sounds it makes, how it lives, etc. Activities with an animal theme can range from collages incorporating magazine pictures of animals, drawings which combine mag-

azine pictures of animals with drawn environments, papier mache models of animals, models constructed with plasticene and found materials which include animals in their natural habitat, animal puppets, etc.

Art Activities and Social Studies

Just as with science, the social studies curriculum emphasizes exploratory, discovery, methodology (Siegel, cited in Anderson, 1978, p. 152). Social studies curricula focuses on ideas, relationships, behaviors of individuals and groups of persons—all abstract concepts that can be concretized and clarified through art activities. Themes which relate to the self, family, the home, the neighborhood, transportation, communication, and the world of work—all serve to clarify these abstract concepts. Art activities can help emotionally disturbed children differentiate between the natural and person-made environment, between modes of travel, and other cultures. These kinds of topics are particularly relevant to emotionally disturbed children who tend to be not only isolated from their peers, but also from the external environment. Drawings from observations of neighborhood scenes as viewed from the window, photomontages and collages on community themes, three-dimensional models of a neighborhood or highway (to demonstrate traffic patterns) and the construction of vehicles.

This is just a sampling of activities that can relate art and social studies. For further ideas for art activities related to social studies or science, we recommend that the teacher review the curriculum for each of these areas and determine which topics can be translated into art activities.

Summary

The term emotionally disturbed refers to a group of children who exhibit maladaptive social and emotional behavior. Their marked deviation from age-appropriate behavior interferes with their own development, the lives of others, or both. Although the terminology may differ, there is general consensus that emotional disturbance refers to behavior that is extreme, a chronic problem, not one of short or temporary duration, and behavior that is culturally unacceptable. Children who suffer from emotional disturbance can be categorized as either being aggressive, acting-out or immature, withdrawn. Emotionally disturbed children are also classified as mildly, moderately or severely and profoundly disturbed. Children who are mildly and moderately disturbed may be in regular classes with some time spent in a resource room, or in special self-contained classes. Normalization and mainstreaming is the objective for these children. In contrast, severely and profoundly disturbed are in special self-contained classes or special day schools with the prospect they will need continued prolonged intensive special education methods.

Art experiences can contribute to the emotionally disturbed child's emotional, social, intellectual, and expressive growth. Before these children can participate constructively in art activities, it is necessary to provide an environment that is conducive to their functioning and learning. Elements of such an environment include developing strategies for classroom and behavior management, setting up limitations, and selecting appropriate art experiences. Art activities and art media have to be selected with the needs, capabilities and behavioral patterns of the child in mind. Group environmental activities can help the emotionally disturbed child develop socialization skills; cognitive skills may be reinforced through art activities that develop concepts and skills common to art and other subject areas (math, science, social studies).

References

Anderson, F. E. Art therapy: myths and realities. *Art Education,* April 1980, *33* (4), 18–21.
Cartwright, G. P., Cartwright, C. A., and Ward, M. E. *Educating special learners.* Belmont, CA: Wadsworth, 1981.

Chernin, B. Visual arts experiences for socially maladjusted/emotionally disturbed children. *Readings: developing programs for handicapped students.* Harrisburg: Arts in Special Education Project of Pennsylvania, 1981, 37–39.

Hallahan, D. P. and Kauffman, J. M. *Exceptional children: an introduction to special education.* (2nd ed.). Englewood Cliffs, NJ: Prentice-Hall, 1982.

Kirk, S. A. and Gallagher, J. J. *Educating exceptional children* (3rd ed.). Boston: Houghton Mifflin, 1979.

Kramer, E. with Wilson, L. *Childhood and art therapy: notes on theory and application.* New York: Schocken, 1979.

Le Roy, D. Art and the autistic child. *Adaptive art techniques II: Oregon Adaptive Arts Techniques Project, January 1980-November 1980.* Washington, DC: National Committee, Arts for the Handicapped, 1980.

Lowenfeld, V. *Creative and mental growth* (3rd ed.). New York: Macmillan, 1957.

Lowenstein, N. and Walsh, G. Media dimensions variables in *Perspectives on Art Therapy: The Proceedings of the 2nd Pittsburgh Conference on Art Therapy.* 1978, 51–52 (Summary).

Lowenstein, N. and Walsh, G. A systematic approach to media in art therapy: theoretical and practical applications. In *Art Therapy: Expanding Horizons: The Proceedings of the 9th Annual Conference of the American Art Therapy Association.* 1978, 90–91 (Summary).

Public Law 94–142. The Education of All Handicapped Children Act of 1975. Regulations, *Federal Register,* August 23, 1977.

Quay, H. C. *Classification.* In H. C. Quay and J. S. Werry (Eds.), *Psychopathological disorders of children* (2nd ed.). New York: Wiley, 1979.

Rincover, A. and Tripp, J. K. Management and education of autistic children. *The School Psychology Digest of Behavior Disorders,* 1979, 8 (4), 397–411.

Rubin, J. A. *Child art therapy: understanding and helping children grow through art.* New York: Van Nostrand Reinhold, 1978.

Walker, H. M. *The acting out child: coping with classroom disruption.* Boston: Allyn & Bacon, 1979.

Williams, F. and Wood, N. *Developmental art therapy.* Baltimore: University Park Press, 1977.

Suggested Sourcebooks

Gaitskell, C. D., Hurwitz. and Day, M. *Children and their art: methods for the elementary school* (4th ed.). New York: Harcourt, Brace, Jovanovich, 1982.

Herberholz, B. *Early childhood art* (3rd ed.). Dubuque, IA: William C. Brown, 1982

Linderman, M. M. *Art in the elementary school* (2nd ed.). Dubuque, IA: William C. Brown, 1979.

Wankleman, W., Wigg, M. and Wigg, P. *A Handbook of arts and crafts* (5th ed.). Dubuque, IA: William C. Brown, 1982

Recognizing Emotional Disturbance in Children 5

Functional disturbances arise from a distortion of communication within the apperceptive process. The emotional identification of the child, for the acceptance of communicated reality, may become an extremely difficult task, and rejection may occur even from the earliest beginnings of life. Breakdown may also come gradually after reality structuring has once begun. Since the emotions interact with the rational functioning of the individual, when breakdown does occur, the mind will also function in a distorted manner, and as a result, the individual becomes both emotionally and rationally detached or disassociated from reality. This may occur to varying degrees of severity at various intervals of time. The younger the child when disturbance forms, the more constant and powerful will be the effect of the impairment on his behavior. He may become highly autonomous from reality, and the term *autistic* is therefore often a very appropriate label. Kanner (1966) uses the term *infantile autism* for the severely disturbed child who, from earliest life, is apart from reality. Behaviorally such a child may be very passive and "in his own world" most of the time, but he also contains the potential for violence and aggression in overacting to outside stimuli. Behaviorally he may be bizarre and do highly unusual things such as eat crayons or dirt with no apparent distaste. Many emotionally disturbed children move in stereotyped physical motor patterns as evidenced in continuous rocking or whirling, and they may even become fascinated by bright spinning forms that make noise. At times the vortical motion appears to be symbolic of the abyss in which they live, but more accurately it probably indicates to us the loss of space-time orientation which normal children experience through bodily kinethesis.

When we deal with a disturbed child, the parents are of particular concern, for they very basically are the most important factor in the reality which the child finds unacceptable.

Notice in figures 130, 131, 132, and 133 the sensitivity of a child six and one half years who experiences her home under impending divorce. In figure 130 rain falls on the home to signify gloom on the day her parents filed for the divorce. Then things appear to brighten in figure 131 after news comes in that father may return home. Father does come home but beats up mother (fig. 132). Here the house is blackened and the sun is blue and purple like a bruise. Her final comment in figure 133 is, "The sun burned up everything." While this child is not disturbed, we can begin to feel the hurt and then the anger which may follow. And, needless to say, many children ambulate along through their childhood years and then suffer a major shattering in their late teens when they are faced with the prospects of advanced education, jobs, marriage, and military service. The adult schizophrenic may often be evidenced as a personality which has ambulated from childhood on the emotional level of early childhood.

It is imperative for the mental-emotional health of the growing child that we detect and treat abnormal psychic tendencies and the etiological factors which cause such disturbance. Art is an excellent reflective tool for this purpose, for in the art process the individual continues to express and grapple with unconscious psychic turmoil even when severely disturbed. Through the language of the symbol he will communicate to

Figure 130. Dollie, 6½ years, the day her parents filed for a divorce.

Figure 131. Dollie, 6½ years, "Daddy's coming home."

Figure 132. Dollie, 6½ years, "Daddy beat up Mommy."

Figure 133. Dollie, 6½ years, "The Sun Burned Everything Up."

us and reach out for our understanding and help. The symbol alone will enable us to differentiate emotional disturbance from neurological handicap and mental deficiency.

We will attempt initially to offer some clarification of the etiology of emotional disturbance in the child and then view typical behavioral characteristics in the child's art. In the next chapter, Chapter 6, we will consider the child in the therapy process.

Etiology of Emotional Disturbance in the Child: A Psychoanalytic View

Children need affection for the nourishment of their emotions just as they need physical food for the sustenance of their bodies. Without love the real human personality is never born. Rothenberg (1960) writes of "Johnny" who lived in an incubator the first few months of his life and who, as a result, failed to enter into human contact and response. We must never assume that physical birth and growth will be paralleled with psychic birth and growth. The emotionally disturbed child is often found to be detached from reality almost from the moment of birth, and therefore he cannot truly be called "schizophrenic." That is to say, since he may never have entered into a reality structuring of any extent, we cannot really say he is "split" from reality in the typical schizophrenic sense. In recognizing the severity of such a condition, we note that he must then "relive" or begin at the initial phases of life and grow emotionally from the point where his emotions could not accept the real environment. Other disturbed children may be less severely involved and may be lacking, to some degree, a successful resolving of basic life tasks in early childhood. This latter type of child is the individual who often ambulates for many years and is difficult to detect.

Most writers, recognize the early years as the more formative period of personality, and they therefore emphasize the mother-child relationship. Frankenstein suggests that psychopathic etiology may be found in:

1. More or less complete lack of maternal contact and care.
2. Indolence and apathy in the mother's attitude toward the child.
3. Overt rejection of the child by the mother.
4. Sudden disappearance of the mother.
5. Maternal indulgence.

It is interesting to note that the first four criteria indicate a lack of affection derived from the mother. We know, from our discussion of the normal child, that self-identification must come first *in* and *through* the mother image. The fifth criterion in an indirect manner also suggests a lack of love, since most writers agree that overprotection and absorption of the child's personality by the mother is simply another form of rejection. Such indulgence is actually found to be a compensation for guilt experienced by the parent.

In discussing the normal child we noted the typical developmental tasks of the young child in the drawing of the circle, the cross, and the rectangle. When used symbolically, such reference to form in drawing provides us not only with a basis for recognition of the level of emotional disturbance, but with some understanding of basic etiology as well. We may state: *If the child is arrested emotionally with a basic life task unresolved, then he will continue to project his struggle with that problem through predominant forms or subjects which symbolize that level of conflict in early childhood.* Freud refers to this arrested emotional development as *fixation*. A child of ten years may thus be found fixed in the production of circular forms, or other symbolical references, which would indicate his struggle to identify as a physical self-entity apart from, but emotionally dependent upon, the mother. An older child may tend to be preoccupied with the symmetry of the cross form, or other sexually paradoxical images, and thereby indicate his continued and confused attempt to resolve a sexual-self role which normally would take place at three to four years of age. Finally, a child

may continue to struggle with the problem of ego-closure far beyond the age of four to seven years and thus project his difficulty in the rectangular "grid" form, or other significant overdetailing and structuring of forms.

While this theoretical construction tends to oversimplify the basis for the identification of the disturbed child, it provides a reference from which we might examine more closely the individual child and his particular impairment, especially in relation to his home environment.

Emotional Disturbance and Art Expression

The symbolical significance of form and the use of subject in a symbolic manner both provide a basis for understanding the art of the disturbed child. We will discuss these manifestations in the art of disturbed cases primarily with reference to etiology evidenced in form symbolism.

The Circle

We have noted earlier how the circle represents the child bound up emotionally in the mother. What will occur when the relationship of the child to the mother fails to be established, is impaired by separation, or the emotional climate established by the mother is one of indifference and rejection? We may simply state that the child in such a case will desperately attempt to identify with the mother, even if it means a return to the security of the circular context of the womb which, after all, did offer a type of perfect security. The closeness of the relationship was broken only by birth. In figures 134, 135, and 136 we note the work of Mickie, whose art for some time was as much an enigma as he himself. An Rh_o factor was the only suspect basis for his impairment.

In figure 134 we see a typical drawing by Mickie at six years of age and in figure 135 a similar "man" drawn by Mickie at ten years of age. A sudden revelation came one day when he drew figure 136 with white crayon on black paper. There is an emphasis upon the circular form, and an unmistakable fetal image appears in the mouth of the "face." It is obvious that Mickie is identifying as a fetal child within the mother. At ten years of age this is Mickie's level of emotional identification.

Repetition of the circular form will appear in many subjects drawn by emotionally disturbed children. Ricky (figs. 137 and 138) was fascinated by spinning objects and often drew airplanes with a dozen or more propellers. His human figures were people with "empty" tubelike bodies and highly stylized heads which contain the same circular repetition in the ears. Schilder (1950) has noted that any hole in the body is easily symbolized in other holes of the same human figure. The roundness of the head, the eyes, the ears, the mouth, the umbilicus, the anus, and so on—all become possible symbols of autism in the child. While the circle is the simplest gestalt form and suggests the egocentricity of autism from a lack of motor reference in time and space, it remains, as well, a symbol of the child bound up in the mother.

A quiet boy of fifteen drew figures 139 and 140. The emphasis is upon circular form with concentric repetition. He is very passive but can become extremely violent at times as is evidenced in the horns in figure 141. The mouth is open or absent, there is an emphasis upon the buttons as an umbilical dependency form, and the arms are weak or absent indicating a feeling of helplessness.

Self-destruction or nihilism suggested for one's self may be an overture of escape and despair evidenced in drawings. Running away, drug abuse, suicide attempts, and other similar behavioral manifestations are often the older child's expression which parallels holding one's breath or hiding in early childhood. In figure 141 we see the drawing of a person by a ten-year-old boy who runs away often. The head is simply a drop of paint. There are no hands or feet, and this indicates his helplessness and lack

above left: **Figure 134.** Drawing by Mickie, 6 years.
above right: **Figure 135.** ''Man'' by Mickie, 10 years.
left: **Figure 136.** Drawing by Mickie, 10 years.

Figure 137. "Airplane" by Ricky, 10 years.

Figure 138. "Family" by Ricky, 10 years.

Figure 139. Self-image by boy 15 years.

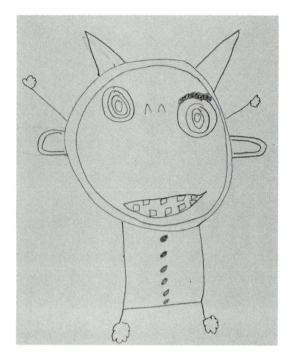

Figure 140. Self-image by boy 15 years.

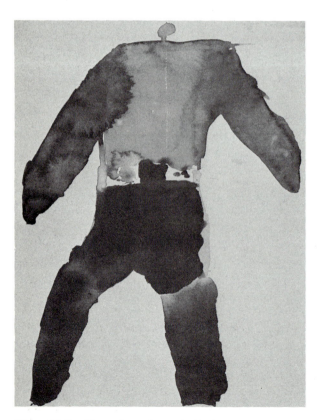

Figure 141. Figure by runaway boy 10 years.

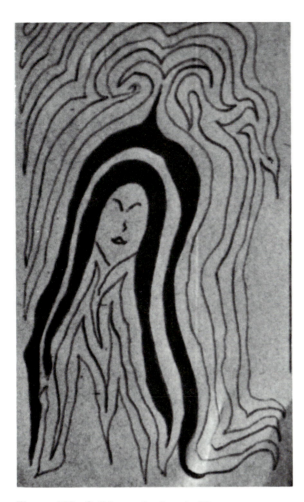

Figure 142. Self-image by female 26 years (during withdrawal from drug abuse).

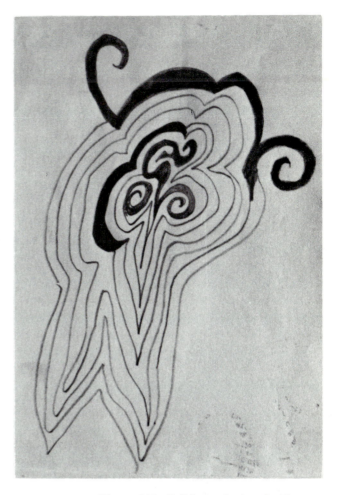

Figure 143. Self-image by female 26 years (during withdrawal after drug abuse).

of security. The color is that of a bruise—black, blue, and purple. He is emotionally "wounded" and calls for affection by his act of running away. The comment of his parents when he is found by the police is "Let him stay in the juvenile center for a few days. That will teach him a lesson."

A girl, twenty-six years old, drew figures 142 and 143. She had been taking heavy doses of amphetamines and LSD and was just starting on heroin. She drew these people and then said, "They are like butterflies without wings—trapped like me." Here the same concentric form persists as a symbol of autism or escape. Like most severely impaired and disturbed individuals, she emphasizes the head and almost totally neglects the body, which symbolically is cut off or empty. The experiencing of the body is simply not accepted psychically. Often even the face, as the face of the cat in *Alice's Adventures in Wonderland,* finally disappears—perhaps until only the smile, or less, is left.

The extreme detachment made in late adolescence, or even in adult life, is often gradually formed from its origin in early childhood. In figure 144 we see a ceramic figure made by an eighteen-year-old institutionalized boy. He has regressed to the state of an infant and, except for the hollow form of the torso, looks like a bird opening his mouth just above the edge of the nest, as if waiting for the nourishment suggested in the mother's return.

Figure 144. Ceramic figure by institutionalized male 18 years.

In figures 145, 146, and 147 we see the drawings of George who is now in his late forties. His parents both died when he was two or three years of age. He was moved from one orphanage to another and was in and out of many foster homes. As a young man he joined the army and made it his career. In essence, the army became the mother for him and maintained him for a number of years. He was clothed, fed, given work, and had a friend or two. At present he still reacts on a primitive level, and his human figure concepts indicate the emptiness of his felt identity. In figure 145 his childlike dependency within the context of the magic feminine circle clearly reveals his emotional level.

Figure 145. Self figure by George, 46 years.

Figure 146. Self figure by George, 42 years.

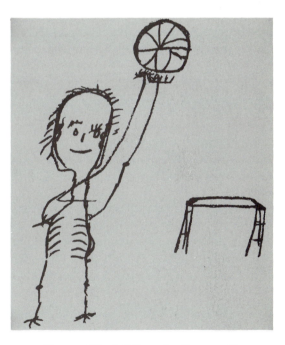

Figure 147. Self figure by George, 42 years.

The Cross

The cross form, as we have seen in previous discussion, represents the dichotomy or dilemma of the child as he seeks to resolve the question of a self-sex role at three to four years of age. His models for the masculine and feminine roles are his parents. If they play their roles well, we can expect the child to form a clear identification within the scope of the home, which will equip him for adequate participation later in a larger society. On the other hand, a poor parental model, a missing parental model, or an absorbing or rejecting parent may cause great confusion for the child.

One particular danger always presents itself in the parent-child relationship at this age. While it is normally resolved as a rule in most homes, it becomes a major basis for emotional disturbance where unusual circumstances compound the problem. It is essentially that the child will tend to gravitate in an almost "romantic" manner toward the parent of the opposite sex and then, to some degree, consider the parent of like sex to be a rival. The little girl may play the mother's role by taking care of the "baby"; she gives tea parties and begins to pattern herself after the mother as we would anticipate. Also, however, in this paradox of what Freud called an "Oedipus complex," she loves the father and seeks his affection, while at the same time she rejects the mother. She may even wish the mother would die, (see chap. 8, figs. 306, 307, and 308). If the father takes advantage of the girl's attention and in turn overly responds to her advances, she may tend to identify too thoroughly in and through the father, and the dilemma of sexual identification may be prolonged and perhaps never resolved. The same circumstance may be presented to the mother and her son, especially if the mother fulfills her need for romantic affection in the boy. This stage is usually set by incompatibility, separation, or divorce of the parents. The child who is overabsorbed by the parent may become inverted in sexual identification. In figures 148, 149, and 150 we note drawings by Joey whose mother dominated him and dressed him in female clothing much of the time. Because she was not close to her husband she obtained much of her affectional needs from Joey. In figure 148 we note how Joey sees himself. The self figure has eyelashes, a ring on the finger, and high-heeled shoes. The sexual reference in the lower body is ignored by drawing the legs directly to the waist. In figure 149 Joey draws a portrait of his mother—with whom he is beginning to identify. The portrait appears more like the glamorous idealized figure that a girl would draw. The family drawing (fig. 150) shows Joey standing on the far right next to mother while his father on the left side of the drawing is flanked by the two daughters. Parents who fulfill themselves through the child of the opposite sex, rather than with each other, are many times creating difficult problems of identity for the child. Oscar Wilde and D. H. Lawrence are famous examples of such a dilemma. Within two years Joey began to fragment as he approached adolescence.

On the other hand a child in such a paradox may find it necessary to overcompensate in his proper sexual role, due to a threatening unconscious which carries with itself the contrasexual image. In short, the child may become a sexual invert *or* a paranoid reactor.

While the roots of the sexual dilemma are found early in the life of the individual, the expression of the paradoxical feelings is not usually seen clearly in art until seven or eight years when sexual symbols are first dynamically expressed. In figure 151 a nine-year-old boy drew a type of self-image with the following story on the back:

> A man was on a deserted island and the sharks were after him. He bombed the sharks but demolished the island. Now the man will fall and will be eaten by the sharks.

Notice the symmetry of the cross in the composition of the drawing. It speaks of the ambivalency of identity that he feels. The man has his secure footing on the ground— a symbol of the mother. It is always the unconscious feminine "mother" which threatens the man, but he will usually project that threat in such a manner that it appears from outside. It is by reacting to a threat from outside, which he actually may create, that he destroys the "woman" that threatens him, along with himself. Thus we see that ancient paradoxical process which is typical of the paranoid reactor. Here is the compensating male who, like Hitler, thought he could only be secure when all things were subordinated to himself. Yet the threat was at once arising and pushing from within. It has been said that behind every successful man there is a woman, but it is clear here that the "woman" may work from within.

Figure 148. Joey, self-portrait, 8 years.

Figure 149. ''My Mom'' by Joey, 8 years.

Figure 150. ''My Family'' by Joey, 8 years.

Figure 151. "Man on a Deserted Island" by boy 9 years.

In figure 152 we note a ten-year-old boy's drawing of a strong man. It is an obvious self-image. The mountains rising in the background suggest the dominant mother. The overlapping of the mountains indicates his extroversion and field-dependency which Witkin (1954) notes lies in a "growth-constricting" mother. The large belt buckle reveals a strong umbilical tie, and even though the man is strong in biceps, he also has strong feminine characteristics as are displayed in the ballet-type shoes, the breastlike development of the pectoral muscles, and the cleft in the chin which is a vaginal symbol on the "torso" of the face. The body position is arrowlike as if to indicate his desire to rise above the mother-image of the mountain. Figure 153 is very similar but from an older boy in a penal facility.

Figure 152. "Strongman" by boy 10 years. **Figure 153.** Self-image by boy 17 years.

Girls experience similar distortions of identity which place them, too, in a paradox of sexual dilemma. In figures 154, 155, 156, and 157 we find a H-T-P series from a sixteen-year-old girl. The house (fig. 154) has been badly abused as a symbol of her aggression toward the mother. From the tree (fig. 155) hangs a feminine circle which has been stabbed and punctured by nails. The human figures (figs. 156 and 157) clearly indicate her own glamorous but masculine self and her superiority over men.

Raymond (figs. 158 and 159) is a ten-year-old boy who was referred by his mother for evaluation. When he arrived, it was obvious that his behavior was highly unusual and that he was greatly suffering with anxiety. He could not sit still, his head moved with mechanical tics, and he periodically made a bizarre noise. His self-projection (fig. 158) contains a large head (egocentricity), a long neck (rejection of bodily identity), legs moving directly to the belt (lack of sexual acceptance), and peculiar "cuts" on the nose, arms, and neck. In the interview he mentioned his desire to cut his fingers with razor blades. Such a symbol in drawing suggests a self-castration. In his family drawing (fig. 159) he draws the self image below the emphasized figure of his mother. It is obvious that he is preoccupied with her person. The father and older brother appear to the right side of the paper. When we spoke with Raymond, he mentioned a dream in which he drove a car into a swimming pool and was thus unable to breathe. The feeling of rejection for, and detachment from, his body was symbolically expressed. Then he later mentioned a dream in which he entered his mother's bedroom at night

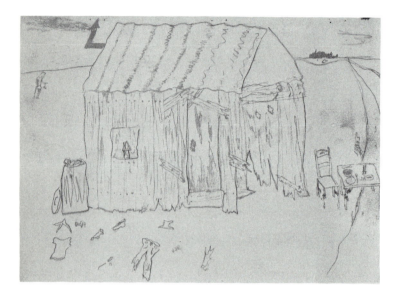

Figure 154. House by girl 16 years.

Figure 155. Tree by girl 16 years.

Figure 156. Man by girl 16 years.

Figure 157. Girl by girl 16 years.

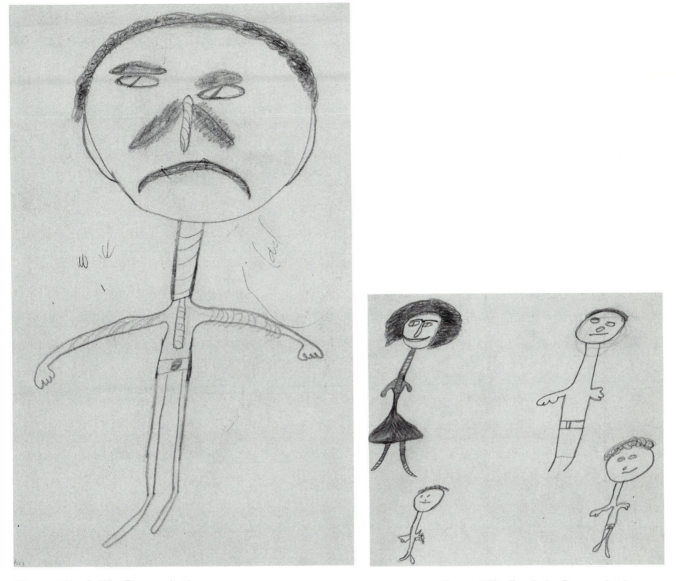

Figure 158. Self by Raymond, 10 years.

Figure 159. Family by Raymond, 10 years.

and her bed was "way down there, and my thumb was stiff." An erection of the phallus in his desire for the mother was thereby indicated. Further study and interview of the parents disclosed that they were incompatible, and they were subsequently divorced two years later. At that time Raymond stayed with his mother, and the older brother went to live with father. The mother had derived needed affection from Raymond and, in effect, had seduced him. He would now carry the suffering of guilt experienced from the relationship.

Long necks and birdlike creatures often are symbolical of the effeminate-male personality. In figures 160 and 161 we see such images in drawings by Chuck, a sixteen-year-old paranoid schizophrenic youth. We notice that the dinosaur even has breasts. This case, reported by Crowl (1968), became obvious when he was asked to draw the most "unpleasant concept" and he responded by drawing figure 162 with the comment, "Father has just shot my lizard." It again is clear in such imagery that the parent had destroyed the path of identification which would allow the child to normally develop. The father, in this case, has actually destroyed the boy's opportunity of sexual identification with himself as symbolically portrayed in the dead phallic "lizard." The mother had deserted the family.

Figure 160. Bird by Chuck, 16 years.

Figure 161. Dinosaur by Chuck, 16 years

Figure 162. "Father Shot My Lizard" by Chuck, 16 years.

Even if the individual ambulates along psychically under the typical circumstances which we have discussed, he will feel incompetent and find it necessary to obtain the masculine power he so desperately needs. A forger often reveals such a dilemma in H-T-P drawings (figs. 163, 164, and 165). The house drawing (fig. 163) indicates the strength of the mother and the subject's involvement with her. Even the driveway penetrates the house as a symbolic sexual relationship. The person and tree (figs. 164 and 165) indicate the weakness and depression of the subject. In an overlay of the person and tree drawings, the broken branch perfectly overlays with the neck, revealing the

Figure 163. House by Forger, 21 years.

Figure 164. Person by Forger, 21 years. **Figure 165.** Tree by Forger, 21 years.

suicidal tendencies within this young man. Though he is twenty-one years of age, his present difficulties originated very early in life through the parent-child relationship.

Rabbits, birds, and other small, timid creatures are often the projected self-identity of the male who is weak or sexually-inverted. They may turn to deviate sexual patterns of behavior such as exhibitionism and voyeurism, or possibly to more overt homosexuality. The popularity of latent homosexual publications and entertainment indicates

Figure 166. Drawing by Bing, 13 years.

Figure 167. Drawing by Bing, 13 years.

the magnitude of the problem today. Some individuals, through their self-identification in the dilemma, edit highly successful magazines and fly around the world like big "bunnies" in their personal "birds." In figures 166–170 we note the drawings by Bing, a boy of thirteen years, who identifies as an emasculated bird and other similar weak and timid creatures. The cold, sharp ground usually looms up above him or completely surrounds him as he shakes in a homosexual panic (fig. 170) as "batman."

Figure 168. Drawing by Bing, 13 years.

Figure 169. Drawing by Bing, 13 years.

Figure 170. Drawing by Bing, 13 years.

Figure 171. Self-image by Carl, 16 years.

Some people, today, do not believe that the homosexual is a threat to himself or society, but most of the evidence is strongly to the contrary. It is not the homosexual's interest in those of the same sex that makes him a basic threat to society, but rather his sadistic hatred which is directed toward the opposite sex. The hatred is based upon fear of the woman. Generally homosexuals are initially, and on the surface, seen as obnoxious. (The homosexual as a potentially violent person is discussed in Chapter 6). In figures 171, 172 and 173 we note human figure drawings by Carl, a sixteen-year-old boy. He is an overt homosexual and had just been removed from his local high school. Notice the exhibiting of the phallic tongue, the lack of nose, and the vaginal character of the ear in figure 171.

Figure 172. Human Figure by Carl, 16 years.

Figure 173. Self-image by Carl, 16 years.

Figure 172 holds a stress on feminine characteristics—wide hips, breasts, and a lack of phallic imagery. Shoelaces are seldom included in human figure drawings but suggest castration when they are drawn (like tattos and scars).

In figure 173 we find no hands or feet, and the hard, shell-like concentric barriers of the body, along with the "rat-fink" label, reveal his essential nihilism and despair. The degree of disturbance at this point was just beginning to surface after exposure and expulsion.

Three juvenile sex offenders reveal their crimes in the ceramic images of figures 174, 175, and 176. The smooth surface, preoccupation with "holes" in the facial "body," and the weak chin with a vaginal cleft—all indicate overt homosexuality in figure 174.

Figure 174. Homosexual image.

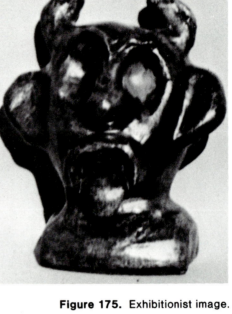

Figure 175. Exhibitionist image.

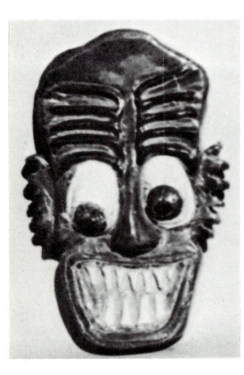

Figure 176. Rapist image.

The hostile horns, the lack of eyes (lack of self-acceptance of actions), and the protruding tongue reveal exhibitionism in figure 175. Figure 176 was produced by a rapist, and he reveals himself in knifelike teeth, a strong jaw, and protruding eyes. In criminal sexual acts the offender projects and destroys the feminine image over which he often feels he must exercise power. Aggressive acts and suicidal acts have much in common, and it is not surprising to find homicide followed by suicide.

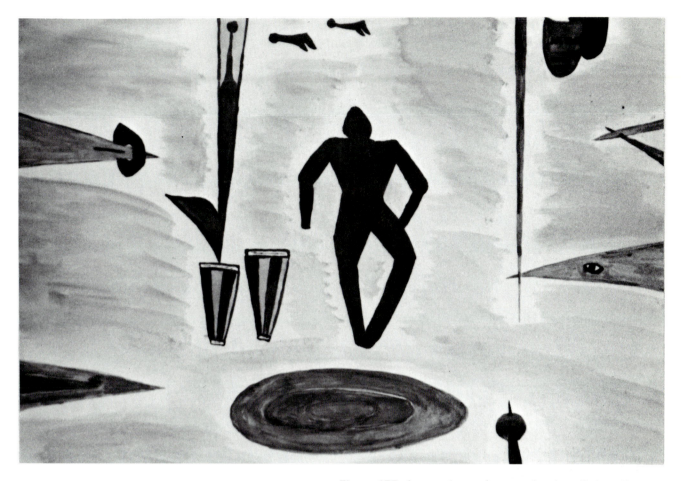

Figure 177. Image of sexual aggression, juvenile boy 16 years.

In figure 177 we note again the dangerousness of the juvenile who is threatened by his feminine unconscious self. The feminine circle is jabbed over and over again.

The Rectangle

When one's environmental perspective fails to provide an acceptable climate for the structuring and maintenance of reality, desperate attempts are made to organize and subordinate that environment which poses a threat. If such efforts fail, there is no recourse but to withdraw into the reference of the body-self and then finally out into the transcendental world of the spirit where space and time cease to exist. Disassociation is a frightening experience, for no child or adult ever leaves reality on the basis of his own desire. It is the purest form of existentialism, and the journey is a house of horrors where motion factors are fragmented and the real events of the temporal world gradually become more unreal and crystalline. It is of our interest here to consider in art expression the dissolution of the ego of the child as he experiences a breakdown of identity within his environment and then with his own body. In most respects such a process is the reverse of normal personality growth. The structured detailing of rectangular organization is our basic reference for ego-structuring, and therefore we may expect a preoccupation and struggle within the context of that form.

Many factors previously mentioned may contribute to a difficulty in identifying with one's self in the context of the real environment. The child may suffer the loss of the mother's affection, and this may have a severe effect if she had previously been over-protective and affectionate. In figures 178, 179, and 180 we see drawings by Mike, a

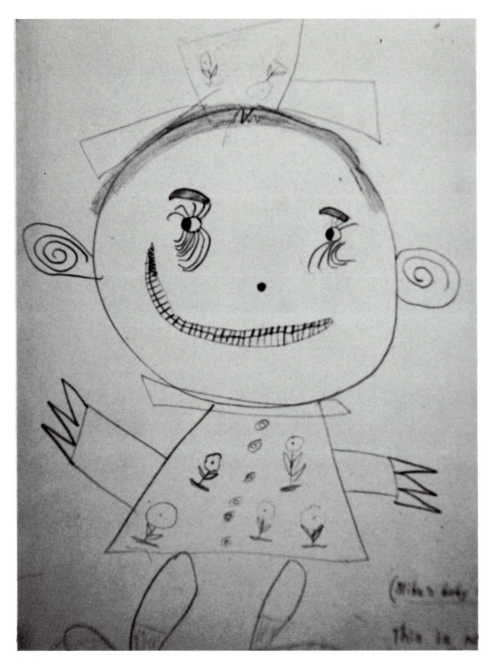

Figure 178. "That's My Sister" by Mike, 8 years.

boy of eight years who had been the sole recipient of his mother's affection all the years of his young life. He has identified in her person to the degree that he lacks a strong self-identification. Now he has been "replaced" by a baby sister whom he draws in figure 178. He not only would like to wipe out the sister, but in his jealousy he would like to be the sister, for his own identity is feminine to begin with. Here we notice the concentric circular forms again in the ears, a preoccupation with the eyelashes, the dependency buttons down the front of the dress, a tremendous structuring of the teeth, and sharp hostile fingers on the hands. Mike is obviously a very intelligent boy, but also a very disturbed boy. In figure 179 we note that the whole drawing takes on the character of a large face. The suns are simply eyes, again with lashes, and even each "eye" in itself has a face with eyelashes included. The tree is highly detailed or "structured" in the upper region and thus is an expression of his rational preoccupation. The

Figure 179. Drawing by Mike, 8 years.

Figure 180. Tree drawing by Mike, 8 years.

trunk of the tree is a single line which speaks of a loss of bodily self and a very weak emotional "footing." In figure 180 he replaced his bird subjects with a rabbit. In telling about his tree drawing, he said, "That's the bunny rabbit and he jumped, and jumped, and jumped until he bumped his head on the tree. He cried and cried and ran home to tell his mama." Mike is desperate for attention of any type, positive or negative, for it in some degree substitutes for the loss of his mother's affection.

Figure 181. Family by Henry, 7 years.

Other factors which we have not examined may also contribute to the difficulty the child experiences in ego-structuring. In figure 181 we find the work of Henry, a seven-year-old black boy who lives in an all-white neighborhood and attends an all-white school. When he drew this picture of his family, he left his face off and thus indicated his lack of self-acceptance. He is certainly not emotionally disturbed at this point, but such a circumstance of difference in race, physical appearance, cultural background, and similar factors could compound a child's attempts in structuring and maintaining reality, especially if the home were not ideal as in Henry's case.

Figure 182. Person by Penny, 7 years.

Children who are confused in regard to the reality about themselves are often highly threatened by the rules and demands of others. It is not unusual to find them moving rapidly out of a very passive state into violent behavior. Teachers of the exceptional sometimes make such statements as, "We are just going to have to do something about Jimmy as he is beginning to kick and bite the other children." Well, great! It looks as though Jimmy is improving! We must keep in mind that interaction with the environment, even in a hostile behavior, is far healthier than withdrawal. Disturbed children will usually come out fighting, and we had best let them win a few even if it means shin guards and helmets. If we force them back into their shell, we will make it twice as difficult to encounter reality again. It will be well to look carefully at their deeper difficulties.

In figure 182 Penny, a seven-year-old girl in a "slow" second-grade class, has drawn a self-image. The arms have the appearance of paper ribbons with no hands. Her helpless feeling is evident. In testing, her verbal intelligence was measured at an IQ of 86 while her performance record revealed an IQ of 126. After drawing the self-image, she jabbed at it over and over again as if attacking herself.

What could best be called "barriers" or "fences" are often in evidence as a protective device for the body-self. It is as if the child has crawled into a box to protect himself from a hostile environment. In figures 183 and 184 we note such protective forms in the work of Arthur, a seven-year-old who was being evaluated. His color usage was also highly unusual—green features and an orange, purple, and blue body. There was a definite feeling of the body being "cut-up" or segmented by the color. His ground color was never green—always orange, black, or purple. The symmetry of the drawings

Figure 188. Drawing by Christine, 18 years.

Figure 189. Drawing by Christine, 18 years.

Figure 190. Houses by Christine, 18 years.

Figure 192. "Myself" by Tim, 13 years.

Figure 191. Pots by Christine, 18 years.

in number. There are no eyes to the figure, and the back of the head has been cut off.

Drug abuse tends to fragment the individual from reality in much the same manner as emotional disturbance. In figures 188 to 191 we note how Christine, an eighteen-year-old girl, struggled to organize the chaotic perceptions of her environment into real form. Over several weeks' time, she moved from the disorganization of figures 188 and 189 to a type of pointilism (fig. 190), and finally to a realistic ability (fig. 191).

When the individual withdraws from a threatening environment, he will, as a rule, draw only the bodily reference, and if his condition continues to deteriorate, he will lose a sensitivity to the body as well. This is often evidenced by an attack upon the human form and then a projection of an "empty" or segmented form. Actual detachment may occur through some type of severing at the neck; this is frequently indicative that the individual is living in the psyche (head) and is disregarding sensory communication (hollow body). The head in such a case is often highly detailed and rigidly stylized.

In figure 192 a boy of thirteen tears apart the bodily self. It is hung, electrocuted, and shot at by both cannon and bullet. Notice also the weak and ineffective hands. He drew three similar human figures over a year's time. The following years he attended school less and less until he dropped out completely when he was sixteen. Care needs to be exercised in assessing such gruesome use of the human figure as "disturbed." In figure 193 we see a drawing by a high school boy which had accompanied a creative story that he had written. The story utilized morbid humor, typical of adolescent boys, and concerned the "day he got caught in the buzz saw." First his legs went, then his stomach, but, as the saw started to reach his face—it began to slow down and "it looked

Figure 193. "The Day I Got Caught In The Buzz Saw," by George, 16 years.

Figure 194. Person by James, 10 years. [Lines darkened]

like he would be okay after all!" While the story was not usual adult reading, it was creative, and he received an "A" grade. Here we do not evidence any type of separation at the neck, weak hands, segmented forms, or "empty" bodily character.

Figure 194 is drawn by a ten-year-old boy. Here we notice a fine break at the neck. The stylized head is much like a cork that does not quite reach the neck of the empty

Figure 195. Person by Melvin, 9 years. **Figure 196.** Person by Melvin, 9 years.

bodily form. The only detail on the body is a belt buckle without even a belt attached to it. Here again we see the concentric linear forms in the ears. The figure is rigidly symmetrical; even the nose is split down the center. The boy was a very withdrawn paranoid reactor.

Melvin, a nine-year-old boy, drew the human images in figures 195 and 196. He is so dissociated from bodily identity in figure 195 that he is not even certain regarding the number or position of the limbs. In figure 196 he drew a segmented human, and far up in the right corner of the paper is a small dark-red sun which suggests his dogmatic and rejecting father.

As the emotionally disturbed individual loses awareness of the body, by psychically retreating from it, the bodily boundaries as well as content may become highly confused. Confusion of bodily boundaries is often evidenced through the drawing of "x-ray" views (fig. 197). Because the person is not certain regarding the essential character of the body they may draw inner organs of the body appearing through clothing—and sometimes identify with another object or person outside of the body as a part of themselves. Notice in figure 197 how the toes appear through the shoe. The heavy line at the neck again suggests the separation of the psyche from the body.

Paula, a sixteen-year-old girl, drew the H-T-P series in figures 198–201. She projected the "empty" body by making a face out of the torso (figs. 198–199). This is not unusual for emotionally disturbed individuals, and at times such a person may draw a number of heads telescoping out of each other. Her tree has the typical single-line trunk and a lack of support below (fig. 201).

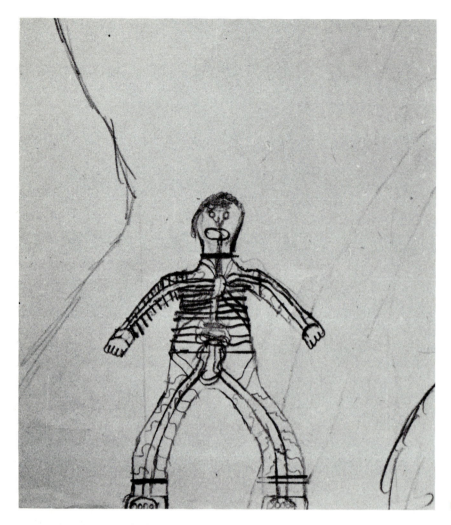

Figure 197. Human figure drawn by Andy.

Figure 198. Drawing by Paula, 16 years.

above left: **Figure 199.** Person by Paula, 16 years.
above right: **Figure 200.** House by Paula, 16 years.
right: **Figure 201.** Tree by Paula, 16 years.

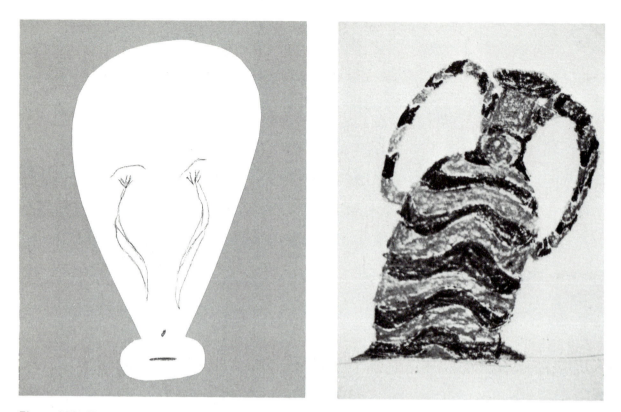

Figure 202. Head by Thelma, 12 years.

Figure 203. Person by Thomas, 12 years.

Thelma, a twelve-year-old girl, drew and cut out the head in figure 202. It, too, represents the concept of the head alone being the entire body-self. The hands cover the eyes suggesting that she is not willing to see and experience self. Notice the similarity between the drawing by Thelma (fig. 202) and one by Thomas (fig. 203). The same weak arms and lack of "seeing" appear. The lack of facial features and the segmented body character in the drawing by Thomas emphasizes his autistic status. He is essentially frozen in a position of nonexperience regarding the real world of time-space and motion.

The importance placed upon the face cannot be overemphasized in the work of the emotionally disturbed individual. Bender (1952) has stated that the face is the last bodily part lost and the first identity rediscovered. Perhaps this is due to the child's first experiencing the face of the mother and being bound up in the circle which symbolizes the mother. In figure 204 we note a face drawn by Nancy who is twelve years old. As a self-identity, which in itself is all of reality that she now knows, she attempts to structure and organize it the best she can. The image, only too often, is like Humpty-Dumpty attempting to put himself back together. When the child loses an awareness of the body, the face may attach itself to numerous objects and in multiple "free-floating" relationships (figs. 205 and 206). This adolescent girl, Marilyn, experienced frightening detachments and often calls for help in her drawings (fig. 207).

Molested Children and Incest

In our day we are hearing more and more about sexual exploitation and abuse of children. The implied relationships which we have considered in the Oedipal conflict often have very serious implications, but the actual sexual involvement of adult-with-child and child-with-child is often a lifetime disaster. In figures 208 and 209 we see human figure productions by Nancie, a thirteen year old girl, who was molested by an older child when she was about four years old. There is also evidence of strong Oedipal

Figure 204. Face by Nancy, 12 years.

Figure 205. Free-floating faces by Marilyn, 14 years.

Figure 206. Free-floating faces by Marilyn, 14 years.

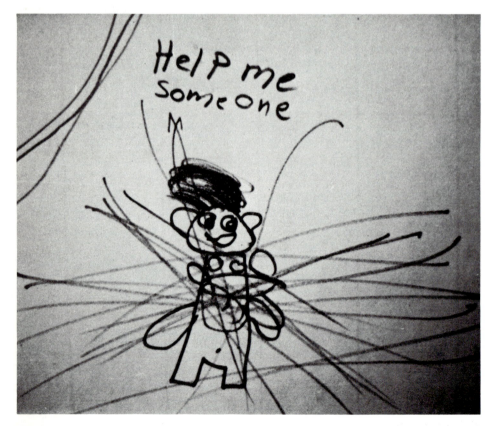

Figure 207. "Help Me" (detail) by Marilyn, 14 years.

Figure 208. Person by Nancie, 13 years.

Figure 209. Person by Nancie, 13 years.

conflict in her case and she is suffering from anxiety hysteria. She is ignoring the lower (sexual) part of the body in figure 208 by stopping the figure at the waist. The arms are cut off by the paper as to render her helpless, while in figure 209 the hands are small and ineffective looking. Her eyes are always very small (fig. 208) or the figure is faceless (fig. 209) in an attempt to block out reality. Hysteria involves an extremely rigid physical arching of the body in her case as a way of expressing trauma which she cannot verbalize. She is afraid that she will die while having an attack. Much of the same rigidity is seen in the work of Eddie (fig. 210). He is now an adult schizophrenic, being arrested in his emotional development and detached from reality by sexual abuse as a child. Like Nancie, his eyes often have small pupils or pupils that look down in fright at a lower (sexual) area which is not drawn. Many times the sexually exploited child also feels tremendous guilt from their involvement even though they were not an active participant. The ceramic portrait in figure 211 is an example. The "pop eyes" reveal the over-stimulated sexual experience and are accompanied by a strong phallic nose. The large ears indicate guilt. This adolescent was institutionalized and was often homosexually raped by others.

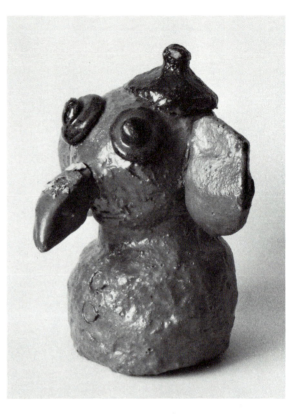

Figure 211. Ceramic portrait by Tim, 16 years.

Figure 210. Person by Eddie, adult.

Figure 212. "Bad Love" by Carol, 15 years.

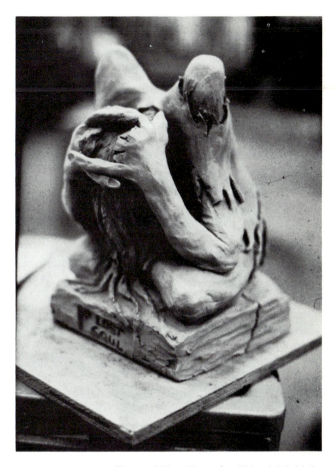

Figure 213. "Lost Soul" by Adult Male.

Extremely bright "raw" color is often typical of children who have been sexually abused and this is in turn often smeared over with a rather "sick" looking yellow-green-orange mixture of color in paintings. Figure 212 is an example. Carol, 15 years, has titled her painting "Bad Love." She started with a brilliant red heart (symbol of sexual love) and then crossed over it with heavy black strokes (marking out, or, an attempt to repress). She then smeared over the top with the "sick" color, as described, as if to suggest disease. She had been sexually assaulted by her father.

Child molesters are invariably men with immature sexual identity who do not feel adequate in approaching a mature woman—therefore they choose a child. Often they are extremely naive about sex and are often just curious. Often they kill the child for fear that the child will report them to parents. They are often very remorseful regarding their crime—and depressed (see fig. 213). They should be commited to hospitals where they will obtain in-depth therapy for their problems. Notice the "castrated" fingers in figure 213 indicating sexual inadequacy.

Cases of Multiple Impairment

Discussion of the emotionally disturbed child up to this point has centered upon basic etiological theories and recognition of disturbed characteristics. It is also necessary to recognize that many children will, to some degree, suffer multiple involvements. It is not unusual to find a child with neurological handicap who is mentally

Figure 214. Self-image by Jimmy, 15 years.

deficient as well, and perhaps orthopedically involved too. The criteria previously mentioned as characteristic of the art of the child will remain as a valid tool in evaluating impairment for the multiple-handicapped child. To illustrate the use of art for such a purpose, two cases of emotionally disturbed children will be presented.

Jimmy, Fifteen Years

When Jimmy's drawings were first observed, his more obvious problem of mental deficiency was not detected as the observer viewed the drawings without first seeing him or having knowledge of his age. Jimmy suffers mental deficiency from Down's syndrome but appears alert and could almost be called hyperactive. This, along with a great deal of aggressiveness, makes him a very unusual boy. Typically he would be expected to be slow, congenial, and shy at fifteen years of age, but he is none of these.

His first drawing (fig. 214) is a type of self-image, with the expected homunculus forms of the child with Down's syndrome, but there is an obvious "deification" of self by placing a rainbow over the head. The body is an effeminate "vaselike" form. We might also notice the aggression suggested in the teeth. His first attempt, to the right of the major figure, is purple, and all of these signs together would tend to point to a paranoid reactor, a highly unlikely circumstance for a boy with Down's syndrome. Yet, this is exactly the situation. Jimmy is actually more active and extroverted than we would expect because his behavior is more tuned to his paradox of sexual role-identification than to his mental deficiency. In fact, he perfectly expresses the dilemma in his naïve and thoroughly unconscious manner.

Jimmy's parents are divorced, and he lives with his mother. She fulfills her need of affection through him, and as a result he has identified strongly in and through her person. Behind such a relationship, however, lurks his hostility toward her, for as a final course he ultimately wishes to be a man. His identity fits perfectly the paranoid image of the Mother Goose rhyme:

Peter, Peter, Pumpkin Eater,
Had a wife and couldn't keep her.
He put her in a pumpkin shell,
And there he kept her very well.

Figure 215. Self-image by Jimmy, 15 years.

In figure 215 we see that image projected in Jimmy's art. He is the man but also the mother as is symbolized in the pumpkin image. If he would marry, he would not adjust to his wife until he had put her in the projected "mother" image of himself; he would treat her according to the threat he feels from his own unconscious. We see this portrayed even more viciously in figure 216 where he takes on a devil character. His hostility is clearly in evidence.

In figure 217 the cross form contains two interesting subjects which very well clarify the deeper meaning of the form. The horizontal member was labeled a "house" by Jimmy, and he called the vertical member "an elevator." It is essentially a boy attempting to rise above, and thus subordinate, his mother.

In figure 218 he drew a purple spearlike tree growing from a yellow rectangular ground, a clear picture of a sexually confused boy with his origin in a masculine mother.

Jimmy is a very confused boy, and because he lacks the finer rationale of a normal child, he has difficulty in organizing himself in the context of his environment. In figure 219 we note the defensive barrier forms which symbolically indicate his protective character. If he is defeated, he will sulk and become very negative in attitude. In figures 220 and 221 we note his despair and nihilism. Like most paranoid reactors, he will tend to express himself in a dark hole—a black circle or rectangle—when defeated. In figure 220 the rectangle is black with a red form, suggesting a human figure, in the center. In figure 221 the circular "house" is black and blue and purple—like a bruise.

Figure 216. Self-image by Jimmy, 15 years.

Figure 217. "Elevator and House" by Jimmy, 15 years.

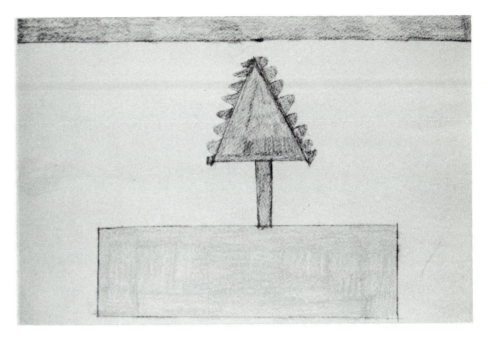

Figure 218. Tree by Jimmy, 15 years.

Figure 219. House by Jimmy, 15 years.

Judy, Eight Years

Judy at eight years of age was a very quiet third-grader who never expressed emotion. She was neat and performed each academic requirement with extreme thoroughness. She was noted as being preoccupied of mind, and though her reading skills were sufficient, she had very poor recall and comprehension.

Figure 220. Drawing by Jimmy, 15 years.

Figure 221. Drawing by Jimmy, 15 years.

One day the teacher asked the class to draw "The Most Beautiful Thing" and Judy responded with a drawing of a gas station pump (fig. 222). At this the teacher referred Judy for evaluation. We note that the pump is actually a self-image with the station itself serving as a fence or barrier form for protection. The pump has small legs, a

Figure 222. "Gas Station" by Judy, 8 years.

skirt, and a face with a number one and a number two drawn on the face. The face is vermillion with a blue line around it, while the figure itself is red. The pump image suggests that she is identifying strongly with a mechanical object and that she is essentially mechanical herself. Her poor ego-structure calls for the organizational protection of the fence form with its sharply pointed corners.

Judy was asked next to draw the house, tree, and person figures which were found to additionally suggest emotional disturbance (figs. 223 and 224). Her house had no windows, was colored a cold brown, and had sharp points at the top like her gas station. It was suspected, from the typical symbolism of the house, that her own mother is represented in this form. The self-image was colored a masculine red with small, weak arms and barely visible hands. The tree (fig. 224) was split down the middle and thus suggested the ambivalency of the cross form. The top of the tree had a hard defensive shell around a meticulously organized interior which was significant as a structured gridlike form. From the drawings, it was suspected that Judy was much closer to her father than to her mother and that she was having great difficulty in resolving the ego-identification of self-in-the-environment.

At a conference the parents stated that Judy was indeed closer to her father since he had taken care of her during her first year of life while the mother worked. Twin boys had been born into the family at the time Judy was nearing her third birthday,

Figure 223. Person and House by Judy, 8 years.

Figure 224. Tree by Judy, 8 years.

and this, too, had turned her to her father for attention, as mother was very busy with the infants. Therapy measures were instituted according to what was believed to be a purely functional disturbance.

During the school year Judy became constantly more rigid and organizational. Her art (figs 225 and 226) reflected this structuring. She could not wait to leave school at the end of the day, it seemed, and often had her coat on a half hour before dismissal.

Figure 225. Person by Judy, 8 years.

Figure 226. Flower by Judy, 8 years.

At the end of her third-grade year, she produced a second H-T-P drawing series (figs 227, 228 and 229). The human figure was highly stylized and looked like a mechanical robot. The tree, like the previous gas station pump, was structured with a barrier form. The house revealed a new factor. The roof had a very regular pattern in the structured form on the right side, but a very disorganized pattern on the left. This suggested a bodily imbalance and hence neurological handicap. The parents were again called, and they replied that she had suffered encephalitis at just a few weeks of age and had been placed on medication until about school age. They added that she had just suffered a cerebral seizure. She was given a thorough physical examination and placed back on medication. Her emotional disturbance had a deeper and more significant neurological etiology.

The following year her condition tended to deteriorate even though medication continued. While the structuring of the forms persisted, the space-time orientation of the body began to fragment. Rotation to the right (figs 230, 231 and 232) was evidenced to some degree in all of her work.

Signs of the loss of physiological identity are evident in the human figure drawings. In figure 231 the person throwing a ball is drawn by the use of small dashes, and the hands are small starlike forms. In figure 232, a self-image, Judy draws the figure with a chest-of-drawers neck and, by that means, suggests the cutting off of the psychic

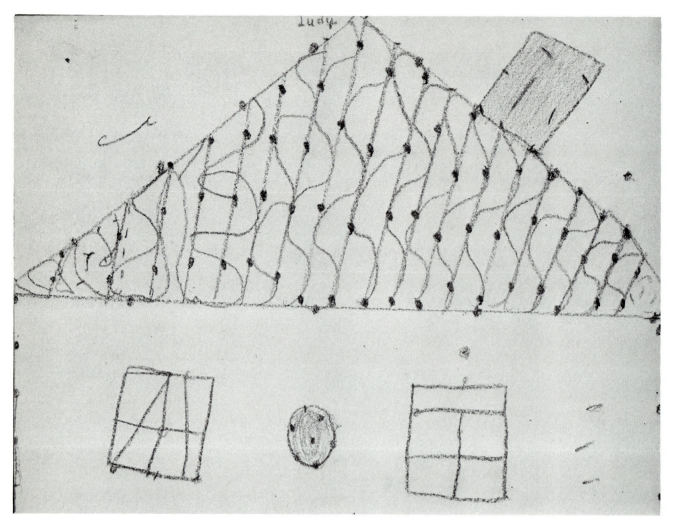

Figure 227. House by Judy, 8 years.

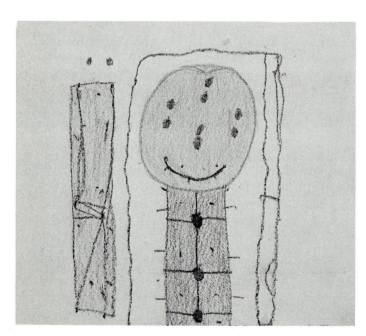

Figure 228. Tree by Judy, 8 years.

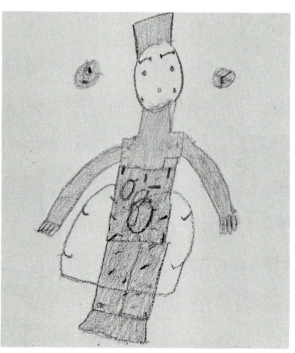

Figure 229. Person by Judy, 8 years.

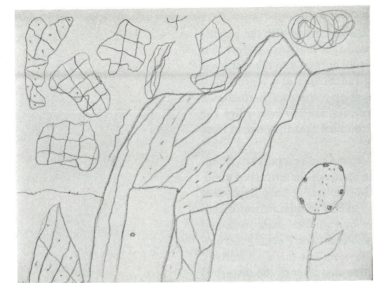

Figure 230. House by Judy, 9 years.

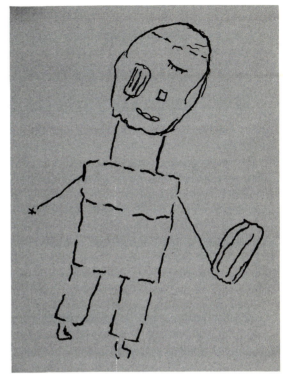

Figure 231. Person by Judy, 9 years.

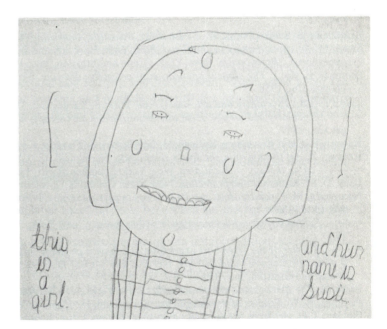

Figure 232. Self-image by Judy, 9 years.

head from the physical body. Notice the double pupils in the eyes and the balancing from the center as evidenced in the symmetry which extends outside of the body to two vertical marks. These marks indicate a desperate attempt to "balance" or maintain one's self in the temporal space of the environment.

After Judy's fourth-grade year, the family moved and no further records of her progress have been made available.

Figure 233. Shawmite by Mary, 11 years.

Mary obviously was too alert to be mentally deficient. It was decided to work with her through art several times a week and develop general overall strategies regarding our approaches through consultation with her teacher, foster parent, school psychologist, principal, and social worker.

The most significant point to start appeared to be the figure of the Shawmite. We asked her to draw Shawmite and she willingly produced figure 233. Then, knowing that children strongly identify with the images that they most fear, we sought to extend her reference regarding this monster with questions. What does he eat? Who lives with him? . . . but all to no avail for Mary would twist her hair and clench it more powerfully in her teeth.

After several sessions she began to respond to questions slipped in just as she was finishing her drawing of Shawmite. When asked if she liked Shawmite she stated that she loved him but was afraid of him because he is "the Bad Murderer." When asked where he lives she said, "In the water." Eventually Mary told how the Shawmite, as the Bad Murderer, was coming to take her to drown her in the water. At this point she covered a paper with black crayon which she said was the water (fig. 234) and held it up to her face, laughing in a shrill voice and saying "He is murdering me."

Her story was repeated for several months with only minute variations and the image of Shawmite became a threatening face with appendages at the bottom suggesting legs of some type. Mary produced hundreds of these and cut most of them up immediately after producing them. It was felt again that the Shawmite image in some way must contain the significant key to her disturbed identity. (See figs. 235 and 236).

The eye of the Shawmite was of particular interest in that they were formed by circles with a vertical pupil rather than by circles with a round pupil. The drawing of the eye was identical to drawings by two year olds who draw their first person in the context of a circle representing the mother (see fig. 7, and the context of the "child bound-up emotionally with the mother"). This suggestion in the Shawmite's eye, along with the emphasis upon water in Mary's story, raised the question of emotional fixation in infancy regarding the child in the context of the mother—even to the point of a physical-emotional relationship as at birth or in the pre-birth state.

Figure 234. ''Shawmite is drowning me in the water,'' Mary, 11 years.

Figure 235. Shawmite by Mary, 11 years.

Figure 236. Shawmite by Mary, 11 years.

With the eye of the Shawmite in mind the therapy sessions began to place emphasis upon this feature. Mary was asked what the eye saw, if the eye was opening, etc. She responded by drawing the eye itself over and over (fig. 237A). Then, without any stimulation, Mary drew figure 237B and stated, "This is the eye I'm afraid of." This comment was almost immediately followed by, "People are born out of the eye." Now, as Mary began to identify experientially with the level of her emotions at birth, a new form was given to the Shawmite. The form was not easy to identify as a fetal horse at first (figs. 238 and 239) but very soon it became evident (figs. 240 and 241). The horse is symbolic as the image of the primitive unconscious (see fig. 1) and in myth was produced from the sea by Neptune who is usually seen driving three horses from the sea with his trident. The birth imagery in such illustrations is evident.

At this point when Mary was beginning to tear and cut paper into beautiful forms, she was given a large ice cream carton. Spontaneously she created the beautiful sculptural form of Shawmite in figure 242. She would hold this figure of Shawmite by the neck and dance about the room happy as a lark.

In subsequent sessions she was provided with large sheets of butcher paper up to ten feet long. From them she cut and tore more Shawmite images which resemble the horse and which have fewer appendages and thereby seem to approach closer to reality (figs. 243, 244, and 245). Then one day Mary produced the "Shawmite" with a thousand eyes (fig. 246). This figure appeared almost human with two "arms" and two "legs" but with no head. The body was covered with the "eye" form as if to clarify that the mother's body is producing eggs or wombs with fetal people inside—ready to be born.

Figure 237A. Eyes by Mary, 12 years.

Figure 237B. "The Eye I'm Afraid Of"— "People are born out of the Eye" by Mary, 12 years.

Mary's final work was torn from an automatic washer carton which when extended was seven feet long (fig. 247). She called this human form "an astronaut" after having seen a space shot on TV. The figure has two arms and two legs, two large eyes with lashes, and "grid" lines cover the body surface of the figure. Mary took this human figure, placed it in a sitting position in a rocking chair, and then she herself sat across the lap of the figure—pulling the arms about herself and putting her thumb in her mouth. Mary, with her self-created "mother" had finally been "born" into reality.

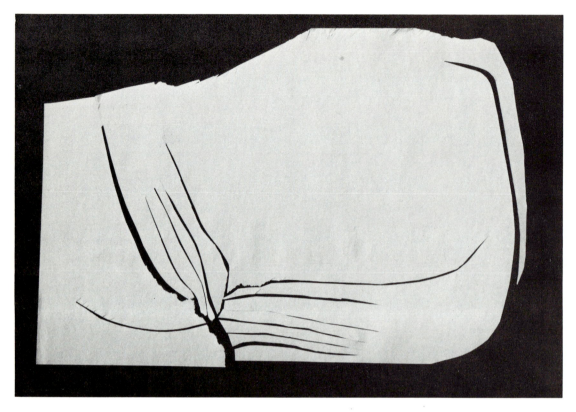

Figure 238. Shawmite by Mary, 12 years.

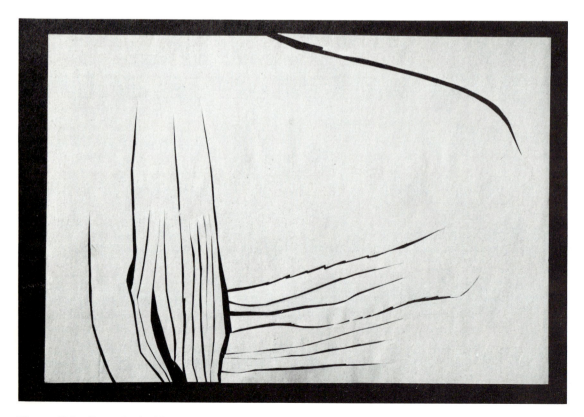

Figure 239. Shawmite by Mary, 12 years.

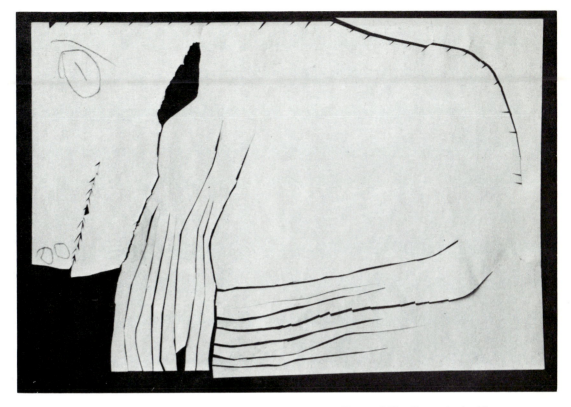

Figure 240. Shawmite by Mary, 12 years.

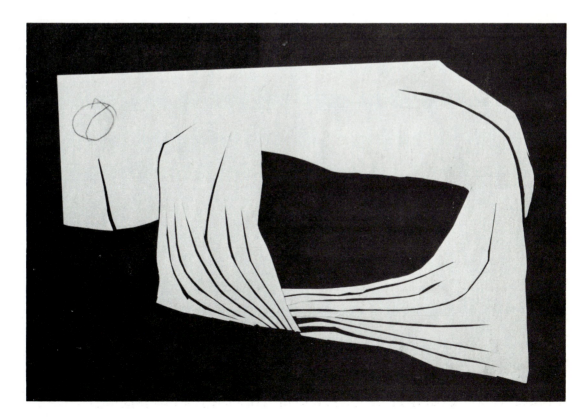

Figure 241. Shawmite by Mary, 12 years.

left: **Figure 242.** Shawmite by Mary, 12 years (Cut from round ice cream carton).

below: **Figure 243.** Shawmite by Mary, 13 years.

Figure 244. Shawmite by Mary, 13 years.

Figure 245. Shawmite by Mary, 13 years.

Figure 246. "Shawmite with a thousand eyes" by Mary, 13 years.

Figure 247. "Astronaut" by Mary, 13 years.

(Not long after this Mary's foster home released her and she was sent to a state hospital. We had worked with her two years to see her begin to move into reality— but now she is lost in a bureaucratic institutional system and we have not been able to continue our work with her.)

The Case of David

Children in our society who are seriously disturbed by the parenting influence often progress in an ambulatory sense for many years before notice is taken of their dire inner structuring. Some disturbed children are recognized early and their needs are assessed but the treatment process is only partially introduced or is lacking altogether. A few children, due to unusual circumstances or the severity of their need, are not only recognized and evaluated early in life but they as well receive the continuous intensive therapy which is necessary to enable them a chance to fulfill their potential. The case to be considered is of this rare and latter type.

Soon after David was born his mother reported that he cried excessively and all of her efforts to console him were to no avail. As a result she became very frustrated. By the age of eight months he actively resisted being held and preferred to lie in his crib.

His parents were unable to cope with him and he was examined by a psychiatrist who subsequently diagnosed him as suffering from infantile autism. At one year David could not be weaned from a bottle to solid food. He also resisted toilet training efforts vigorously and spent most of his time either rocking or pounding the wall. An attempt was made to treat David at a child guidance clinic but the parents were found to be very critical of the clinic and soon declined to bring him in for therapy. It soon became evident that they were having severe marital difficulties.

By eighteen months David was becoming increasingly destructive and would not tolerate human contacts. Most of his activity involved twirling, rocking, clapping, and odd posturing. He rarely made eye contact. A thorough examination at the Langley-Porter Neuropsychiatric Institute in San Francisco revealed no significant basis for physical etiology and his IQ was assessed to be approximately 40. At two years ten months David was again examined and he was recognized as mentally retarded with a mental age of less than 14 months. He was hyperactive, very irritable, and agitated. He used no speech, could not feed himself, and was not toilet trained. His parents were separated and his father overdosed on sleeping pills. A few days later David's father shot his mother and killed her and he then shot himself and died.

David's foster mother at the Woodcare Home visited him in the hospital and found him initially to be "like a crotchety old man." He was in a crib wearing diapers and was moving constantly so that the staff had found it necessary to place a board over the crib to keep him from falling out. He would flash his hands before his eyes and seemed to be fascinated by the light and shadow effects. The foster mother even at that first visit found a very positive relationship in interacting with David. She asked him if he wanted his toes tickled and he put his foot out. She touched his toes but withdrew her hand before he pulled his foot back. She has been interrelating in the same positive encouraging manner with David over the past nine years. At first he hit himself, rocked in his crib, and banged his head a lot. He soon desired to be held but continued to scream much of the time. At first he would eat no solid food but soon responded to crackers. Then a dish was placed near him much of the time which he constantly emptied.

After one year in the foster home David began to develop significantly. He was a constant performer, responding to singing and clapping by rhythmic bodily responses. He was now functioning at two years though his chronological age was now almost four years. He began to say a few words like "mama" and "papa" and was assessed to be functioning on a moderately retarded level. He remained hyperactive and was medicated with Mellaril.

David was not placed in a school program until nine years of age but was tutored at home. By the age of six years ten months his drawings attracted notice, as an expression of his development, and as a means for working-through developmental tasks. His first drawings were maze-like productions (figs. 248 and 249) which indicated that he was expending a good deal of energy in an attempt to structure the ego. Or, we might state that he was attempting to develop self-identification by forming an awareness of interactions with his environment. Usually such effort becomes evident by four years but in David's case much more effort is being, and perhaps will continue to be, placed into the task.

Part of this "getting organized" effort is expressed in mechanical interests. In figure 250 we note his "House with Electric Wires" and in figure 251 he drew himself as "sad" because he could not play with the dishwasher, refrigerator, and washing machine like his "happy" friend to the left. Keeping David from operating all the gadgets in the house was a major task at the age of seven. His "House" (fig. 252) became at times a highly elaborate aesthetic form *indicating that the aesthetic richness of the child's art production is intrinsically related to the developmental task of structuring and maintaining the ego.* In figure 253 we note that even an art therapist may become

Figure 248. Drawing by David, 6 years.

Figure 249. House by David, 6 years.

a "bugging force" which must be organized. David had been "highly encouraged" to draw when he did not wish to do so and finally responded with this drawing of "A Man in Jail."

Due to his weak ego strength many forces appear threatening to David. He utilizes various subjects to symbolize aggression and retaliation as he develops the "give-and-take" transactions of reality. At first the over-powering forces of retaliation are por-

Figure 250. "House with electric wires" by David, 6 years.

Figure 251. "Happy" and "Sad" by David, 6 years.

Figure 252. House by David, 6 years.

Figure 253. "Man in Jail" by David, 7 years.

trayed as monsters (fig. 254). They may be best evidenced as the controlling and re-
taliating mother figure (even though they have a penis) and there is also some suggestion
of uncontrollable Id forces which overrule the weak ego as we see in figure 255. Here
David's monster is about to bite "the lady in the striped dress" (his foster mother wore
a striped dress that day). David in real behavior was indeed a "biter" at this time and
some of his drawings (fig. 256) took on piranha-like characteristics. His foster mother
finally retaliated sufficiently to stop the behavior by stating, "David, if you bite me
again I will bite you right back!" From that time on the aggressive instincts have be-
come somewhat more internalized.

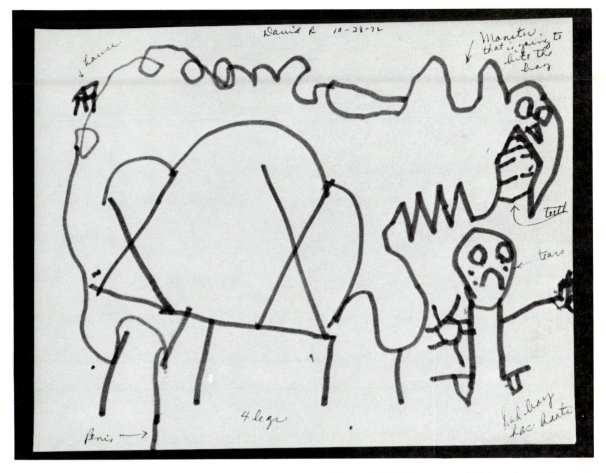

The handwritten annotations on the drawing read: "David R 10-28-72", "Monster that is going to bite the lady", "teeth", "tears", "4 legs", "penis →", "Lady that has teeth".

Figure 254. Monster retaliating on David, 7 years.

Figure 255. "The Monster Will Bite the Lady in the Striped Dress," David, 7 years.

Figure 256. "Biter" by David, 7 years.

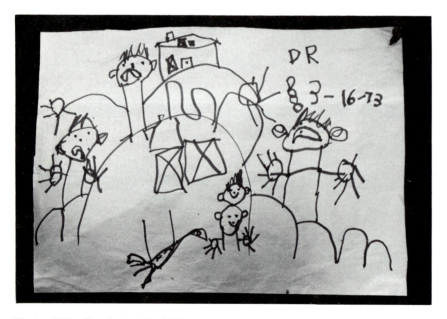

Figure 257. Drawing by David, 8 years.

During David's eighth year the socialization process is evident in spatial sharing through baselines (fig. 257). There is even a tendency toward overlapping of forms as a move in representing spatial depth. The aggressive relationships which earlier involved biting monsters now are related by storytelling which utilizes the boy and a dog as the chief characters. In figure 258 David states:

Mother has gone to a cabin in the snow and left the boy alone. The dog is going to bite him. He will bite the dog. The boy is sad because the dog bites his eyes out and he can't see.

Here separation of the dog from the boy by the form of the house again indicates how significantly spatial relationships are being utilized. In figure 259 David was asked to draw a dog after which he was asked, "What is the dog doing?" He immediately drew a boy in the dog's mouth being bitten. He stated,

Figure 258. "The Boy and a Dog" by David, 8 years.

Figure 259. "The dog bites the Boy" by David, 8 years.

After the dog bites the boy the boy goes to the hospital. When he is well he jumps down (large figure) and breaks the dogs back.

When almost nine years David was placed in a private special school for a few hours a day. By this time he had developed into an active talkative fellow who was very responsive. It was noted in testing him for entrance that his thought processes would become somewhat disconnected at times. He was often able to stay in touch for 30 minutes but after that would become tired and would refuse to continue. His visual-motor skills were about one year late and his fine motor skills were poor. His reading placement was at about the third grade level and it was noted that he had a very active fantasy reference with poor ego control. Many of his drawings indicated a continuing struggle to maintain the ego through strong structuring or grid forms. Often the forms suggested a restrained hostility.

Figure 260. "Straw Hat Pizza" by David, 9½ years.

At nine and one half years a "Gang Age" perspective began to appear in David's drawing (fig. 260). Some typical schematic features such as "x-ray" views remained but they were combined within the general view with elevated plane. Such elevated views of the whole neighborhood reveal very strong social orientation and suggest that the school environment was substantially aiding David in developing peer orientation.

Power interchanges at this time were often expressed between humans and caged monkeys (fig. 261). Often David continues to draw large structured buildings which are called hospitals and very often are called "The Davyland Hotel." These subjects suggest that he continues to structure and defend a fragile ego. There are times yet when the conflict of his environment finds him momentarily regressing to a rocking activity which was typical in his early years.

At ten years of age David was placed in a normal fourth grade classroom where he immediately made a fine adjustment. His "Trampoline" (fig. 262) reveals his growing self confidence. Presently David is a superior student in a fifth grade class.

His drawings often deal with power plays but they lack the former aggressiveness. A tongue-in-cheek humor now is taking place as we see in figure 263. Two small figures argue over going into a building that has a keep out sign on it while a giant figure states, "Don't let that kid tell you what to do or I will hurt both of you. You hear me?" A bird flying by says, "I better walk, he is a biggie."

David's development indicates how early disturbance from parental influence may largely be resolved by a total program of foster home treatment which includes art therapy. In fact, the creative-aesthetic functioning often appears very high in such cases where in normal circumstances such potential may not be as highly realized. (Note the cooperative 4′ × 5′ oil-egg tempera painting painted by David, Hal, and Scott—fig. 264.)

Figure 261. "Have a Good Time Monkey" by David, 9½ years.

Figure 262. "Trampoline Class" by David, 10 years.

Figure 263. "Don't Let That Kid Tell You. . . ." by David, 10 years.

Figure 264. Oil-Egg Tempera Painting by David, Hal, and Scott.

Summary

The cases of Mary and David indicate to us how very important early and consistent treatment is for the therapy of the child. While Mary did begin to move into reality over a two year period of treatment, she was much older and progress was somewhat slower due to that factor. She also indicated slower progress perhaps due to some lack of consistency in the total team function of those working with her. Society had shifted her from one foster home to another for years and thereby she suffered a multitude of rejections along with the initial rejection from her own mother. This is the manner in which we perpetuate a child's disturbance in order to satisfy our own needs. Placing her finally in a state hospital, where she would undoubtedly regress, was society's final act of indifference to her needs. Mary's case does on the other hand benefit us in that it indicates how art experience becomes a vehicle for therapy. Not only did Mary communicate to us through her art that we might understand her, but her art became for her a vehicle for experiencing physical-emotional identities which had completely blocked her development into, and with, reality.

David's case is altogether different for it is a success story rather than a tragedy. He was taken out of his troubled environment into arms which provide consistent loving care—even to this day. There was no shifting around from one place to another. He has been treated with *real* love as his foster mother has acted toward him in *his* interests according to *his* needs. Therapy in his case has been a total effort involving consultation with a psychiatrist and social worker. However, the foster mother has been the key individual by providing parental love and positive reinforcement. She has structured her home around art in the general sense—including projects for her boys like building a tree house and encouraging multimedia explorations. We note how David's art beautifully reflects his developmental therapy over the years—expressing his flexible adjustment as a highly creative person.

References

Bender, L. *Child psychiatric techniques.* Springfield, IL: Charles C. Thomas, 1952.

Bettelheim, B. Joey: A mechanical boy. *Scientific American,* March 1959, 2–10.

————. Schizophrenic art: A case study. *Scientific American,* 1952, *186,* 30–34.

Glasser, W. *Reality therapy.* New York: Harper and Row, 1965.

Kramer, E. *Art as therapy with children.* New York: Schocken, 1971.

————. *Art therapy in a children's community.* Springfield, IL: Charles C. Thomas, 1958.

Naumburg, M. *Psychoneurotic art.* New York: Grune and Stratton, 1953.

————. *Studies of free art expression of behavior problem children and adolescents as a means of diagnosis and therapy.* Nervous and Mental Disease Monograph Series, 1947, *71.* New York: Collidge Foundation.

————. *Schizophrenic art.* New York: Grune and Stratton, 1950.

Pickford, R. W. *Studies in psychiatric art.* Springfield, IL: Charles C. Thomas, 1967.

Rothenberg, M. The Re-birth of Johnny. *Harpers,* February 1960.

Schatzman, M. *Soul murder.* New York: Random House, 1973.

Schreiber, F. R. *Sybil.* Chicago: Regnery, 1973.

7 Art and the Violence Prone Personality

Since fifty-seven percent of violent crimes against persons in our large cities are committed by youths aged ten to seventeen years, it is imperative to understand what is behind this statistic. Most of us have difficulty identifying with the inner dynamics of those who commit such violent acts as aggravated assault, homicide, and rape—in a sense such crimes are unreal in their shocking and dramatic character. Since art expression provides a total reflection of psychical functioning it is our purpose now to utilize it in viewing acts of violence through the projections of human thought and feeling. Perhaps art will thereby enable us to more fully assess the causes of violence among youth and provide insight for therapy in correctional facilities for youthful offenders.

Homicide

The first case that we will consider is a sociopathic young man who committed a homicide and was subsequently institutionalized. He is seventeen years of age. Sociopaths have, in the past, been labeled "psychopaths" and now some are referring to them in terms of a "defensive character neurosis." The most significant feature of this type of personality is that they commit violent acts with a seemingly lack of emotional response to their deed. It is evident from this that they are responding *reactively* and that the actual criminal situation and deed relate as a substitutionary image to a hidden, but very real, influence. In short, society and the individuals who compose society become the recipients of anger basically directed toward people and situations who have personally and closely molded the inner life of the youth. Our youthful murderer thus reacts in a strong aggressive-defensive stance (fig. 265). As the wild animal he emerges from his lair to face a hostile society of wolves who attack him. Here the explosive instinctual level is operating in the form of animals and we feel in such "impulse dyscontrol" that the ego is no longer able to contain the surge of emotions which underlays the violent personality.

The grandiose stand taken by this murdering youth may easily be seen as an act of extreme desperate compensation. The degree of compensation may be evidenced to be as extensive as the projected image itself. In this case, where the youth identifies *as* Christ (fig. 266) it is evident that he is severely inadequate. Abrahamsen states:

> When a man commits a violent crime, it is invariably founded on his unconscious feeling that he must show his mother that *he is not insignificant* and is able to take revenge upon her for rejecting him. These feelings are grouped around his Oedipal helplessness— 'The struggle against passivity,' as Freud termed it—and his attempt to restore his self-esteem. (Abrahamsen, 1970, p. 102)

The Oedipally based homosexual threat is indeed evident in the inner struggle as we view the effeminate qualities of this subject's next two works (figs. 267 and 268). The human figure of figure 267 is difficult to discern clearly as male *or* female and the up-turning of the collar and the jester's hat in figure 268 suggest an over-clothed man who is ashamed of his body and experiences a lack of virility. Bromberg speaks to this point:

Figure 265. Painting by Douglas, 17 years.

Figure 266. "Christ" by Douglas, 17 years.

Figure 267. Person by Douglas, 17 years. **Figure 268.** Jester by Douglas, 17 years.

> There seems little reason to doubt that assaults and homicides by young men perpetrated on persons they meet by chance, and for whom little or no enmity exists, are motivated by reactions to buried homosexual elements. . . . It is the individual who may be struggling with homosexual tendencies, or whose ego is poorly integrated, who is triggered into an aggressive act. (Bromberg, 1965, p. 116)

Such weak or fluid ego boundaries are invariably due to poor superego controls arising from an inadequate or absent father. The youth has little chance in such a state to diminish his grandiose fantasies which provide the fertile ground for violent acting out. It is the inadequate father who is so often seen brutalizing the son—projecting his wrath *into* the son. Is it any wonder that the youth can "justifiably" beat up an older man on the street with no apparent feeling?

The fantasy of limitless power and violent acting out due to lack of identity with a positive masculine father figure could not be clearer evidenced than in the following case of Jose (figs. 269–272). We note in figure 269 the compensatory fantasy of inordinate strength. Figure 270 is Jose's attempt at drawing an idealized self figure but the over-clothed "shoulder padded" character of the image simply clarifies further his deep feelings of inadequacy and subsequent attempts to compensate. Jose's father rejected his boy in many ways. He constantly debased him by humiliating criticism. There was no encouragement. Physical disciplinary measures were never ministered by love and understanding as to "win" Jose to better behavior, but they were rather, usually beatings which only sealed the feelings of rejection and resentment. There were seldom moments from the abasement. It is well to note here that violence is an ego defense against a deeper intolerable anguish! Anxiety, the greatest of suffering, produces tensions which must be resolved! There is a castrating anxiety—a homosexual panic—based upon a rejecting, hostile father and an over-absorbing, close-binding mother. Abrahamsen states:

> Since anger is not socially accepted, they will repress it and become anxious, and this anxiety at times can be more disruptive than the anger. Anyone, if he is too fearful and anxious, may violently act out his anger when he is particularly threatened. (Abrahamsen, 1973, p. 9)

Figure 269. "Strong Man" by Jose, 16 years.

Figure 270. Figure by Jose, 16 years.

Violence frees from anxiety. Notice the sharp hostile features in figure 271. Horns, sharp fangs and fingers all appear. In a sense they are all phallic compensations for a lack of sexual character ordinarily seen in the form of the nose. There is a general feeling of panic and lack of adequacy similar to the character in figure 270. In figure 272 Jose reveals both the compensatory side of himself and the inadequate emasculated side. The detailed border about the drawing suggests the tensions that he is experiencing and the attempt to control his impulse life by structuring the ego. If Jose were not to release the tensions by overt violent behavior, he would probably turn the aggression inwardly and possibly commit suicide. It is not unusual to find violent acts followed by suicide.

Violence culminating in homicide may also be directed toward a woman who, as in rape, generally represents the mother. Many writers feel experiencing of the primal scene may be the origin of such hostility while others find as well that frustrations during the oral and anal periods may be significant. Abrahamsen states:

> Thwarting of oral attachment may leave the child feeling rejected, fearful, frustrated, and angry—sadistic impulses may come to the fore. . . Such individuals are dependent, fearful, passive, and frustrated to such an extent that their frustrations can sometimes mobilize their oral-sadistic fantasies into violent aggressions, particularly criminal sexual acts. (Abrahamsen, 1970, p. 117)

Such personality characteristics parallel accurately the "field-dependent" perceptual type which Witkin (1972) finds resulting from the "growth-constricting" mother. The field-dependent person is characterized by: passivity in dealing with the environment, fear of self impulses, poor control of impulses, lack of self-esteem, and a primitive and undifferentiated body image. Homicides and rapes committed by such individuals rest

Figure 271. ''Demon'' by Jose, 16 years.

Figure 272. Drawing by Jose, 16 years.

upon the premise of revenge . . . *"he must show his mother that he is not insignif-icant and is able to take revenge upon her for rejecting him. He must show her that he is not helpless, that he has the power to strike back."* (Abrahamsen, 1973, p. 42)

Our next case illustrates the homicidal youth who follows such a description. He is extremely fearful, dependent, passive,—and frustrated. He has been diagnosed as schizophrenic. (It is significant that 40 percent of one group of murderers was found to be seriously mentally ill). This subject's primitive and undifferentiated body image (fig. 273) could suggest that he falls within Witkin's field-dependent type group or it could also raise the question of cerebral dysfunction. Bromberg (1965) notes that 50 percent of all psychopaths given the EEG reveal cerebral dysfunction. Tom's human figure drawing lacks facial features and has weak arms and hands. Extreme insecurity is expressed in the lack of feet.

When Tom started working with clay he initially produced small inadequate looking bald heads (figs. 274 and 275). These portraits were pitiful just to view and the youth needed constant support to attempt further expression. After some time he responded to the idea of drawing his family and produced verbal comments as well (figs. 276 and 277). In the family drawing he is an animal to the far left which he described as "the black sheep." Next to him is a small black form which represents his brother who he called "a chip off the old block." His father is pictured as a triangular form with a mouth-down face. Mother is next to him on the right, represented by a flower with a rope which ends with a noose over the top of father's triangle. The youth stated, "Mom has Dad by a noose." (see detail—fig. 277). His sister is a rain cloud to the far right. There are other forms in the picture but these, along with the comments, very clearly revealed the interrelated identities in his family.

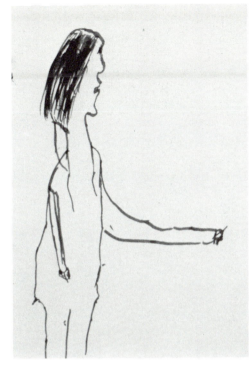

Figure 273. Person by Tom, 16 years.

Figure 274. Ceramic Head by Tom, 16 years.

Figure 275. Ceramic Head by Tom, 16 years.

Figure 276. Family Drawing by Tom, 16 years.

Figure 277. Family Drawing (Detail) by Tom, 16 years.

Tom was institutionalized for attempted murder at fourteen years of age. He had agreed to murder another boy's mother for him and, after obtaining a 22 magnum revolver, he waited in her living room while her son stood lookout. When the mother came in the front door, Tom, whom she had never met, stood before her. He shot twice and the bullets entered her right chest and right arm. She remembers only the blank look on the youth's face before she broke away and was able to call police. She has fully recovered. After two years Tom was finally able to produce a clay figure which indicated empathy with his victim (figs. 278 and 279). The face of the figure reveals shock and horror. The left arm grasps the right chest and half of the right arm is missing. The youth has become his own victim in now "owning" the reality of his violent action. Even the back of the figure (fig. 279) shows tense muscles of a body about to receive the bullets. After Tom had been able to accept and live through his actions and develop new responsibility for his behavior he was able to express higher self-esteem and strength in both his general behavior and art before being discharged. He was no longer a weak and inadequate shy loner.

Our discussion to this point has indicated how violence in youth is basically related to the parenting factor. There is little question about violent criminal acts among youth being tied to families where the father is weak and ineffective (except for brutality) or absent altogether and the mother is cold and controlling. This background becomes very clear in the following case where the death of the father became the trigger for a psychotic episode.

Larry, a twenty year old student, suddenly was noticed to "drop out" and live as a transient not long after his father's death. On one occasion a conversation was initiated with him and he was asked to describe the funeral of his father which was closed to many of his friends by the mother. He produced a drawing (fig. 280) which clarified

Figure 278. Ceramic Figure by Tom, 16 years.

Figure 279. Ceramic Figure by Tom, 16 years.

Figure 280. Father's Funeral by Larry, 20 years.

Figure 281. Human Figure by Larry, 20 years.

much of his inner conflict. In the upper left corner we note his father's tombstone and below the ground is the casket. To the right of the tombstone stands Larry and then to his own left side he drew a "black heart" which he more fully decided to clarify as his "mother with a black heart" by drawing arms and legs on it. When asked to tell about his father's death he drew a clock lower in the picture with a hand pointed to the number 18. Then he wrote the question. "Where the 18 minutes went?" and stated that his mother had called eighteen minutes before his father died to tell him that he was already dead. When asked how he felt about this he drew a tightly pressured small circle to the right—a strong symbol of the anger and anxiety which he associates with the event.

His hostility toward his mother is especially found in a later drawing (fig. 281) where the entire lower portion of the body becomes sharply pointed roots which are apparently directed toward the ground (a symbol of the mother). The upper green "receptacle" form of the body suggests identity with the mother since it as well contains the "black heart." The segmented quality of the body along with weak ineffective arms and hands are typical schizophrenic features. The dangerous condition of the patient became evident when he entered a National Guard facility and stated, "My name is Peter Gunn and President Ford sent me to get a gun." He then further explained that the gun was to "take care of the people who are hassling me on the street."

Rape

The average age of rapists is twenty-three years but there is a tremendous increase recently in this crime among adolescents. It has been found that most rapists actively masturbate at thirteen years and have regular heterosexual sex by fifteen years. Most marry early and raise families. Rape is not a sexual act of normal character—it is a

violent power-based act with roots in the family and childhood. Sex may be concealed behind violent behavior and violent behavior may be concealed behind sex.

Forcible rape perfectly exhibits how fear of the woman leads to a threatened and confused sexual identity in the male and ultimately to extreme anxiety and violence. The aim of rape is basically to physically harm, degrade or humiliate, and defile the woman—who in the end is a substitute for the mother. This explains why elderly women are raped and sometimes murdered. The parental reference of the rapist involves a weak father figure and a controlling seductive mother similar to the parents of the perpetrators of other violent crimes. A study of rapists at one large prison indicated that 44 percent of the rapist population slept in the same bed with the mother throughout childhood and 67 percent of the same group continued to show strong Oedipal desire for the mother into adulthood. Schulz states:

> In every case an erotic element in the boys' relationship with their mothers was found to be at the root of the aggressive, antisocial behavior of the youngsters. Consciously or unconsciously, the mothers have tried to have the sons replace the husbands. (1965, p. 182)

The incompatibility of the parents encourages the mother to fulfill herself in the son and the result is strong sadistic or homosexual tendencies. Stekel (1950) recognizes homosexuality as a flight to the same sex motivated by an attitude of sadism toward the opposite sex. By the same rationale we note that sadism is basically a flight from homosexuality. The brutal rapist maintains both tendencies in his violent acts for 80 to 85 percent of forcible rapes involve fellatio and/or sodomy. The aggressive hate impulses of the rapist are triggered, in 50 percent of the cases studied, by alcohol. 100 percent of rapists studied have been found to be influenced by pornography. Most significant, rapists are found to be restrained only by the child level of fear of detection and punishment—never by conscience. This clarifies the lack of a strong father figure to develop superego or conscience control. As a result rapist are very rigid and over-controlled (as a defense against loss of control). Rapists sit "on a powder keg" of tensions. And while 77 percent of all rapes are planned, and the hatred limits of violence are not planned, this crime against the woman easily spills over into acts of sadistic homicide.

The art of rapists is usually highly controlled or "hard-edged" to the extreme. Sharp forms, as penetrating aggressive objects appear and pierce objects or forms representing the female (fig. 177). In faces produced by rapists (figs. 176, 282, and 283) teeth are often presented as knife-like phallic images. (Rape is often initiated by a knife held to the woman's throat). The long flattened nose lacks the typical masculine phallic character since the artist feels a castration complex. A crown or other sharp forms becomes the displaced and compensatory image of the phallus. This explains why stabbing someone often has sexual connotations. The ears indicate the paranoid character of these individuals.

Etiology in Childhood

The answer to violence in society is prevention and that necessitates the child's security in the home with proper role models in the parents or parent. Violence is bred in insecurity, fears, and frustrations which lead to anxiety (from a fear of expressing anger). As we have seen from earlier discussion, the anger in a repressed state produces psychical illness, while, overt projection brings the threat of violence to others.

A lack of love and security expressed through unfulfilled and improper interrelationships in the home may bring a demand from the child which can be called a "danger sign," Most "disturbed" behavior from a child is, in fact, a response to abnormality in the home and a demand for normality. John, a boy of nine years, tells us a good deal about his home in a few drawings (figs. 284–289). John set fire to his house and burned it to the ground one night when his parents left him alone. He said, "It was cold and dark" and in a more deeply significant sense he was expressing the fact that

Figure 282. Ceramic Face by Rapist.

Figure 283. Painting of Head by Rapist.

Figure 284. Drawing of House and Woodpecker by John, 9 years.

there was a lack of love in the home. Normal sharing relationships were not taking place. Mother was the strong controlling parent and John places heavy color design in the image of the house itself as a result. In figure 284 a woodpecker aggressively works on a tree which could be interpreted as the parent figure. His tie to the controlling parent is evidenced in figure 286 where the paranoid defense, and crown, is expressed in the rainbow over the house. In figure 287 we note his aggressive efforts to overcome the image of the mother's dominance as expressed in the mountains. Such aggression, as we have seen, may some day turn toward her in the form of retaliation. The schizoid tendencies which John is beginning to experience are found in figures 288 and 289. The teeth begin to reveal his hostility, the structured neck begins to express separation of the psychic self from the body, and the sexual area has become a vaginal form like a "peace" symbol.

Summary

It is evident that the parenting influence is the determining factor which relates to violent prone tendencies in adolescence. Further, it is also clear that preventative measures are the answer to resolving the wave of youth crime which is sweeping the nation. Family therapy, involving art, may at least partially present a means for working with families to improve communication and clarify roles.

The violent prone individual typically comes from a home situation where the father is weak and ineffective, or brutal as well, and this factor tends to produce poor conscience sensitivity and control for the youth. The mother on the other hand is controlling and dominant. She may be called seductive and tends to fulfill her needs of affection with her son rather than with her husband. The child is not naturally loved but is rather rejected.

Figure 285. House by John. (Detail)

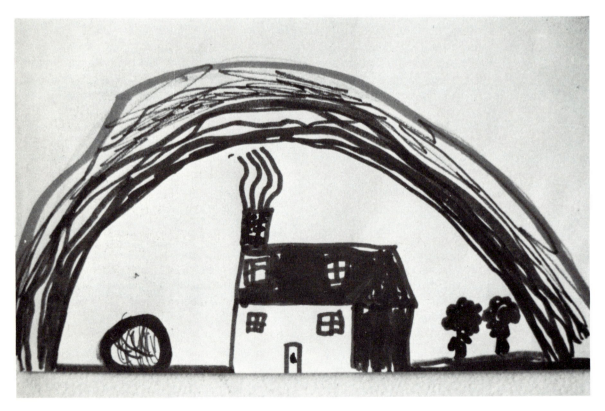

Figure 286. House with Rainbow by John, 9 years.

Figure 287. Landscape drawing by John, 9 years.

Figure 288. Human Figure by John, 9 years.

Figure 289. Human Figure (Detail) by John, 9 years.

Lack of love and improper inter-personal relationship in the home brings deep feelings of resentment, anger, and frustration in the growing child. A fear of expressing such hatred brings strong repression of feelings with resulting anxiety and guilt. The youth becomes restricted, quiet, and shy. As he grows the tension builds along with a sense of inadequacy, and one day, his primary instinctual forces overwhelm his ego controls and he commits a violent act. Violence relieves the tension. He has proven that he is not insignificant and is able to take revenge for being rejected.

Violent youths tend to be strong passive-aggressive types who typically behave in a paranoid reactive stance. Their art is often hard-edged and realistically descriptive. The body-image expresses strong feelings of sexual inadequacy and efforts to compensate. In fact, most acts of violence are in themselves filled with substitutionary sexual imagery similar to the art of the perpetrator.

References

Abrahamsen, D. *Our violent society.* New York: Funk and Wagnalls, 1970.
————. *The murdering mind.* New York: Harper and Row, 1973.
Bieber, I. et al. *Homosexuality.* New York: Basic Books, 1962.
Gager, N. and Schurr, C. *Sexual assault: Confronting rape in America.* New York: Grosset and Dunlap, 1976.
Lunde, D. *Murder and madness.* Stanford: Stanford Alumni Association, 1975.
Rappeport, J. (Ed.). *The clinical evaluation of the dangerousness of the mentally ill.* Springfield, IL: Charles C. Thomas, 1967.
Schulz, G. *How many more victims?* New York: Ballantine, 1965.
Stekel, W. *The homosexual neurosis.* New York: Emerson, 1950.
Swanson, D., Bohnert, P., and Smith, J. *The paranoid.* Boston: Little, Brown, 1970.
Witkin, H. et al. *Personality through perception.* Westport, CT: Greenwood, 1972.

PART THREE

Theoretical Considerations

Structuring and Maintaining Reality 8

What Is Reality?

They said, 'You have a blue guitar,
You do not play things as they are.'
The man replied, 'Things as they are
Are changed upon the blue guitar.'[1]
(Wallace Stevens, The Man With The Blue Guitar. Reprinted with permission. Alfred
A. Knopf, 1952, p. 3)

Material reality is found to be organized from substance which is basically energy subjugated to the bonds of time and space. Matter, according to Einstein, is energy caught in a unique balance of space and time. We may say, therefore, that unseen energy is the essence of material which we perceive with our physical senses. We may as well consider this clarification of the nature of material reality to be analogous to the nature of man, for he is similarly composed. His essence is found in the spiritual component of his being which we refer to here as *personality*. As the spiritual facet of the person, the personality is bound *to* and expresses itself *through* a material body.

Man is most readily recognized as a part of temporal reality by the physical component of his person. Usually we speak of this physical component as the *body;* but in a more technical language it is called *soma,* and its activity is referred to as *somatic function.* Often we tend to consider a man's soma to be the man but, of course, in essence it is not, for the center of man's reality must always be regarded in terms of his awareness of self. Such self-awareness lies within and is the basic characteristic of personality. Physical experiencing of a physical environment, on the other hand, indicates to us that the soma is basically a communication center which connects the personality with temporal reality. It is a house of clay to which the personality is limited while dwelling therein. Our stress upon somatic function in later discussion will help us recognize that the condition and purpose of the soma must not be overlooked. Its appearance, on the other hand, is usually overstressed.

The Human Personality as Center

Generally when we speak of personality, we are referring to expression determined by the interaction of functions which we place under the labels of *mind, emotion,* and *will.* This is the "heart" of the individual, and yet we must not confuse it with his physical heart, just as we must not confuse the mind of a man with his physical brain. They are as distinctly and essentially different as the spiritual is different from the physical and the heavenly from the earthly.

The human personality has a *rational function* which we most often consider in the word *thinking.* This is descriptive of *mind. Emotion,* in like manner, we consider in the word *feeling,* but it may more properly be regarded as the *affective function. Will* is the *responsive function,* and because it ultimately determines behavior, we often consider it the core of the human personality.

PERSONALITY

Center
of
Reality
and
Self-Awareness

Functions:

Thinking—Mind
Feeling—Emotion
Responding—Will

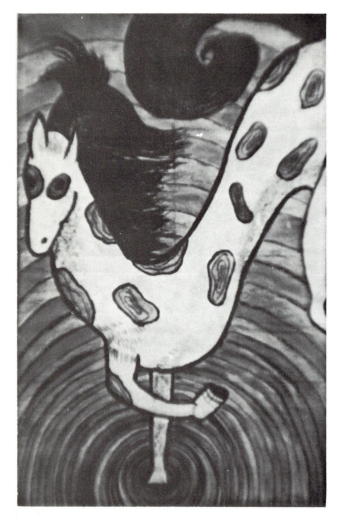

Figure 290. "Horse." Tempera painting by girl 16 years.

It is important here to note that the human mind functions on two levels: a large unconscious operation and a smaller conscious operation. For our later purposes it is also significant that while the conscious level carries with it the dominant sexual identification of the individual, the unconscious level, in contrast, holds a contrasexual image. Thus in the dominant masculine personality we have an opposite sexual image which is of a feminine character. It is the "woman" in the man and is referred to by Carl Jung as the *anima*. In the woman is found a "man" which he refers to as the *animus*. The rabbit hole in Alice's *Adventures in Wonderland* symbolically describes the devouring female characteristic of the anima. The implication of such an imagery, of course, is that the story takes place "underground" or in the unconscious mind. Poe uses a similar image of the threatening feminine unconscious in the subject of a terrible whirlpool in his story *A Descent into the Maelstrom*. In like manner, the animus of the woman in art and literature is often seen as a horse emerging and disappearing into a mist or hole (fig. 290). In this role the horse is often associated with the more primitive unconscious.

In summary we must note that man is created in a unity with the body; he is a body and a personality, but the personality, like a vapor, is not bound to remain. Perhaps this fact, among other reasons, is why the butterfly, with its erratic flight, is the symbolical equivalent of the personality or soul.

Communication through Somatic Function

The human personality is like the vacuum space of a container. It appears from birth to be just waiting to feel, to know, and to respond. We may best look upon the human soma, or body, as the container itself—it is the most immediate environment for the human personality, and anything which will become a part of the individual's reality must, of necessity, be experienced in and through the container itself.

One of man's most distorted viewpoints is that regarding his own body. He constantly lavishes much of his time on it by exercising it, feeding it, combing it, dressing it, and sleeping it. Too often it ends up being worshipped and served rather than fulfilling him by serving him. After all, what possible good is it to him or to anyone else once he finally leaves it? If we are to view the body properly, we must see it as a means to an end and not as an end in itself. We are not essentially our physical body, but it is given to us to care for properly that we might experience in the deepest and fullest respect.

While man is restricted to his body, it is the sole means for him to experience, structure, and maintain temporal reality which we note is characterized by motion. Time and space, of course, are the factors producing what we call motion. The material of temporal reality, in turn, will provide a basis for meanings found outside of the space-time reference. Such meanings will be discussed briefly at the end of this chapter.

The senses of the body provide a communicative function, and we may state that the body, then, is the physical counterpart in the total process of perception. Experiences communicated to the personality through the body are initially, and for the most part unconsciously, registered. Some experiencing is never brought to a conscious level of awareness in the mind, but it may be expressed almost entirely on a physical-emotional level. This is most often the case for exceptional children and for younger children generally. For instance, as adults how consciously aware are most of us of our bodily positioning or even of our weight on our feet? It is a very meaningful experience, but too often we do not consciously recognize such a fact until it is altered by our riding up or down in an elevator. Unconscious as most of our bodily experiencing is, it is the one source through which we constantly structure and maintain ourselves in temporal reality.

Postural status, the constant positioning and repositioning of the body, is meaningful and essential for the security we all find necessary in order to maintain ourselves. The creative personality may often be viewed as a person who identifies well in and through the body—who is very secure in himself and therefore higly flexible emotionally. Steinmetz, the electrical genius, is said to have once been asked to fix a huge dynamo, and in response he brought in a cot and slept next to the machine for several days. He then calculated and reported the necessary repairs. He had felt the vibrations of the motor in his body and could empathize sufficiently to accurately determine the need. In contrast, we often find that the exceptional child, and the normal individual generally, lacks the ability to transmit in a rational manner that same bodily sensitivity. Also, the exceptional child may receive distortions of somatic information due to some impairment within his own body.

Reality must always be viewed as dependent upon the interrelationship of the personality and the body. Through the interaction of the personality and the body, an image of one's self is constantly constructed and destroyed. Such a self-view is called *body-image*. A proper concept of body-image is basic to our later discussion of projection in art.

It is significant for our later discussion to note that the soma, or body, does serve the personality and cannot voluntarily withdraw from it of its own accord. A portion may, of course, be blocked or cut off due to injury, or the function may be distorted due to injury or illness. The personality, on the other hand, with a tremendous conceptual image mass, may of its own effort withdraw any distance from the body. Such

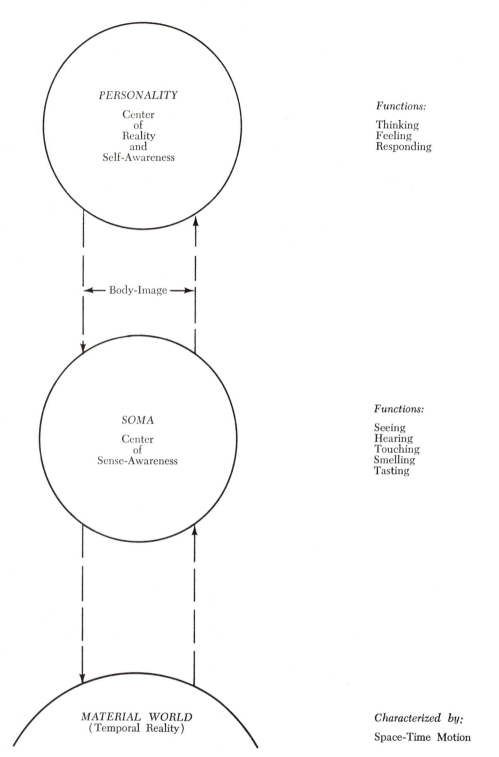

an extreme act of detachment is best labeled *disassociation.* In the event of this oc-
curring, we are dealing with psychopathological circumstances which in common terms
may be called a psychic suicide or "mental breakdown." The break is actually emo-
tional *and* mental, as the conflict affects both the feeling and the thinking functions.
The healthy personality strongly holds material reality in view as a gestalt configu-
ration by building and maintaining constantly from the multitude of interactions of
the personality, the body, and the material world.

Significance of Body-Image Projection

In dealing with art as a total reflective device for the life of the individual, we must first recognize how art allows us to stand where another has stood to see him as he expresses himself. The key to such significance in art may basically be found in what we have already referred to as body-image.

Let us recall here that body-image is not purely from the somatic reference or from the personality reference but that *it is a gestalt image of self produced through the interaction of both the physiological and personality components as they function to structure and maintain reality.* Paul Schilder called body-image "the tri-dimensional image everybody has about himself." (1950, p. 11) Sir Henry Head, an eminent physiologist before the time of Schilder, stressed the somatic function in body-image and referred to a "postural model of the body" or "schemata." (1963, p. 488) Others have discussed the body-image with emphasis upon the psychological functions, but we must reemphasize that we are not primarily interested in a definition on a conceptual level, with somatic or psychic emphasis, but rather we are interested in the implied meanings found in the total body-image function as it is expressed in art.

The implied meanings in body-image are both symbolic and organic since they are expressed from respective psychic and somatic functions. Due to the interaction just mentioned, we note that these meanings, in projected form in art, make up a composite self-view. Indeed, it is malfunction or loss of interaction of either the psychic or somatic component which provides a clue to pathology in art expression. Evaluation of psychopathology in art will be available according to the sensitivity and insight of the individual who is utilizing spontaneous art productions or a projective drawing tool as found in the House-Tree-Person Test. An "open view" of the total state of the subject, in regard to both somatic and psychic functions, may be seen by the trained observer. Herbert Read has stated in regard to this:

> . . . art is deeply involved in the actual process of perception, thought and bodily action. It is not so much a governing principle to be applied to life, as a governing mechanism which can only be ignored at our peril. (1958, p. 14)

When a person draws a human figure, or a related configuration such as the house or tree, he projects his personal body-image with all of its somatic and psychical meanings. The physical view of one's self is most readily discernible in such a projection as simple comparison often brings immediate visual corroboration. Puppet construction is an interesting activity from this point of view, for the producer works quite unconsciously and fails to recognize the projective factor (fig. 291). In most of these projections the body-image includes the subject's hair and eye coloring, and some females may spend considerable time mixing paint to produce the exact color for painting a mouth which will correspond to their own lipstick. Of even more significance, however, are the subtle exaggerations of form which reflect a phenomenal sensitivity to the basic structure and spatial extension of the body mass.

Psychical function in the body-image projection is clearly evident in the puppet's role, as the puppet first appears, and then later behaves, in a puppet production. Some individuals may generally project a passive role in such subjects as a rabbit, a squirrel, or a cat, while other personalities may produce a tough bandit, a prize fighter, or a wolf. Such roles are, of course, described by many individual exaggerations and delineations which, while symbolical, produce an overall character. Drawings will be found to be identical to the puppet in the projected characteristics, but often the individual will more readily construct a puppet than draw a person due to the greater "distance" of unconscious projection in the puppet.

In puppet construction the effect of somatic variation on the personality is evidenced many times by respective physical irregularity or an unusual role regarding the puppet. A young girl whose face was covered with smallpox scars was noted to construct an "Ugly Duckling" puppet—a clear expression of the somatic state interacting with, and

Figure 291. Bag puppet and the highly creative artist-teacher who produced it. She is confined to a wheelchair due to a polio disability.

hence affecting, the personality in the projected body-image. Such expression is simply due to the unique character of the body-image and again indicates that art, as a projective expression, is a wonderful mirror of the inner self-view.

Throughout this work the H-T-P Test will be utilized as a basic drawing reference. Its application is rapid and economical, and it is a valuable tool as a screening device or as a part of psycho-diagnostic test batteries in the case of individuals. The test is administered by giving the subject 8 ½-by-11-inch white drawing paper and a No. 2 pencil with eraser. On separate sheets of paper the subject is instructed to draw a house, a tree, and a person. Often, with children, the Drawing of the Family is added for further insight. Protocols for the test will not be discussed separately here but may be found in a great body of other available literature. Our purpose is simply to describe the operating principles upon which such tests are founded while we discuss the needs of the exceptional child.

Symbol in History and Personality

In the Book of Proverbs we read, "The spirit of man is the candle of the Lord, searching all the inward parts of the belly." We may say that the spirit component of man is, therefore, the center of God-consciousness and a means of communication with transcendent reality, just as the physical body is a means of communication with material reality. The communication of the spirit, however, must be understood to be in regard to *meanings* which are spiritual. The previously discussed factors of physical

experience provide the concept basis through which spiritual meanings are discerned. Thus we may say the "inward parts of the belly," as the physical concept basis, must be searched by the spirit itself to discern meanings of symbolic character. John Chrystostom once said,

> If man had been incorporeal, God would have given him purely incorporeal gifts; but since his soul is joined to a body, things suprasensible are ministered to him by means of sensible things. (cited in Hulme, 1899, p. 5)

In determining meaning in reality structuring we must ask, "Is seeing believing or is believing 'seeing'?" The spiritual "seeing" we are discussing assumes symbolic meaning in physical content, *for the language of the spirit is the symbol.* This is most logical, for we recognize that symbols are not dependent upon the space and time characteristics of temporal relationships. All temporal life experiences, on the other hand, are symbolical when we view them from the spiritual level. As we shall see, real meanings in life are found when we understand temporal experiences on the spiritual level through the language of the symbol.

For matters of clarification of function we have categorically separated the personality and the *spirit* of man. When the components are united, as many people prefer, they would best be spoken of as *psychical*. Some would even prefer to consider spirit a function of the personality. While this would be acceptable in most discussion, we prefer here to differentiate the two in order to clarify the functions involved for the communication of experiencing in reality structuring.

It is evident from our discussion that the temporal reality of the material world and the spiritual reality of the symbol both communicate initially to the unconscious level of awareness in the mind. However, there is far greater tendency for temporal experiences to rise to consciousness—and be recognized for what they are on their surface level of meaning—than for their symbolical significance to become evident. Most often the spiritual implications of the experience are, therefore, only unconsciously "known." This fact, of course, implies the danger of symbolic content to the mind—something the advertising man is well aware of in taking advantage of us. We should be careful regarding the choice of experiences with which we decide to populate our minds.

Further, and especially pertinent for our later considerations, is recognition of the mind as the center of a battlefield for psychic identification and acceptance. It is here that the hermaphroditic "gods" of the anima and animus wage their warfare and the individual's "old man" or "old woman" threatens the field of consciousness. The conscious mind performs a censorship function for unacceptable facts by forcing them into the unconscious. Often, however, the process of art or dreams will indicate the manner in which they attempt to force themselves back into some degree of consciousness.

A dream may be very vivid in its imagery but be "lost" the moment one becomes fully conscious. In an attempt to recapture the unconscious factor, we often seek to return to the sleeping state to "finish" or resolve the image. We fail to actually bring the dream to consciousness, but even if we were to be successful in the attempt, it would remain on a purely symbolic level. As such it would continue to hold its fascinating and puzzling character. Such a course of events is to be expected, and we must now understand the dream more deeply to see the spiritual communication conveyed through its symbolic imagery.

Dreams are symbolical. They are most probably static images which, at the moment of awakening, are fused together into the characteristic motion of consciousness. The example of Alfred Maury's famous dream is a case in point. Maury dreamed himself a subject of the French Revolution who was sent to the guillotine after having been tried and convicted. His dream, however, appeared to be obvious instantaneous reaction formed from the physical shock of the bedrail, just above his head, falling across his neck, thus triggering the dream by the culminating sensation of the guillotine blade on his neck.

REALITY STRUCTURING

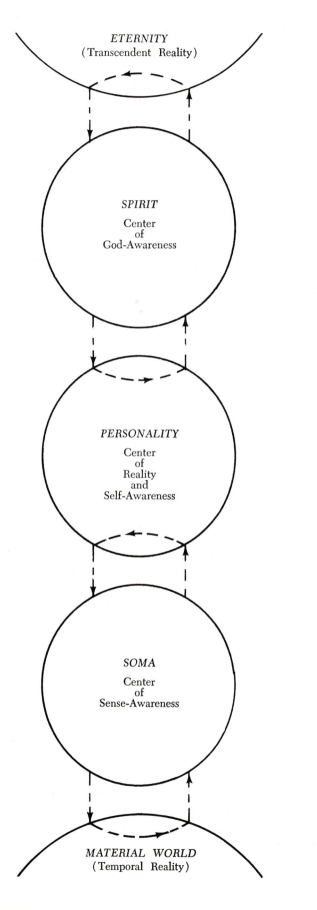

Characterized by:

No Space-Time

Functions:

Symbolic "Seeing"

Functions:

Thinking
Feeling
Responding

Functions:

Seeing
Hearing
Touching
Smelling
Tasting

Characterized by:

Space-Time Motion

It was Maury who attempted to indicate that all dreams have a physical origin. Subsequent study, however, has suggested that dreams are of at least three sources of origin. These three levels correspond to the three components of man: soma, personality, and spirit.

The first, the *somatic dream,* is clarified by Isaiah:

> It shall even be as when a hungry man dreameth, and behold, he eateth; but he awaketh and his soul is empty; or as when a thirsty man dreameth, and behold, he drinketh; but he awaketh, and behold, he is faint, and his soul hath appetite . . .

This statement describes well the physically based dream. The real bodily need in such a case activates the memory images leading to satisfaction in the unconscious mind.

A second type of dream may be called a *soul dream.* In this type of dream the human personality attempts to work out in unconscious symbolism a successful conclusion or "fulfillment" of that which in conscious life is a basis of difficulty and anxiety. Jeremiah in regarding false prophets speaks of this type of dream as "your dreams which ye cause to be dreamed." Most people recognize the matter of wish fulfillment and problem-solving in such dreams. It is logical that such activity should not only be sought and continued in sleep, but that it also should be more highly "colored" and enhanced. Anxieties, as found in such dreams, are often symbolically expressed in sufficient clarity to provide an excellent basis for counseling. A young woman, for instance, who was greatly in fear of pregnancy spoke from the following dream reference in a counseling session:

> I found myself opening the hall door which leads down into the basement. The entire basement was filled with a huge plastic bag in which two bear cubs were fighting over vegetables on the floor. I slammed the door in fear knowing that when they finished the vegetables they would come upstairs and raise havoc.

This dream appears immediately to be bizarre but actually holds only a thin disguise over conscious recognition in the mind. The door is the entrance to the womb as signified in the image of the basement. The plastic bag is the amniotic sac, while the bear cubs are obviously two fetal infants nourished within the mother. The woman fears that their birth will bring a mental-emotional disturbance as expressed in the phrase "havoc upstairs."

The third type of dream, the *spirit dream,* is the most difficult to clarify because of its origin outside of that which Jung calls the "biological substrate." These dreams tend to evade rational examination because they are *transcendent* in nature and origin.

From the dream, and from art as well, we may say that symbol is the one truly universal language. While the experience upon which it is based enters through the senses, it is basically spiritual in character. The fact that art communicates meanings across the time and cultural barriers of history reveals and verifies the spiritual character of symbol. Cirlot states:

> . . . symbolism adds a new value to an object or an act, without violating its immediate or 'historical' validity. Once it is brought to bear, it turns the object or action into an 'open' event. . . . (1962, p. xiv)

He further states:

> The symbolist meaning of a phenomenon helps explain these 'intimate reasons,' since it links the instrumental with the spiritual, the human with the cosmic, the casual with the causal, disorder with order, and since it justifies a word like universe which, without these wiser implications, would be meaningless. . . . (p. xiii)

That man is ministered to through the symbol is evident, and symbol is therefore basically anthropomorphic—spiritual but in man-form. Consequently, the symbol has a perfect continuity of meaning on the archetypal level. Jules Le Belle states:

> . . . every created object is, as it were, a reflection of Divine perfection, a natural and perceptible sign of a supernatural truth. (p. xxx)

Figure 292. "Cain and Abel" by boy 7 years.

Because man is created in the image of God, the "prints" reflect the "Imprinter." Symbol is innately a part of man's being. In final analysis we must agree with Cirlot:

> This language of images and emotions is based, then, upon a precise and crystallized means of expression revealing transcendent truths, external to man. . . . (p. xxx)

While some variation of meaning will undoubtedly occur within the context of the individual's personal and social reference, archetypal levels of meaning remain consistent. No one teaches the child that the sun is the God-Father image. The symbolism is inherent to the child's spiritual awareness. In figure 3 we note how wonderfully a child utilizes the archetypal symbolic meaning of the sun to tell the story of Cain and Abel. The sacrifice of Abel is received by God through the image of the smoke rising, while Cain's sacrifice is rejected in the returning smoke, due to its bloodless character. No question need be asked regarding the sun as a symbol for God.

In figure 293 we note how a five-year-old child represents the family—three flowers for the three children and a large sun for the strong father-image. The mother in this family was institutionalized, and the father was raising the children by himself.

Mother may be symbolized in dreams or art by the moon, water, a house, or a mountain. Ground, in a general sense, is one of the most common symbols for mother. We all have heard of the mother in the following Mother Goose rhyme:

> There was an old woman lived under the hill
> If she hasn't moved she lives there still
> Baked apples she sold and cranberry pies
> And she's the old woman who never tells lies.

This description is simply typical of the earth mother-image most mothers provide for the child. Such a mother loves and nourishes, she never lies, and of course never changes in the eyes of the child. Figure 294 provides a contrast to this image. To this eleven-year-old boy, the mother is cold and dominant; the father is weak and ineffective. The

Figure 293. Painting by boy 5 years.

Figure 294. Landscape drawing by boy 11 years.

Figure 295. Tree drawing by boy 10 years.

Figure 296. House and Tree drawing by boy 16 years.

boy himself, in the self-image of a tree, tries to rise above the mother but often is defeated as is indicated in the drooping foliage. His further attempts to defend or separate himself from the mother is evidenced in the fence.

While the tree may often be an image of self, it may be an image of mother as well if the individual is highly bound up with and dependent upon the mother (fig. 295).

In figure 296 the same type of squirrel's hole is seen, but along with that dependency form, this sixteen-year-old boy indicates his close association to mother by placing his small, effeminate house next to hers.

Other Significant Psychological Theories

Our consideration of human personality in structuring and maintaining reality has been presented from a basic viewpoint apart from the formal psychological theories of this century. This has been purposefully done in order to avoid numerous terminologies as well as association with only one, or even a few, positions which characterize today's study of human behavior. However, while remaining eclectic, and even independent, in subsequent discussion it is imperative that the basic psychological movements of our time be given consideration in regard to their organization and benefit. Much will be drawn from them in the proposed evaluative-diagnostic and teaching-therapy methods which follow and a critical understanding of their origin and philosophy appears to be in order here. We need to recognize especially how psychology, as the study of human behavior, rests basically upon philosophical thought in the culture.

There are three major movements in 20th Century psychology: the Behavioral Movement, the Psychoanalytic Movement, and the Humanistic Movement. Each of these movements will be briefly discussed here with definitive application made later in the discussion of the exceptional child. Since comments here are brief, further reading from the bibliographic references at the end of the chapter is strongly encouraged.

Behavioral Psychology

This movement originates from a searching of nature for truth through observation, and, use of the empirical method. It is typical of a deistic-material age. Proponents of behavioristic theory believe that all behavior is due to environmental conditioning. From J. B. Watson, father of the movement, to B. F. Skinner (*Beyond Freedom and Dignity,* 1971), they deny the exercise of human will and the moral choices associated with autonomous human identity. To the behaviorist personality *is* merely conditioned behavior! It is from the effect of this movement and its teachings that greater impetus has been given to political and social organizations which seek to change society by improving conditions rather than by motivating individuals. Recently, for example, the public media has been speaking of those who leave their keys in an unlocked car and "turn a good boy bad." Now, while it is unwise to leave an auto in such a state, the *real* criminal needs to be better identified. Such thinking by behaviorists is quite reminiscent of the moral decay in France at the time of the Marquis de Sade who stated:

> There have even been societies in which the victim was punished for not watching his property any better! It is unjust to sanction possession by a law for then all doors are open to the criminals who are reduced by this knowledge. It is indeed fairer to punish the victim than the thief. (cited by Bloch, 1931, p. 224)

Skinner, chief spokesman for behaviorism today, states, "It is the environment which is 'responsible' for the objectional behavior, and it is the environment, not some attribute of the individual, which must be changed." (1971, p. 74) If we *really* accept what Skinner says, then we cannot any longer allow individual freedom, and we ultimately will help him usher in the "Big Brother" society described by George Orwell in *1984.* There will be no exceptional individuals in that society as they will not benefit for the progress of all. It will be necessary to abort them, as we are beginning to hear today, or to leave them in the woods for animals to devour in the manner of the ancient "enlightened" Greeks.

The behaviorist has a low mechanistic view of people, who *must* act out on a simple "stimulus-reponse" animal level. Behavioral therapy is today used extensively in correctional settings where people experience little conscience control. Such "aversion

therapy" or negative conditioning does reinforce "right" behavior in such facilities, but it also accounts for the high recitivism rate among inmates associated with such institutions. It is evident that these people have not become *responsible* as autonomous individuals in society! Responsible control must develop from internal strengths as we note in the following diagram.

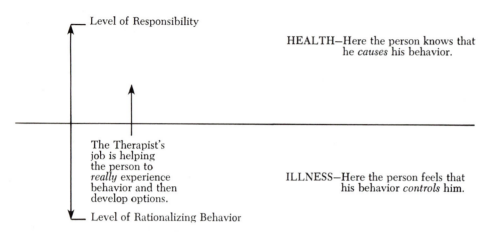

Figure 297. The Therapy Process.

Here we note that individuals who *really* experience their negative behavior in the inner depth of self-identity—will develop an inner moral aversion to committing further criminal acts. As we will see later, such therapy involves sensitivities developed from the love and disciplining of reparenting.

Now, while the behaviorist philosophy is to be rejected, there have been many valuable contributions by researchers in this field. Most of our understandings of visual-perceptual experiencing are found within the behavioral context. And, reactive functioning, especially within the reference of the family, may best be recognized from the behavioral standpoint. From a view of the autonomy of the individual we may well ask, "At what point or age does the child become responsible for his behavior and apart from the role conditioning of the family?" This becomes a central question as we consider the disturbed child later within the context of his family.

The Psychoanalytic Movement

Sigmund Freud, the father of *psychoanalysis,* developed a theoretical structure for human personality and behavior early in this century which provides great insights regarding conflicts of the inner and outer worlds of the developing child. His prize pupil and associate, and later rival, Carl Jung, became the founder of *analytical psychology* in departing from Freud's theories of the unconscious. Consideration will be given to both men in regard to contributions centering upon theory of personality, creativity, and psychopathology.

Freud

Because he found hypnosis very difficult, Freud turned to free association methods and the study of dream content as a means for probing the unconscious mind of his patients. Strong emphasis upon symbolic significance naturally resulted. His study of the unconscious instinctual drives, or *Id* forces, and their organization on various levels of development is of particular interest in regard to our study of the exceptional child.

Figure 298. Ceramic Head, Adult Psychiatric Patient.

Freud discerned two types of instinctual drives in the unconscious Id and he labeled them *libido* (life forces) and *thanatos* (death forces). These forces both demand immediate and total fulfillment—they are insatiable and operate on the *pleasure principle*—they demand relief! He defined the libido as demanding love and protection and generally centering about sexual drive. The thanatos he defined as the aggressive core of personality where destructive impulses work to produce the "death wish." These destructive impulses may project themselves outwardly upon others in which case the individual becomes a threat in society—or they may turn upon the individual himself for Freud believed that the thanatos drive was essentially organic matter seeking to return to inorganic matter. His materialistic view here becomes prominent as he clarifies the body itself as the deeper source of the painful tensions.

The libido and thanatos instincts of the Id are organized according to *pregenital, latency,* and *genital* levels of development. Perhaps most significant for our interest, the pregenital level, is further divided into *oral, anal,* and *phallic* periods. Significance for our study is based upon the fact that we are dealing with individuals who are often primarily in a state of *fixation* or *regression* at these emotional levels.

The oral period or level basically deals with dependency—the mouth suckling at the mother's breast—but later biting it. (fig. 298). In the more general sense the dependency of the oral stage may be expressed in numerous relationships of the child with the mother. In figure 299 we note two plants together similar to the relationship in an earlier viewed work (fig. 296). In figure 300 another adolescent boy in a correctional facility draws a type of Jack-in-the-Box which is easily evidenced symbolically as the individual connected to the mother or womb, as a receptacle form, by the umbilical form of the body. Helpless dependency is emphasized by the lack of arms.

Anal development is expressed by *expulsive,* and then *retentive,* behavior. Through a growing narcissism the child is using the feces first for *power* and then for *approval.* The expulsive act is an aggressive attempt to overwhelm others. In the symbolic con-

Figure 299. Painting by Delinquent Youth.

Figure 300. "Jack-in-the-Box" by Delinquent Youth.

tent of the art expression the aggression is often evidenced in flooding or burning. Cruelty and destruction may initially express an attempt to "get even" but the ultimate direction of the aggressive drives may be toward one's self. In figure 301, for example, we see a drawing produced by a young man who was involved in arson. The monster about to devour him from behind represents the instinctual drives which overwhelm him and which he is unable to control. In figure 302 he paints the fire alone as the conflagration of his schizophrenic episodes in which he is split from reality by the overpowering instinctual forces.

Phallic development occurs in the child basically from three to six years of age. Narcissism rules at this time. Aggressive drives now are associated with the genital organs and subsequent retaliation is often evidenced in castration performed by some monster or robot with scissors-like hands (fig. 303). Often aggressive overt features expressed in art (fig. 304) are immediately followed by castration symbols in the form of tattoos or scars (fig. 305). This subject had attempted a homicide which was followed by attempted suicide.

It is during the phallic period that the acts of masturbation, and associated fantasies, set the stage for the Oedipal conflict. In figures 306, 307, and 308 we view drawings by a four year old girl whose mother was concerned by the daughter's obvious hostility and rejection. When asked to draw a house (fig. 306) the daughter drew a house for everyone but mother and stated, when asked, that, "Mommy's house died."

Figure 301. Painting by Arsonist.

Figure 302. Painting by Arsonist.

Figure 303. Drawing by Male, 13 years.

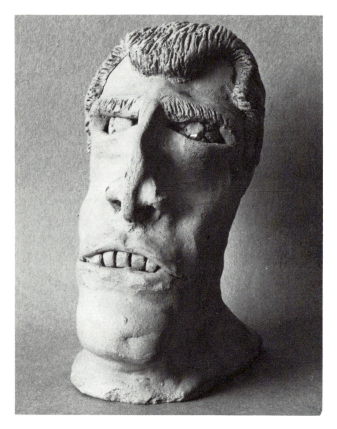

Figure 304. Ceramic Head by Delinquent Juvenile, 16 years.

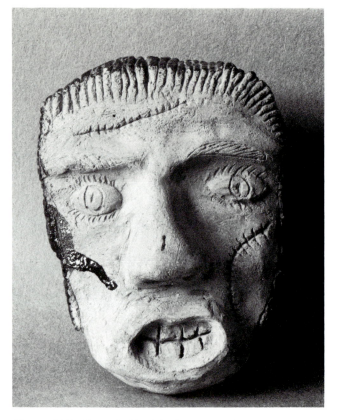

Figure 305. Ceramic Head by Delinquent Juvenile, 16 years.

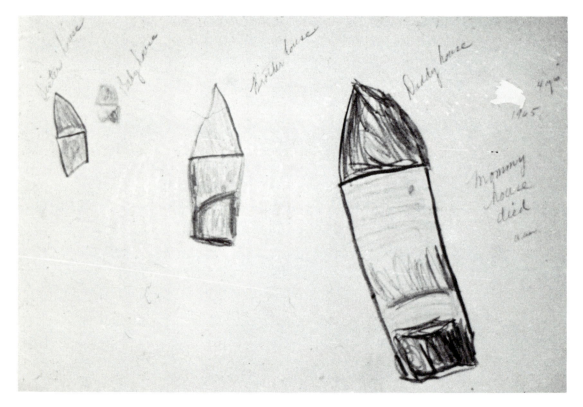

Figure 306. ''Mommy's House Died'' by 4 year old girl.

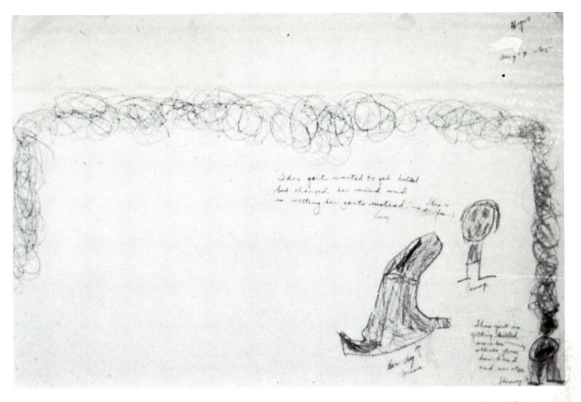

Figure 307. Drawing by girl, 4 years.

In figure 307 we see two figures of the girl after a big argument with mother. In connection with the upper figure she stated, "This girl wanted to get killed, but changed her mind and wet her pants instead" (self destruction by water). Down in the corner the girl is burning up (self destruction by fire). The form to the left of the figures is her "dog house." In figure 308 we see a "Great big beautiful sun" in the sky as a symbol of the father while down in the left corner is the "Bride"—the girl is about to marry father after having "wiped out" mother. In this case it was difficult to convince mother that her daughter was moving through a very normal period of development. In a further case, abnormal continuance of the incestual threat between the child and the parent of the opposite sex is in evidence (figs. 309 and 310). In the first drawing this thirteen year old girl draws a boat representing herself in the figure of the female genitals. The sun represents the father while the hills on each side represent the mother. Bender states of the boat:

> The use of the ship as a female symbol is very widespread in literature. Groddeck quotes an old Irish legend in which the female genitals take the shape of a ship's hull, and the male genitals take the form of the mast. An old Irish colloquial term for 'clitoris' is 'the little man in the boat.' In *The Way of the World,* by William Congreve, and in the more modern *Infanta Marina* by the poet Wallace Stevens, are further examples which illustrate the recognition of Freud's symbolic evaluation of the ship in terms of the female genital. (1952, p. 168)

The extreme character of this girl's situation appears in the second drawing (fig. 310) where "The King's Royal Boat" rests upon the water below a brilliant sun decorated with two hearts.

After six years the child enters the *latency stage* as the second Id development stage. Sexuality is represented as we see in the story examples of *Snow White* and *Sleeping Beauty*. By twelve to twenty years however the individual enters the final *genital stage* where sexual awakening takes place and is directed within social channels.

Figure 308. ''Bride and Great Big Beautiful Sun'' by girl, 4 years.

Figure 309. Boat in the Channel by Gloria, 13 years.

Figure 310. "The King's Royal Boat" by Gloria, 13 years.

Because the Id forces do not exist in harmony with each other or reality, Freud clarifies that the *Ego* is formed to handle transactions with the outside world. The Ego is the real *us* as we think of ourselves and acts on the *reality principle* to control our conscious actions in our particular environment.

Freud states that the *Super-Ego* is formed out of the unconscious as a result of the Oedipal Complex. It is the "Ego Ideal" which absorbs both positive and negative feelings about the parents by *identification*. The Super-Ego is the moral aspect of the personality and operates on perfection rather than pleasure. It modifies and inhibits the strivings of the Id forces as acceptable behavioral expression by the Ego.

If adequate defenses cannot be set up in the Ego we find a person who acts out impulsively and probably will be apprehended in some manner by society. On the other hand too much repression of the aggressive drives restricts the individual's creativity and may even leave him with unwarranted feelings of guilt and worthlessness. Freud clarifies that *neuroses* represent a fixation at an earlier psychosexual level while *psychoses* involve a splitting of Ego functions under intolerable stress . . . when the split forms between the conscious Ego and reality—then fantasy replaces reality. In art expression such experiencing may develop into a loss of form and compositional integrity (fig. 311).

Jung

Carl Jung, like Freud, was a physician. His father had been a pastor in a center of strict Calvinism and Carl departed from the tenets of the Christian faith as he grew. He had a burning desire to be an archaeologist and that interest, plus the evolutionary emphases in the early part of this century, sent him off eventually on a spiritual quest through Eastern cultural and religious thought. He makes direct reference to a book by Friedrich Creuzer titled *Symbolism and Mythology of Ancient Peoples*. The transcendent movement, promoted by such men as Swedenborg and Kant, undoubtedly also had at least an indirect influence upon Jung's thought. But it was Friedrich Hegel, the German philosopher and father of dialecticism, who most deeply influenced the

Figure 311. Drawing by Homicidal Paranoid Schizophrenic, 37 years.

culture of Jung's time. He has sent both Karl Marx and Charles Darwin into their respective fields with dialectical-evolutionary theory. It was Hegel who defined "God" as "the people collectively marching through history." Therefore it is not surprising to find Jung stating:

> The collective unconscious contains the whole spiritual heritage of mankind's evolution born anew in the brain structure of every individual. . . . Mythological themes, symbols rooted in the universal history of mankind, or reactions of extreme intensity always indicate the participation of the deepest strata. These motifs and symbols exert a determining influence on psychic life as a whole.
>
> (cited by Jacobi, 1943, p. 34 and p. 39)

In Hegel's philosophy we find the root of Jung's *collective unconscious* or "unconscious memory traces" which he first called "primordial images" and then later *archetypes*. Jung rejected Freud's idea that psychopathology was due to material morally repressed from consciousness and he sought to show that at least the major depths of the unconscious were made up from phylogenetic memory. While the contents of the archetypal energy can never be recognized directly in consciousness, Jung states that the symbol becomes the vehicle through which the energy of the archetypes is expressed in the conscious level. The archetypes are autonomous in character and provide the substance of neuroses and psychoses if they rise too forcefully into consciousness where the Ego is unable to asssimilate them quickly enough. In such circumstances the Ego defences attempt to "wall them off," and may succeed for a time but the behavior of the individual in such cases becomes rigid and uncreative. Pressure builds up and when the defenses are overwhelmed the invasion of archetypal forces into consciousness will upset the compensatory balance of the Ego functions and thereby produce neurotic or psychotic symptoms. On the other hand, Jung emphasizes, the archetypal energies are also the source of visions and hallucinations of creative people—people who are "open" to experiencing the "irrational" world within each of us. Jung also believes in a "forward going character" in man's personality development which strives to continuously realize ultimate balance and unification (similar to Hegel's "God" and the goal of Eastern religions). The process of gaining these insights which relate to one's collective

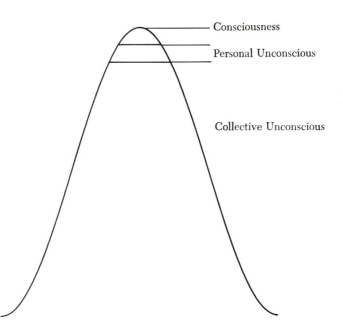

Figure 312. Structure of Jungian View of Personality.

unconscious is termed *individuation.* The process of individuation involves experiential exploration of symbolic content which typically is defined by patients as a journey in which they encounter such figures as the Shadow, the Anima, the Wise Old Man, and the Uroboros. Jung identifies the "journey" of psychical death and regeneration in such practices as alchemy or in such fables as *Theseus* who battles the centaur in the labyrinth (a symbol of the unconscious). Indeed, it is Jung's study of the symbolic content in fables and cultures that provides such a wealth of understanding in the art of the disturbed. Whether we agree with his interpretation of symbols or not, we must note that he was a most notable and arduous investigator—perhaps he *had* to be for this was his life's quest for the truth.

While the collective unconscious and its contents have become the focal point in our consideration of Carl Jung, we must also deal with the two other portions of the human personality which are part of his theory: the *personal unconscious,* and *consciousness.* (fig. 312). The personal unconscious is composed of material that was once a part of consciousness but is now forgotten or repressed. Consciousness is usually discussed through the Ego which is the center or "subject" of consciousness. Jung speaks of four *functions* of the Ego: *thinking, feeling, sensation,* and *intuition.* The natural elements which are often symbolically associated with these in art are, in the respective order: air, fire, water, and earth. These ego functions are complementary and compensatory—that is, when one function dominates consciousness the opposite function will set up a compensatory drive in the unconscious (fig. 313).

Jung also speaks of two attitudinal types within consciousness: *introversion* and *extraversion.* These determine the individual's reactions to the inner and outer worlds. The introvert attitude orients the individual more specifically to the inner subjective world while the extravert attitude orients the individual more dominantly toward the outer objective world. These attitudinal types will be discussed further in the following chapter as they relate to perception.

The Humanistic Movement

Abraham Maslow is the father of Humanistic Psychology but there are numerous individuals who have set the stage for this "Third Force" in psychology. Existential philosophers from Kierkegaard to Camus and Sartre have brought a stress upon the

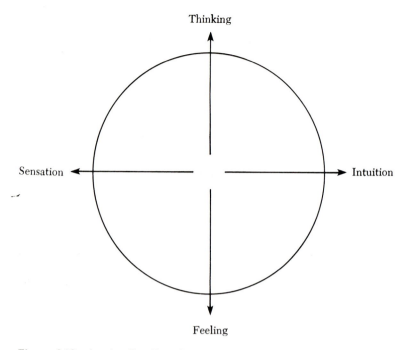

Thinking

Sensation ← → Intuition

Feeling

Figure 313. Jungian Ego Functions.

individual to the movement. Humanists like Buber and Frankl have not only influenced the movement through a stress upon the significance of the individual, but as well by the importance of human *experiencing*. Also, this movement, in stressing individual experiencing, places emphasis upon the *now* or *moment* and disregards the causative factors of the past. It is therefore a movement based also upon phenomenological philosophy. Emphasis is above all placed upon autonomous human characteristics such as choice (the exercise of will which Skinner denies), creativity, values, and self-actualization (fulfilling all people, from every level, by helping them realize their potential).

It is not our purpose to fully describe this movement here but to only point out how supportive it is of individual needs such as we find in exceptional children. Its idealism is as refreshing as Skinner's behavioral philosophy is depressing. The present emphasis upon the "expressive therapies" (art, music and movement or dance) comes from this movement and we look for innovative experiments and beneficial results in the lives of people as this relatively new thrust in psychology develops.

Summary

A foundation for understanding and discussing the individual through his art has now been established. We understand that every child structures a reality through the total interaction of physical and psychical components: the soma, the personality, and the spirit. The soma and spirit are communicative components for the establishment of reality in the personality. Sensory communication of temporal reality is provided by the body, while symbolic meaning, concerning transcendent reality, is communicated by the spirit. The mirror of art may act as a reflection of any or all of these functions due to the projective character of the art process. Further discussion will now clarify how art utilized in therapy and education may encourage promoting the fulfillment of individual potentialities.

The three 20th Century movements in psychology have also been briefly reviewed in order to recognize their contribution in understanding the needs and art of exceptional children and their role in helping to resolve these needs through the art experience. Such contribution will become evident in further discussion.

References

Bender, L. *Child psychiatric techniques.* Springfield, IL: Charles Thomas Co., 1952.

Bieliauskas, V. J. *The house-tree-person research review.* Beverly Hills, CA.: Western Psychological Services, 1965.

Buber, M. *I and Thou.* New York: Scribners, 1958.

Buck, J. *The house-tree-person technique: Revised Manual.* Beverly Hills, CA: Western Psychological Services, 1966.

Cirlot, J. E. *A dictionary of symbols.* London: Routledge and Kegan Paul, Ltd., 1962.

Digby, G. F. W. *Symbol and image in William Blake.* Oxford: Oxford University Press, 1957.

Edinger, E. F. *Ego and archetype.* Baltimore: Pelican Books.

Frankl, V. *From death camp to existentialism.* Boston: Beacon Press, 1959.

———. *Man's search for meaning.* New York: Simon and Schuster, 1972.

Hall, C. S. *A primer of Freudian psychology.* New York: Mentor and Plume, 1954.

Hall, C. S. and Nordby, V. J. *A primer of Jungian psychology.* New York: Mentor and Plume, 1973.

Hammer, E. *The clinical application of projective drawings.* Springfield, IL: Charles C. Thomas, 1958.

———. *The H-T-P clinical research manual.* Beverly Hills, CA: Western Psychological Services, 1955.

Head, H. *Aphasia and kindred disorders of speech.* New York: Hafner Publishing Co., Inc., 1963.

Holy Bible. King James version. London: Oxford University Press.

Hulme, F. E. *Symbolism in Christian art.* New York: The Macmillan Co., 1899.

Jacobi, J. *The psychology of Jung.* New Haven: Yale University Press, 1943.

Jolles, I. *A catalogue for the qualitative interpretation of the house-tree-person.* Beverly Hills, CA: Western Psychological Services, 1964.

Jung, C. *Collected works.* 17 Vol., Bollingen Series. Princeton, NJ: Princeton University Press, 1961.

———. *Man and his symbols.* New York: Doubleday, 1965.

———. *Psyche and symbol.* New York: Doubleday Anchor, 1958.

Koch, C. *The tree test.* New York: Grune and Stratton, Inc., 1952.

Machover, K. *Personality projection in the drawing of the human figure.* Springfield, IL: Charles C. Thomas Publisher, 1949.

Maslow, A. *Motivation and personality.* New York: Harper and Row, 1970.

———. *Toward a psychology of being.* Princeton, NJ: Van Nostrand, 1961.

Pickford, R. *Studies in psychiatric art.* Springfield, IL: Charles C. Thomas Co., 1967.

Read, H. *Education through art.* New York: Pantheon Books, Inc., 1958.

Sartre, J. P. *L'existentialisme est un humanisme.* Paris: Editions Nagel, 1946.

Schaeffer, F. *Back to freedom and dignity.* Downers Grove, IL: Intervarsity Press, 1972.

Schilder, P. *The Image and appearance of the human body.* New York: International Universities Press, 1950.

Skinner, B. F. *Beyond freedom and dignity.* New York: Alfred A. Knopf, Inc., 1971.

PART FOUR

**Procedures:
Selected Art Activities**

Art Activities and Procedures 9

The art activities that are selected to be included in this chapter are those requiring advance preparation, involve a number of steps or operations, or their complexity necessitates an extended explanation.

For each activity the following information will be included in the description.

MATERIALS: All the materials required for the activity are listed. The term clean-up supplies refers to materials such as soapy water, paper towels, sponges, etc.; work surface covering, refers to either unprinted newsprint paper* or plain paper. (For some children it is advised to mask the paper to the work surface.)

ADVANCE PREPARATION: This section is included where appropriate to indicate materials that the teacher/therapist or the children will have to prepare *before* beginning the activity. For some activities the preparations involve materials such as plaster of Paris, modeling materials, or cookie dough; these are presented in the Recipe section at the end of chapter nine.

PROCEDURE: This section gives step-by-step directions of how to do the activity. Unless it is indicated, the children are to do all the steps. Procedures will be directed to the children, when necessary instructions for teachers are given in parentheses.

VARIATIONS: Activities that are either follow-up activities, more complex versions of the original activity or related to the original activity are presented in this section. VARIATIONS are not provided for each activity.

ADAPTATIONS: This section provides information and teaching strategies for children with different handicapping conditions who need more structure, assistance, or prepared materials in order to do the art activity. Adaptations may be given for a specific activity or at the end of a series of activities within the same category. An adaptation section is not included for all activities or for all exceptionalities.

The activities are grouped in categories:

- Exploring an Art Element: LINE
- Exploring Techniques: RELIEF
 CONSTRUCTION
 MODELING and SHAPING
 PRINTMAKING
 WEAVING
- Integrating Art and Other Subject Areas: ART and SOCIAL STUDIES
 A Thematic Approach: The Neighborhood

*Printed newspaper is not recommended because the print wears off; the print may also distract the children.

The division of the art activities into categories is for the purpose of demonstrating the different approaches that may be used in the design of art curricula. Only a sample of activities are given within each category. However, the use of resource materials, experience and the imagination can provide the teacher/therapist with a host of ideas for other activities. For the most productive use of the suggested art activities in this section and throughout the book, the following questions should be asked when reviewing a specific art activity: "Knowing the child (children) that I am working with, what activity should precede this activity?" "What activity should follow this activity?" The answers to these questions will provide a series of activities that progress in a sequential and meaningful manner.

As has been mentioned before in the book, it is important to try an activity before presenting it to the children so that the procedures are understood, that they can be demonstrated and/or explained clearly, and that adaptations, if necessary can be made. A completed example (made either by the teacher/therapist or a child) to show as a model, will help the children understand the task.

Exploring an Art Element: Line

Lines are everywhere. There are "real" lines and "virtual" lines (Montgomery, 1973, p. 229). "Actually, the difference between lines as observed movement [virtual] and as recorded movement [real] is the difference between specified and unspecified time, rate, and direction" (p. 104). A line is a record of action, a defined movement in space, a path the eyes take, an edge. Lines are found in the person-made environment (clocks, fences, maps, climbing bars) and in the natural environment (tree branches, veining of leaves, spiders' webs). Lines are elements in math and art.*

Lines have different qualities: short/long, thick/thin, curved/straights, broken/continuous, rough/smooth. They may take different directions: horizontal, vertical, diagonal, they can express moods: sad, happy, angry, and be used to notate movement: running, jumping, climbing, falling, and reaching. The conception and perception of line is crucial for locomotion, moving to a target, estimating distance, sewing, following trails and maps, and for art: drawing, stitchery, and construction. (Montgomery, 1973)

The art activities in this section deal with lines that are basically two-dimensional. Three-dimensional activities that incorporate lines are described in EXPLORING TECHNIQUES: CONSTRUCTION. In the two-dimensional activities a variety of media, materials, and techniques are introduced.

ACTIVITY: LINES THAT MOVE

MATERIALS: 12″ × 18″ white drawing paper (smaller sheets for physically restricted children), jumbo crayons (three colors per child).

ADVANCE PREPARATION: Write words that suggest movement (run, skip, jump, fly, climb, bend, reach, hop) on the chalkboard. Prepare sheets for distribution that have the identical words in a list. Read the words and point to them on the board one at a time.

PROCEDURE:

1. As each word is read, draw a line in the air to show the movement of the word. For example, what kind of line would you draw for the word *run?*
2. As the words are read to you this time, *draw* the lines on your paper. Under each line write the word that the line represents. (Emphasize the personal interpretation—there are no right answers.)

*The elements in art are the building blocks; they are what the artist works with to create drawings, paintings, sculptures, etc. Line is a very important element.

3. Select two of your favorite movement lines. Make a new drawing with these lines, e.g., lines that *jump* and *skip*. Do variations of these lines—long, short, thick, thin. Title your drawing, for example, "Jumping and Skipping".
4. Share your work with your neighbor. Explain your drawing to him.

VARIATION: This activity can be implemented as a painting experience. Use black poster paint, 1″ brush, and 18″ × 24″ newsprint paper.

ACTIVITY: LINE RUBBINGS

MATERIALS: 9″ × 12″ manila paper for the background, 9″ × 12″ newsprint paper for the rubbing, sheets of colored construction paper to cut the paper strips (one sheet per child), black jumbo crayon with the wrapping removed, masking tape, hole puncher (optional), paper to cover the work area.

ADVANCE PREPARATION: Break crayons in half and remove the wrapping. Cover each work area with sufficient paper so that the children will have a smooth surface to work on. Provide samples of rubbings with overlapped strips and those that have had holes punched.

PROCEDURE:

1. Cut out the paper strips. Vary the kinds of strips—long, short, thick, thin.
2. Select 5 to 8 strips for the rubbing. Arrange the strips on the background paper. Overlap some of the strips.
3. Place the newsprint paper over your arrangement. Be careful not to move the strips. You now have a paper sandwich—background paper, paper strips, newsprint paper. Tape your work to the table so that it will not move as you do the rubbing.
4. Use the side of the crayon over the areas with the paper strips. Work lightly at first, when the image appears, press heavily on the crayon.

ADAPTATIONS: For some handicapped children it may be necessary to precut the paper strips or to provide a lighter weight paper such as newsprint or typing paper to cut the strips. In some cases it may be advisable to have the child paste the strips in place before doing the rubbing.

ACTIVITY: LINE COLLAGE

MATERIALS: all kinds of found object lines (string, wool, toothpicks, coffee stirrers, net scraps, plastic or wood utensils), white glue and brushes, container for the glue, background cardboard 9″× 12″, colored construction paper 9″ × 12″.

PROCEDURE:

1. Select a colored construction paper and glue it to the cardboard background. Arrange the line materials. (Limit the kinds and number of materials)
2. Glue to the background.

Exploring Techniques: Relief

Relief is a form of sculpture in which one part of the form stands away from the background. You can walk around a free-standing sculpture and view it from all sides, but a relief you can not see from behind. Art activities that emphasize relief can reinforce concepts of figure-ground, depth perception, gestalt formation (seeing the relationship of parts to the whole) and high and low. The relief activities that are described are aluminum foil, wood, egg carton, sandcast and clay relief.

ACTIVITY: ALUMINUM FOIL RELIEF

MATERIALS: Tools (brush handles, pencils, ball point pens) heavy aluminum foil folded over several times to provide thickness, mounting cardboard, india ink, 1″ paint brushes, newsprint paper, ooo steel wool, polymer medium or diluted white glue.

ADVANCE PREPARATION: Prepare the aluminum foil for the relief by folding it in four. Demonstrate the methods of tooling (drawing lines, shapes, texture) and getting depth by reversing the foil and working on the other side. Show samples in various stages of completion so that the children can see (feel) the process. Distribute small pieces of foil for practice.

PROCEDURE:

1. Do several practice sheets, drawing directly on the foil.
2. Draw a picture on newsprint paper, then retrace it on to the foil with a ball point pen (do not press too hard). Place a thick pad of paper (newspaper covered with newsprint) to provide padding so that the foil will not rip when being tooled.
3. Draw into the foil until parts of the design are raised.
4. Paint india ink over the entire surface, wipe off the excess. When the ink is dry, polish the foil design with steel wool (gently) until the desired effect is obtained.
5. Apply polymer medium or diluted white glue as a finish.

ADAPTATIONS: This is *not* an activity for children who need quick results or who have a limited attention span. Allow visually impaired children to draw directly on the foil. The shiny side of the foil may be distracting for some children—it can be reversed or a diluted wash of india ink can be brushed over the surface before tooling.

ACTIVITY: WOOD RELIEF

MATERIALS: wood scraps, large piece of wood for the background, sandpaper, white glue, brush and container for glue, white paint or wood stain, brush for paint, Q-tips for the stain.

PROCEDURE:

1. Select the wood pieces for the relief and sand them if they are rough.
2. Arrange the wood pieces (try several arrangements before deciding upon a final one). The wood can be placed in one or more layers on the background. It can be arranged to form an image (truck) or design.
3. Paint or stain the background and individual pieces of wood before they are glued to the surface.
4. Glue the pieces to the background wood
5. A hook can be placed in the back of the wood for hanging.

ADAPTATIONS: It is not necessary to sand the wood pieces. If children have difficulty painting or staining the wood pieces, it can be left unpainted.

ACTIVITY: EGG CARTON RELIEF*

MATERIALS: cardboard for background (12″ × 18″), egg cartons (styrofoam or cardboard in different colors), white glue, scissors, brush and container for glue.

*Source: Insights, 1981

ADVANCE PREPARATIONS: Remove egg carton lids. Cut egg cartons into various units (long strips, half strips, in half units. Children may cut the egg sections into smaller units). Demonstrate the concept of a unit design (each of the sections touch) and the possibilities of arrangement (facing upwards, downwards, horizontally, vertically.

PROCEDURE:

1. Select several egg carton units (one to three colors). Choose either styrofoam or cardboard egg cartons so the design has a unity.
2. Arrange the units, making sure that they each touch. Try a variety of directions and placements (face upwards and downwards) for the different parts of the relief.
3. When you are satisfied with the arrangement, spread glue on the background and press the egg cartons into the glue.

VARIATION: *EGG CARTON PICTURE RELIEF:*

PROCEDURE: Cut the egg carton forms into smaller pieces or change the shape of the egg cup by cutting into it. The pieces are arranged to form an image: fish, person, flower, animal or another design. NOTE: This is a more advanced activity.

ACTIVITY: SANDCAST RELIEF

MATERIALS: fine sand, box or aluminum pan at least 1 ½″ to 2″ deep, masking tape, scissors, plaster of Paris, small scrub brush, small shells, stones and objects for imprinting the sand.

ADVANCE PREPARATIONS: After each child has completed his sand mold, mix the plaster of Paris.

PROCEDURE:

1. Dampen the sand with water and fill an aluminum pan or cardboard box about ¾ full with sand.
2. Make a design in the sand by pressing objects face down into the sand. Objects may remain or be removed after the impression is made.
3. Check to see that the design is deep and that the sand has been pressed firmly.
4. When the design has been completed, pour plaster of Paris into the pan. Cover the pan with at least an inch of plaster. (More than one cup of plaster has to be prepared for each relief.)
5. After the plaster is set, allow at least one day for the plaster to dry. The excess sand can be brushed off with a brush.

ACTIVITY: CLAY RELIEF

MATERIALS: water base clay, 4″ high boxes (shoe or similar boxes) plastic wrap covering for work surface, carving tools (pencils, stirrers, ball point pens, plastic utensils), objects for imprinting the clay (broken jewelery parts, combs,—other objects that have patterns), plaster of Paris, petroleum jelly, wire for back.

ADVANCE PREPARATIONS: Prepare the plaster of Paris. Be sure to mix enough for each clay relief.

PROCEDURE:

1. Pack 2″ of clay into a 4″ high box.
2. Make sure some parts project from the background and others go back into the surface by pressing down with your hand to make some areas lower.

3. Use tools to draw into clay, create patterns with tools and objects.
4. Cover the clay with a piece of plastic wrap or a wet cloth. The clay relief will be used as a mold for the plaster of Paris.
5. Allow the work to dry for at least a day.
6. Cover the surface of the relief with petroleum jelly.
7. Strengthen the sides of the box with masking tape.
8. Pour the plaster in the box about 2″ thick, so it covers the entire relief.
9. When the plaster begins to set, place a wire in the plaster so that it can be hung when it is finished. (Children may need assistance with the placement of the wire. If the plaster has not set sufficiently, the wire tends to sink in.)
10. When the plaster is dry enough to be removed from the clay mold, be sure to pry it apart carefully so that the plaster does not crack into two pieces. (Children definitely need assistance with this procedure).
11. Store the plaster relief where it can continue to dry.

Exploring Techniques: Construction

Construction is a sculptural process in which the materials are shaped, cut, or found and joined together with adhesives, nails, or the welding process. In a classroom situation, constructions can be made out of wood scraps, sticks, straws, cardboard, and found objects. Construction activities are valuable for exceptional children because they provide concrete experiences with part-whole relationships and spatial and depth perception. Construction activities that are described are: scrap wood, box, and stick and wire construction.

ACTIVITY: SCRAP WOOD CONSTRUCTION

MATERIALS: scrap pieces of wood (about 8 for each child), masking tape, a base of wood, white glue, brush and container for glue, tempera paint (one color for each child), water container, paper to cover work surface, clean-up materials.

PROCEDURE:

1. Try various arrangements for the sculpture. Place the sculpture on a base if desired.
2. Use glue and then masking tape to hold the pieces that are joined. The masking tape can be removed when the glue has set. (Children may need assistance with joining.)
3. Remove the tape and paint the entire construction one color.

ACTIVITY: BOX CONSTRUCTION

MATERIALS: assorted boxes, paper tubes, cardboard sheets, base if desired, white glue and brushes, wire, scissors, container for glue, tempera paint (3 colors for each child), paper to cover the work area, sharp tool to pierce cardboard, clean-up supplies.

PROCEDURE:

1. Try different arrangements with your boxes and tubes. It may be a design or imaginative building (space station), animal, or robot. (Children may need assistance cutting tubes.)
2. After you have decided on your construction, paint each piece and allow it to dry. If you are using a base, paint it also.
3. Use glue and then masking tape to hold the pieces that are joined. The masking tape can be removed when the glue is set. (Children may need assistance with the joining.)

ACTIVITY: STICK AND WIRE CONSTRUCTION

MATERIALS: all kinds of sticks (twigs, tongue depressors, stirrers, popsicle sticks (with holes if available), dowels, telephone and light-weight wire, cardboard base, white glue, brush and container for glue, masking tape, scissors.

ADVANCE PREPARATION: Demonstrate bending, curling (around pencils and brushes), and cutting wire. Children may need assistance in wrapping the wire around the sticks or threading the popsicle sticks with it.

PROCEDURE:

1. Decide whether your construction is going to have a theme (a boat, creature, scientific structure (such as a weather machine, moon machine, time machine) or design. (This decision can be made prior to the activity or individually determined.)
2. Try different arrangements with the sticks and wire and then glue. Use masking tape until the glue has set.
3. Give the construction a name.

Explorating Techniques: Modeling and Shaping

Modeling and shaping are activities in which children in all stages of development enjoy and can participate. Modeling materials can be made of a variety of materials: water base clay, plasticene, salt ceramic, salt flour dough, and cookie dough which exceptional children can manipulate. For children who have difficulty modeling a more resistant media like clay, softer more plastic materials such as salt flour dough can be mixed to a proportion that is more suitable or commercial play dough can be substituted. When a child manipulates a modeling medium, he is able to make changes quickly, he has a sense of the tactile quality of the material, and a sense of depth and roundness. The modeling activities that are described are: modeling with clay, modeling cookie people: heads, and full figures, making beads.

ACTIVITY: EXPLORING CLAY

MATERIALS: water base clay (about the size of a grapefruit for each child), base on which to place the clay, paper to cover the work area, clean-up supplies.

ADVANCE PREPARATIONS: Prepare the clay in advance for the children. Because water base clay dries quickly, use a damp paper towel to keep it moist until the children are ready to use it. Have the children explore the qualities of clay (dampness, coolness, softness) and how it can be worked (squeezed, poked, patted, pounded, pulled apart, restored to a ball.) Allow the children to explore and then either reflect to them what they have done or ellicit from them what they have discovered (The method used is based on the developmental level of the children.)

ACTIVITY: A CLAY ANIMAL

MATERIALS: Pictures of animals, balls of clay (grapefruit size) 1 for each student, clay tools (tongue depressors, actual tools, pencils, popsicle sticks, plastic knives and forks), plastic bags, tempera paint (three colors), brushes (1″ wide and pointed brush), container for water, polymer gloss medium or diluted white glue, 10″ × 10″ cardboard for bases.

ADVANCE PREPARATION: Collect and display pictures of animals (different views and textured surfaces), pictures of animal sculptures. Prepare a ball of clay for each student and keep it moist with damp paper towel. Demonstrate how to make the

animal's body by shaping it with the hands, then add legs, head, tail, and other features. Show examples of completed children's work (put them away before children begin working). Demonstrate how to join parts of the animal.

PROCEDURE:

1. Play with the clay before starting to work on the animal (squeeze, pat, pull, flatten, push holes in it and restore the clay to a ball).
2. Decide on the animal you want to make. It may be like a real animal or one from your imagination.
3. As you work, turn your sculpture all around so that you can see how it looks from all sides.
4. When you are finished with the basic form and the legs, tail, head have been pulled out or added, check to see if all the parts are secure.
5. When the clay is a little harder, use tools to make textures and designs on the clay animals (dots, lines).

ACTIVITY: MODELING COOKIE PEOPLE

MATERIALS: balls of prepared cookie dough (about the size of an orange) 1 for each child, 12″ × 12″ piece of cardboard or masonite with freezer paper taped to the surface, flour in a baggie, large toothpicks for incising the dough, large mirror, chocolate bits, colored sprinkles, and silver balls. NOTE: Make the candy available only after the children have completed the basic figure, otherwise it becomes a source of snacks while they are working.

ADVANCE PREPARATION: Prepare the cookie dough, divide it into balls for the children. Store it in small baggies until the children are ready to begin work. To motivate the modeling of cookie people in action poses, tell the story of the Gingerbread Boy. Have the Gingerbread Boy jump, run, raise his hands and skip. Show the children examples of baked and unbaked cookies to demonstrate the spreading and rising qualities of the dough when it bakes.

PROCEDURE:

1. Decide on the action your gingerbread boy is going to take. Have the child next to you pose if you need help in picturing the position or look in the mirror.
2. When the figure is all shaped, small candy pieces can be added for the features (eyes, nose, mouth), belt, hair, or for decoration on the clothes.
3. Carefully place your cookie person on the baking sheet that has been prepared. (Children may need assistance, or it should be done by the teacher/therapist.)
4. Cookies are baked either in the classroom in a portable oven or other arrangements are made.

VARIATION: MODELING COOKIE FACES: The materials used for this activity are the same as for MODELING COOKIE PEOPLE, with the exception of the candy for details and trimmings. In the cookie face activity children are encouraged to model and incise (draw into) the dough instead of adding to the surface.

ACTIVITY: MODELING BEADS

MATERIALS: Colored salt ceramic or baker's clay (prepared), food coloring, plastic bag, aluminum foil, toothpicks, petroleum jelly, polymer medium or diluted white glue, needles with large eyes for stringing wool (smaller eyed-needles if thread is used), Orlon yarn, nylon thread doubled, or elastic thread.

ADVANCE PREPARATIONS: Prepare the clay, wrap it in aluminum foil or a plastic bag and place it in the refrigerator until ready to use. Food coloring can be added when the clay is being made or worked into the clay when it has cooled slightly. Make several batches, cover and store them separately. Demonstrate how to roll the beads, cut them, and make holes in them for stringing. Older children can make color sketches of their alternating patterns (round red, yellow, oblong yellow, repeat).

PROCEDURE:

1. Try some practice beads before you decide the shapes, sizes, colors and pattern of your strand of beads.
2. Make all the same size and same type of beads at one time, then shape the next group.
3. When all the beads have been shaped, make the holes by pushing toothpicks covered with a little petroleum jelly through them.
4. Place them on aluminum foil to dry. Turn them gently so that they dry evenly and do not flatten out.
5. When they have dried completely, paint the beads with polymer medium or diluted glue.
6. Refer to the pattern you have drawn and string them.

ADAPTATIONS: Large eye needles and Orlon yarn should be used for developmentally younger children or those with fine motor or muscle difficulties. It is not necessary that these children plan or sketch the pattern for the beads. For some, the accomplishment of stringing is sufficient.

Exploring Techniques: Printmaking

The most direct and the least complicated of the printmaking processes are described: monoprinting, found object stamping, designed stamp stamping, relief printing, styrofoam meat tray and cardboard prints. These activities have been selected because exceptional children can master at least one of the processes. Once the children learn the basic skills of printmaking other of the more complicated techniques such as linoleum, woodcut, or silk screen printing can be introduced.

ACTIVITY: MONOPRINTING

MATERIALS: Colored construction paper (different sizes and colors), printing surface (baking sheet, or a plastic or metal tray or counter top) printing medium (tempera paint thickened with Ivory Flakes, liquid plastic starch, or water base ink reducer, or use water base inks), brayer (roller) if ink is used, plastic spray bottle filled with water, tools (sticks, paint brushes), clean-up materials.

PROCEDURE:

1. Mask edges of printing area if a counter top is used.
2. Place small amount of paint on the printing surface. (If ink is used spread with a brayer). Allow the child to select two colors.
3. Scratch into the surface with stick, fingernails, fingers or the back of a paintbrush.
4. Place a sheet of construction paper on top of the design and rub it with clean hands.
5. If paint appears to dry too rapidly, spray the surface of the design with water.
6. Generally, only one design can be pulled from a monoprint, sometimes two. Finished prints can be mounted as pictures or folded and used as greeting cards.

ACTIVITY 3: MODELING PEOPLE

MATERIALS: salt ceramic, toothpicks, small pieces or masonite for bases, tempera paint or vegetable dye, Q tips and brushes (¼" wide), fabric scraps, wool scraps, white glue, container for glue, covering for table, clean-up supplies.

ADVANCE PREPARATIONS: Salt ceramic may be dyed beforehand or painted with tempera paint after the figures are completed. Determination about what process should be used is based upon the developmental level and behavioral patterns of the children. Prepare the salt ceramic for the group. (See recipe p. 276) Demonstrate how to insert toothpicks to help figures stand up, how to attach a figure to a salt ceramic base, and how to slightly moisten salt ceramic to add parts.

PROCEDURE:

1. Model a figure or figures involved in some activity (walking, sitting on a bench, bending over, running) To help get the action ask a neighbor to pose. Different colors dyed salt ceramic may be used for different parts of the body or the figure can be painted with tempera paint when dry.
2. Insert toothpicks in the arms and legs of the figures to help them stand up or place the figure or figures on the base.
3. When the figures are dry add fabric and wool for the clothes and hair if desired.
4. The completed figures will be placed in the neighborhood model.

ACTIVITY 4: CONSTRUCTING VEHICLES

MATERIALS: very small boxes (toothpaste, gift jewelry), small wood forms, cutup sponges or styrofoam, toweling, white paste with brushes, white glue with brushes, container for glue, scissors, toothpicks, small circles cut for wheels, tempera paint, Q tips or narrow brushes, masking tape, clean-up supplies.

ADVANCE PREPARATIONS: Cut the wheels out of cardboard to fit proportion of the small vehicles. Demonstrate how to construct vehicles by combining boxes, using masking tape to hold the form in place, then cover it with strips of toweling adhered with white paste. Prepare a list of vehicles that the children can make on the chalkboard. Let them come up and designate the one they are planning to construct. Provide pictures of vehicles, toy models or completed samples for children who have visualization difficulties.

PROCEDURE:

1. Select the vehicle to be constructed: car, bus, truck
2. A vehicle may be made of one or more parts. If more than one part is needed, join the parts with masking tape.
3. Cover the entire vehicle with paper towel strips and white paste. Allow it to dry.
4. Paint the vehicle.
5. Add the wheels by puncturing the sides of the box with a pencil or toothpick. (Children may need assistance in lining up the wheels, and making the holes in both the wheels and the box to which it is attached.

ACTIVITY 5: CONSTRUCTION LIGHT and TELEPHONE POLES, TREES, STREET SIGNS and TRAFFIC SIGN.

MATERIALS: construction paper tubes (advance preparation) for poles, wider tubes for trees (advance preparation), colored construction paper for branches and signs, colored markers, scissors, white glue, container for glue and brushes, toothpicks, telephone wire.

ADVANCE PREPARATION: Prepare the tubes for the poles by rolling construction paper and securing it with masking tape. The proportions of the tubes should be determined by the size of the buildings. Demonstrate how to cover the tape with a small patch of the same color paper and how to puncture tubes for insertion of wires or toothpicks. Review the neighborhood street signs and traffic signs (have them written on a chalkboard).

PROCEDURE:

1. Select and check off on the chalkboard the utility pole(s), tree(s) and/or signs you wish to construct. Do one at a time.
2. Completed forms will be added to the neighborhood model.

ACTIVITY 6: ASSEMBLING THE NEIGHBORHOOD MODEL

MATERIALS: brown wrapping paper to cover the base, cardboard from large box flattened out for a base, white glue and brushes, containers for glue, tempera paint, containers for water, construction paper, construction paper torn into tiny pieces.

ADVANCE PREPARATIONS: Large boxes such as mattress, bicycle or other large boxes with wide uncreased areas make the best bases when flattened out. Request that the local stores save these boxes. Prepare the box by cutting away the top and sides (retaining a 2″ wall all around so that forms will not fall off). Cut the brown wrapping paper the size of the base (it will be retained for a map of the neighborhood). Assemble the model in sections, not having more than two children up at the model table at once.

PROCEDURE:

1. Place the buildings on the base. (Discuss the arrangement, have them suggest and try alternatives until there is a sense of consensus.) Glue the buildings to the base.
2. Use colored construction paper for sidewalks and streets.
3. Use torn construction paper for the grass. Press the pieces into an area which has been spread with glue.
4. Add poles and signs. (Paper bases may have to be made to help signs and poles stand alone).
5. Add people and place vehicles in the model.
6. (When completed take photographs—slides and prints from different views (aerial, front, sides) and detail shots. This provides an excellent tool for review and reinforcement).

ACTIVITY 7: DRAWING A MAP OF THE NEIGHBORHOOD

MATERIALS: crayons or colored markers, brown wrapping paper that has been cut to size.

ADVANCE PREPARATION: Discuss and demonstrate the procedures. Have completed student examples exhibited next to photographs of previous models.

PROCEDURE:

1. With a partner go up to the model, find your building and locate where it would be on the map. Draw the shape and color it with markers. (Children come up in pairs until all the major structures are located. It may be necessary to prepare templates of the bases of the buildings—bottoms of existing cereal and shoe boxes—for the children to trace around for the map)
2. Add all other permanent structures (poles, signs).
3. Color in ground areas and locate trees.

ADAPTATIONS: Adaptations for each activity in the unit are based upon the group or individual children. Encourage as much independent work as possible. Children who are more developmentally capable or with better fine motor coordination can do more constructing on their own, rather than have precut forms, such as the tubes for poles. For partner activities, select children who can work well together or who compensate each others strengths.

Recipes

Plaster of Paris

½ cup of water
1⅛ cups of plaster of Paris
a disposable container
powder paint if desired

Method

To the water, add the cups of plaster of Paris. This will make about one cup of plaster. Mix until the water is absorbed. The mixture should be thick and creamy. The plaster will set in about eight minutes. Tempera paint can be added to DRY plaster of Paris for color. Note: Mix the plaster in a disposable container (paper cup), so that it may be thrown away, rather than having to pour unused plaster down the sink (which may clog the drain).

Salt-Flour Mix

1 Cup Salt
1 Cup Flour
1 Tablespoon Powdered Alum

Method

Mix dry and then add water until the consistency of cookie dough. Use soon after it is made.

Baker's Clay

2 Cups Salt
4 Cups Flour
1½ Cups Water (approximately)

Method

Mix dry ingredients and then slowly stir in water until the consistency of bread dough. Use soon after it is made.

Salt Ceramic

1 Cup Salt
½ Cup Cornstarch
¾ Cup of Cold Water

Stir constantly in a double boiler until thick as possible—scoop out and allow to cool. Pack in foil and a jar until ready to use. The mix will keep indefinitely in a closed container.

Cookie Dough

⅓ cup sugar
⅓ cup soft shortening
⅔ cup honey (Mix ingredients thoroughly in a bowl)
1 egg
1 teaspoon vanilla

2 ¾ cup flour
1 teaspoon baking soda (Stir together in another bowl)
1 teaspoon salt

Method

1. Mix dry ingredients into shortening mixture.
2. Chill dough 1 hour wrapped in wax paper.
3. Heat oven to 375°. Lightly grease a baking pan.
4. Divide chilled dough into 3 portions. (Place 2 portions of dough in the refrigerator until ready to use.)
5. On a lightly floured board, model your dough into cookie people.
6. Add Candy Bits if you like (m&m's, colored sprinkles, chocolate bits). They can be used for features (eyes, nose, mouth), clothing details (buttons, belts), or decoration.
7. Place cookie people on prepared cookie pan.
8. Bake 8 to 10 minutes.
9. Let cookies cool about 2 minutes on baking pan, then cool on a wire rack or plate.

References

Anderson, F. A. *Art for all the children.* Springfield, IL: Charles C. Thomas, 1978.
De Chiara, E. Modeling cookie people helps improve body image, *Arts & Activities,* October 1980, 40–41, 56–57.
———. Relief action figures. *School Arts,* November 1982, 20–22.
Dimondstein, G. *Exploring the arts with children.* NY: Macmillan, 1974.
Gaitskell, C. D., Hurwitz, A. and Day, M. *Children and their art: methods for elementary school* (4th ed.). New York: Harcourt Brace Jovanovich, 1982.
Herberholz, B. *Early childhood art* (2nd ed.). Dubuque, IA: William C. Brown, 1979.
Insights: art in special education (2nd ed.). Millburn, NJ: Art Educators of New Jersey, 1981.
Montgomery, C. *Art for the teachers of children* (2nd ed.). Columbus, OH, 1973.
Wankleman, W. F., Wigg, M. and Wigg, P. R. *Handbook of arts and crafts for elementary and junior high school teachers* (5th ed.). Dubuque, IA: 1982.

Recommended Source Book

Wankleman, W. F., Wigg, M. and Wigg, P. R. *Handbook of arts and crafts for elementary and junior high school teachers* (5th ed.). Dubuque, IA: 1982.

glossary: terms associated with exceptionality

Affective Pertaining to the emotional sphere of human experiencing.

Anal Period Second developmental phase of Freud's pre-genital stage during which instincts are related to the child's use of the feces for power and/or approval.

Analytic Psychology Jung's system of psychology which in contrast to that of Freud, minimizes sexual factors and stresses transcendental forces as a basis for psychic disorders.

Anima Jung clarifies this image as the feminine *soul* within the masculine personality.

Animus Jung speaks of this image as the masculine *soul* figure in the feminine personality.

Aphasia Loss or impairment of the ability to understand or formulate language; caused by neurological damage.

Auditory Training The procedure of teaching deaf or hard of hearing children to make use of their residual hearing.

Autism A childhood psychosis characterized by extreme withdrawal, self-stimulation, and cognitive and perceptual deficits.

Behavioral Approach A theory that views human behavior as learned and, amenable to change.

Behavior Management Training programs to help children manage or control their own behavior. Strategies require carefully delineating the behavior the child is to exhibit at the end of the program; identifying the present level of achievement or behavior; selecting a behavioral management plan or instructional approach; selecting or developing instructional or supporting materials; and keeping precise records of the child's behavior and progress toward the goal.

Cerebral Dysfunction Malfunction of the brain due to some type of damaging effect.

Convergent Reductionistic thinking process which usually has a singular or simple answer as a goal.

Corpus Callosum The Great Cerebral Commissure of nerve fibers which join the two hemispheres of the brain.

Dialecticism A philosophical view in which the conflict of opposing forces or thoughts is resolved by synthesis or the production of new form and ideas. The cycle repeats itself as each thesis holds the germ of its own antithesis. Note the works of Freidrich Hegel (1770–1831).

Disassociation or Dissociation Separation of the mind or consciousness from groups of ideas which become autonomous and which is expressed in confused identity regarding the body and interrelatedness with reality at the more severe stages of pathology.

Divergent Thinking process which extends into increasingly new and multiple directions— thus raising numerous questions while finding a few answers. (Einstein: "The more we know, the more we realize what is unknown.")

Down's Syndrome Often called *Mongolism.* Mental deficiency caused by abnormal chromosomal attachment. It may be "accidental" or hereditary.

Dyslexia From the Greek meaning "difficulty pertaining to words." It involves problems in learning through reading, writing, and spelling.

Ecological Approach A strategy that stresses the interaction between the child and his environment; supporters of this approach believe that giving a label to a child's exceptionality is harmful.

EEG or Electroencephalogram A laboratory test of electrical patterns in the brain to determine malfunction.

Ego The "subject" of consciousness which we feel is the *real* us. From the Greek word for *I*.

Eidetic Pertaining to persistent visual imagery which originates from within the mind.

Endogenous Mental deficiency originating from familial or hereditary inheritance. From the Greek words for *in* and *genesis* or *origin*— "coming from within."

Existentialism A philosophy which places the individual himself as responsible for all meaning and action in life. Started by Soren Kierkegaard (1813–1855).

Exogenous Mental deficiency originating from injury. From the Greek "coming from without."

External Locus of Control A personality characteristic whereby the individual believes that chance factors of people other than himself are responsible for his successes, failures (similar to outer-directedness).

Extraversion A personality attitude which orients the person to the outside world. (From Jung).

Familial Coming from the family as inherited traits and here referring to mental deficiency.

Fellatio Oral copulation by using the mouth on the male sex organ. Freud finds the basis in early childhood—the child at the mother's breast. Regressive or fixated behavioral identity in any case is obvious.

Field-dependent A perceptual type characterized by low self-esteem, an undifferentiated body-image, and poor impulse control. Apparently determined by a "growth-constricting" mother.

Field-independent A perceptual type characterized by high self-esteem, a highly differentiated body-image, and good impulse control. Apparently determined by the influences of a "growth-fostering" mother.

Fingerspelling One type of *manual communication* in which each letter of a word is represented by a hand position.

Fixation A Freudian term relating to arrested development

Fold-over View Appears from egocentricity in children's art. The action is experienced from the center and objects are "folded" outwardly on baselines.

Free Appropriate Public Education Education and related services provided at public expense, under public supervision and direction, without charge to the individual.

Functional Nonorganic; without apparent structured or organic cause.

Genital Stage The final stage of instinctual (Id) development, according to Freud, which occurs from 12 to 20 years of age. It is characterized by narcissism being channeled into other external objects.

Gestalt Theory which considers whole configurations or behaviors made up of multitudinous relationships. Often stated as, "The whole is greater than the sum of the parts."

Global Pertaining to perceptual experiencing of the visual pattern through a continuous coherent approach.

Haptic A perceptual personality type characterized by sensitivity to the bodily self and non-visual sensations.

Homunculus A figure produced by joining loops together as is typical for the young child of approximately five years. Such a figure is drawn when the child begins to relate his internal world to the external world.

Humanism Philosophic viewpoint which considers man the source of truth.

Hyperactivity Excessive motor activity, e.g., fidgeting, restlessness, inordinate amount of movement around class or at home) with or without a clearly defined purpose and at a higher degree than is considered typical for a particular age group.

Identification The process by which a person takes on the features of another person and incorporates them into his own personality—as in hero worship.

Ideoplastic Art expression in which ideas predominate over visual impressions.

Impulsivity Lack of control over impulses; spontaneous actions with little thought to consequences; responding without adequate reflection.

Individualized Education Program (IEP) Pl 94–142 requires that an IEP be drawn up by the educational team for each exceptional child. The IEP is a statement specifying instructional goals and any special education and related services a child may need: written and reviewed annually. Included are 1) the present educational levels of the child; 2) a statement of annual goals, including short-term instructional objectives; 3) a statement of specific services, if needed; 4) the programs; 5) the date when special services are to begin and the expected duration of these services; and 6) the tests and other requirements or information used to gauge the child's progress to determine if the instructional objectives are being met.

Individuation The therapy process described by Carl Jung which involves development of insights relating to material from the unconscious.

Inner Locus of Control A personality characteristic in which the individual believes he is responsible for his own successes and failures (similar to inner-directedness).

Introversion A personality attitude which orients the person toward his inner subjective world.

Kinesthetic Relating to experiences of bodily motion.

Latency Stage Freud's second developmental stage of the instincts or Id during which sexuality is repressed.

Least Restrictive Environment (LRE) A legal term referring to the fact that exceptional children must be educated in as "normal" an environment as possible.

Libido Life instincts which generally relate to the desire to be loved.

Mainstreaming Efforts to educate exceptional children in the least restrictive environment or educational setting by placing these children in conventional schools and classes, integrating them with normal children to the maximum extent possible.

Mandala A Sanscrit word meaning "magic circle," utilized in Eastern religious practice. Similar meanings are found in "zodiac," "zen," "zoro," etc.

Masochist One who copes with the tensions of anxiety by engaging in painful activity. The painful experiencing is aimed at suspending the increase of anxiety or by eliminating it altogether.

Modeling Showing or demonstrating to others how to perform behaviors.

Narcissism Self love.

Neurosis (psychoneurosis) A condition marked by anxiety, an inability to cope with inner conflicts; doesn't interfere as seriously with daily functioning as *psychosis.*

Oedipal Complex Conflict arising from the child's desire for the parent of the opposite sex and animosity toward the parent of the same sex. Relates back to *Oedipus Rex,* a youth who unknowingly slays his father and marries his mother.

Oral Stage The first stage of instinctual (Id) development in Freud's pre-genital level; it begins by suckling and ends by biting.

Peer Tutoring Instruction of one child by another in a structured situation. Tutors must be trained; special materials prepared, and an appropriate location established.

Perceptual-motor Training An approach to teaching mildly handicapped children that focuses on remediating perceptual problems such as gross and fine motor skills, form perception, memory sequencing, laterality training, visual and auditory discrimination, etc.

Perseveration Persistent repetition of an activity or behavior.

Phallic Stage The third stage of Freud's pre-genital level; it covers the early childhood period from approximately 3 to 6 years.

Phenomenological Philosophical approach which deals with careful descriptive measures but does not see causative factors.

Physioplastic Art expression in which visual impressions predominate over expression of ideas.

Pleasure Principle Tendency of the instincts to remove painful tensions of bodily need by any means possible.

Pre-Genital Stage Freud's first developmental level of the Id. It involves the following substages: oral, anal, and phallic.

Psyche The non-material or spiritual part of the person. From Greek meaning *soul.*

Psychoanalytic "Second Force" psychology of the 20th Century. Involves the *Psychoanalysis* of Freud and the *Analytic Psychology* of Jung.

Public Law 94–142 The Education for All Handicapped Children Act of 1975, which contains a manditory provision stating that beginning in September 1978, in order to receive funds under the Act, every school system in the nation must make provisions for a free appropriate public education for every child between the ages of 3 and 18 (ages 3 to 21 by 1980) regardless of the severity of the handicap.

Reality Principle Personality needs are met through healthy mental process in which the demands of reality are satisfied while the service of the pleasure principle is strongly modified.

Regression Return to an earlier level of development.

Repression The forcing of undesirable material out of consciousness and into the unconscious.

Resource Teacher A teacher who typically provides services for the exceptional child in his school; assesses the specific needs of the child, teaches him individually and/or in small groups, using any special materials or methods that are needed; consults with the regular teacher giving advisement about instruction and behavior management in the classroom. The resource teacher also provides services for the child's teacher, such as demonstrating appropriate instructional strategies and materials.

Schema or Schemata Concepts drawn in representational forms; from the Italian meaning *scheme* or *plan.*

Sodomy Anal copulation.

Soma Body.

Special Day Schools Schools that provide all-day segregated educational experiences for exceptional children.

Special Self-contained Classes Classes for children with a particular diagnostic label, e.g., learning disabilities; usually children within such a class need full-time instruction in this placement, and are only integrated with their normal classmates for a few activities, if any. Art, music, gym are classes to which these children may be mainstreamed.

Stimulus-Response Theory The premise of behaviorism which states that human behavior is determined by the effect of environment (positive and negative reinforcers).

Sturge-Weber Syndrome A physical injury at birth involving severe hemorrhaging of one brain hemisphere.

Super Ego The voice of conscience or "Ego Ideal." Freud believed that the conscience was formed as the child grew as the result of the Oedipal complex. The child absorbs the forbidding and disciplinary aspects of the parents, and solves mingled love and hate for them by becoming like them.

Tactual or Tactile Pertaining to the sense of touch.

Temporal Relating to time.

Thanatos The instinctual strivings related to death and destruction. The death instincts account for aggressiveness (i.e.: destruction projected outwardly upon others).

Transcendent Pertaining to knowledge obtained from beyond the limits of human experience in the material world. See the works of Kant.

Visual Relating to art experience which involves seeing and observing effects in nature.

X-Ray View Drawing an object as to suggest that the outer surface is withdrawn or transparent. Such a drawing indicates that the inside is, as important, or more important, than the outside and in the art of the disturbed it indicates severe confusion regarding reality.

glossary: terms associated with art education

Aesthetic Term in art referring to perception, response, and/or appreciation of beauty in art or nature.

Applique Decorative design made by cutting pieces of one material and attaching it to the surface of another material by pasting or sewing.

Arrangement Organizing and ordering the components of an art work into a pleasing visual composition.

Art Elements The basic visual tools of the artist—line, shape, color, value (dark and light), space, texture, and pattern.

Blot Drawing Subjects for drawing are evoked through shapes arrived at by spreading or allowing blots of paint or ink to fall at random on a piece of paper.

Brayer Rubber roller used for inking in printmaking projects.

Ceramics A word used to describe objects constructed of clay and fired (baked) in a kiln, (e.g., pottery, tiles, figures).

Charcoal Drawing stick or pencil made from blackened, charred wood.

Chipboard Heavy cardboard, usually gray in color, in varying thicknesses, which can be used for construction, collage backgrounds, stabile bases.

Collage Composition made by arranging and gluing materials to a background (e.g., scrap fabric, textured papers, varied shapes of construction paper).

Color An element of art.

Composition Combining the elements of a picture or other work of art into a satisfactory visual whole (may be a painting, drawing, sculpture or collage).

Construction Paper A strong absorbent paper available in a variety of colors. (can be used for collages, drawings, paper sculpture, pastels, painting).

Construct To build or design a structure in three-dimensional form

Contrast Opposites in art work—long-short, rough-smooth, light-dark (may be used to create variety and interest in paintings and compositions.

Design A structured, ordered, pleasing arrangement of one or more elements of art: line, shape, color, texture, form, value.

Finger Paints A thick paint medium that is worked with varied hand and finger pressure on glazed paper or a non-porous surface such as formica, to create a picture or design. (may be used to design monoprints)

Form Usually a three-dimensional or sculptural shape.

Found Objects Discards, remnants, throwaways, and samples that are used in collages, constructions, or as printmaking stamps. (e.g., empty spools, plastic spoons, fabric sample books, plastic containers)

Free Form An inventive biomorphic, irregular or indefinite shape.

Grout A filler such as plaster which when mixed with water is used to fill in the cracks in a mosaic.

Hue Another word for color.

Illustration A picture which usually accompanies a story, poem or written material.

Incise To cut into or indent a surface with tools. (clay can be incised; styrofoam is incised when making a relief printmaking plate)

Kiln An oven for firing (baking) clay.

Line A basic art element.

Manila Paper A general purpose paper for drawing, crayoning, or painting, usually a cream color.

Mat Board A heavy poster board used for mounting or matting pictures. (also useful as background boards for exhibits).

Medium Any material used for art expression (e.g., crayon, paint, clay, wood)

Mobile A free-moving sculpture, made of different parts.

Modeling Forming a sculpture with a plastic material such as clay, which can be formed and reformed (opposite—carving).

Monoprint One-of-a-kind print in which the design is created on a hard surface such as glass or formica with ink or finger paints and then transferred by contact to a paper.

Mosaic A design or composition made by arranging and gluing small pieces of ceramic tile, stones, or cut out pieces of paper or material next to one another on a background. Grout is used to fill in the cracks between the tiles.

Mural A monumental painting, originally painted directly on the wall. In a classroom situation may be designed on a roll of brown wrapping or kraft paper with the areas painted, drawn or collaged (usually a group project).

Newsprint Paper Newspaper stock. (used for sketches, rubbings or preliminary drawings).

Oil Pastel Combines qualities of chalk and crayon (colors brighter and spreads more effectively than crayon)

Paper Sculpture A three-dimensional paper created by bending, rolling, denting, creasing, scoring, folding various weights of paper.

Papier Mache Name given to paper craft technique which uses strips or pulp of paper moistened with wallpaper paste or laundry starch.

Pariscraft A commercial type of papier mache material which is made of gauze impregnated with plaster of Paris, when moistened it can be shaped and formed around a core or maintain its shape.

Pastels Light-valued colored chalk of varying degrees of hardness.

Pattern A design made by repeating a motif, lines, shapes or symbol.

Photo-montage A picture made by parts of pictures to an unusual or incongruous photographic background.

Plasticine A non-hardening oil or synthetic clay.

Positive-Negative Positive shapes in a painting or composition are the trees, objects, people, trees, buildings—solid objects. Negative shapes are the unused or empty spaces in between the positive shapes (similar to the concept of figure-ground).

Relief Design or pictorial element raised from the background; no part of the projection is entirely free from the background. (may be high or low relief, e.g., coin)

Sculpture Three-dimensional forms (can be modeled, e.g., clay; carved, e.g., wood or plaster; constructed, e.g., cardboard or found objects; cast, e.g., bronze).

Shape One of the structural elements. (generally refers to a two-dimensional mass).

Stabile A construction in space, usually with no moving parts (made of materials such as wire or wood and often mounted on a base).

Stitchery Varied textures of wool and/or thread are used with a needle to create stitches and designs on fabric. (may be combined with applique).

Tempera Paint An opaque, water soluble paint, available in powder or liquid form. (also called poster paint).

Warp The threads running lengthwise on the loom in weaving, supports the weft.

Weft The thread or material that goes across the warp from side to side.

author index

subject index